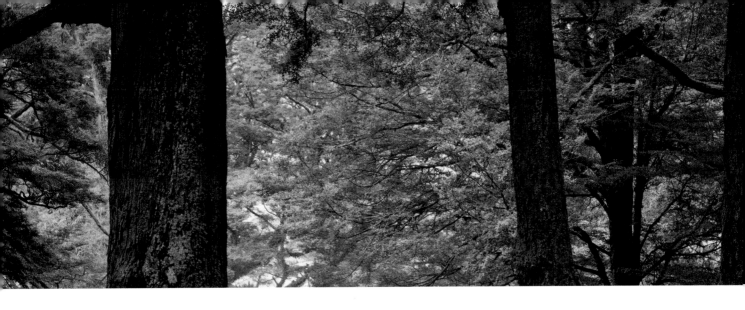

THE HOBBIT™
MOTION PICTURE TRILOGY

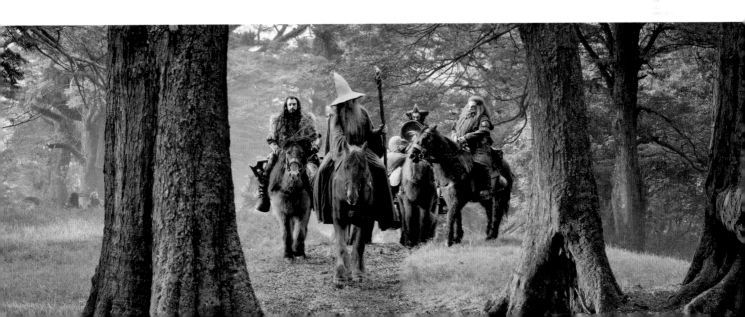

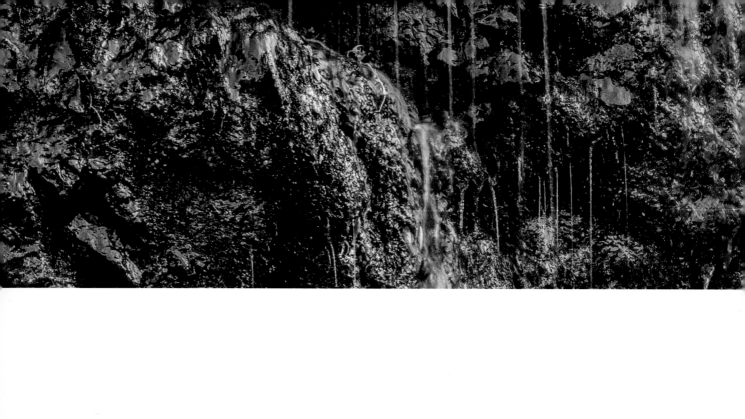

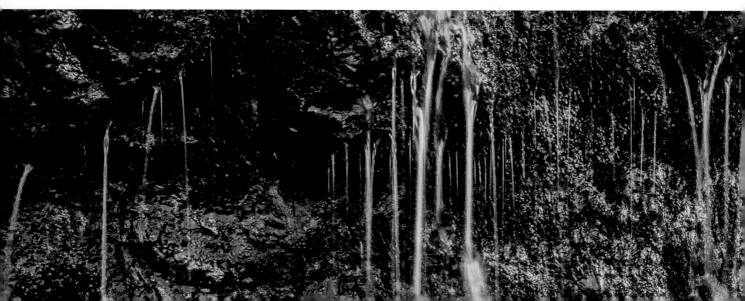

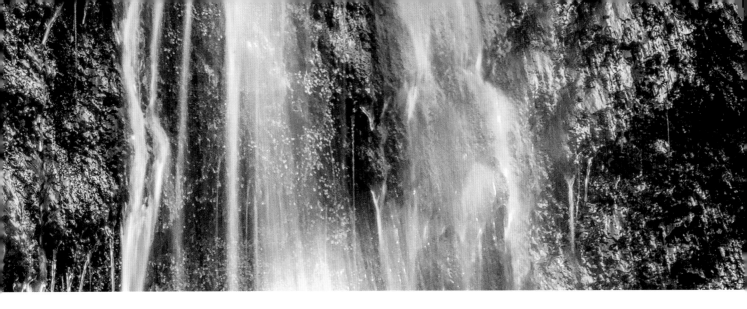

THE HOBBIT™

MOTION PICTURE TRILOGY

LOCATION GUIDE

Ian Brodie

HARPER
DESIGN

An Imprint of HarperCollins Publishers

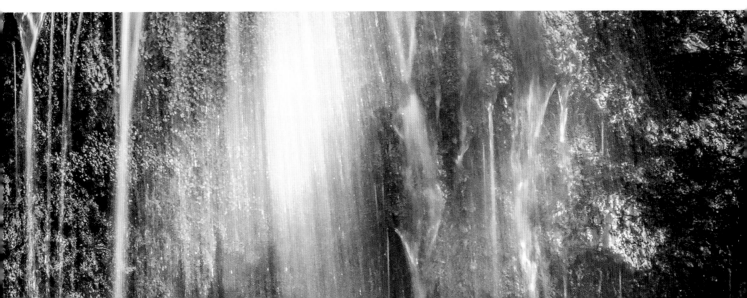

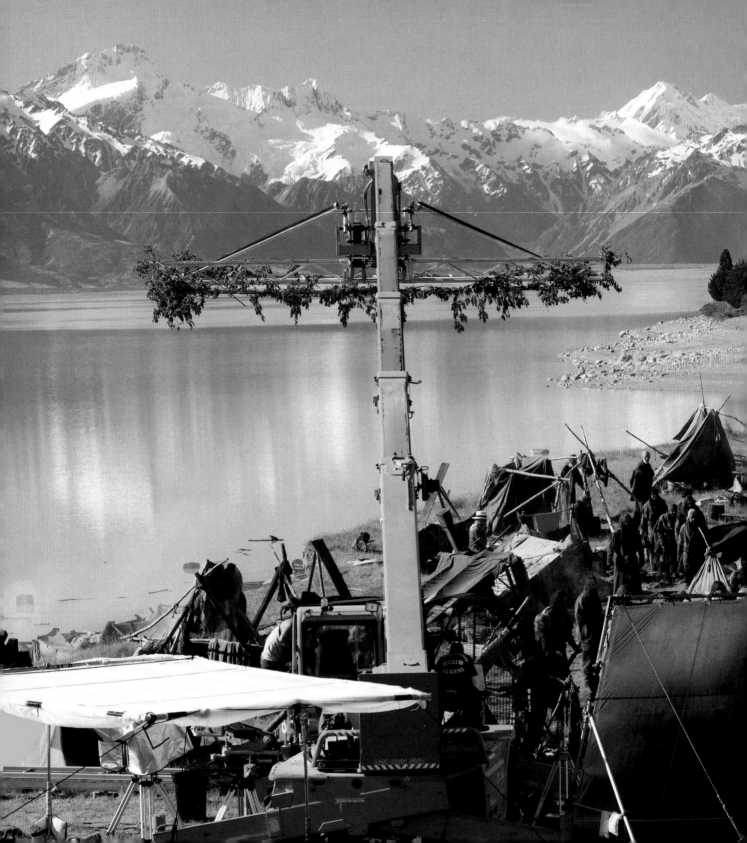

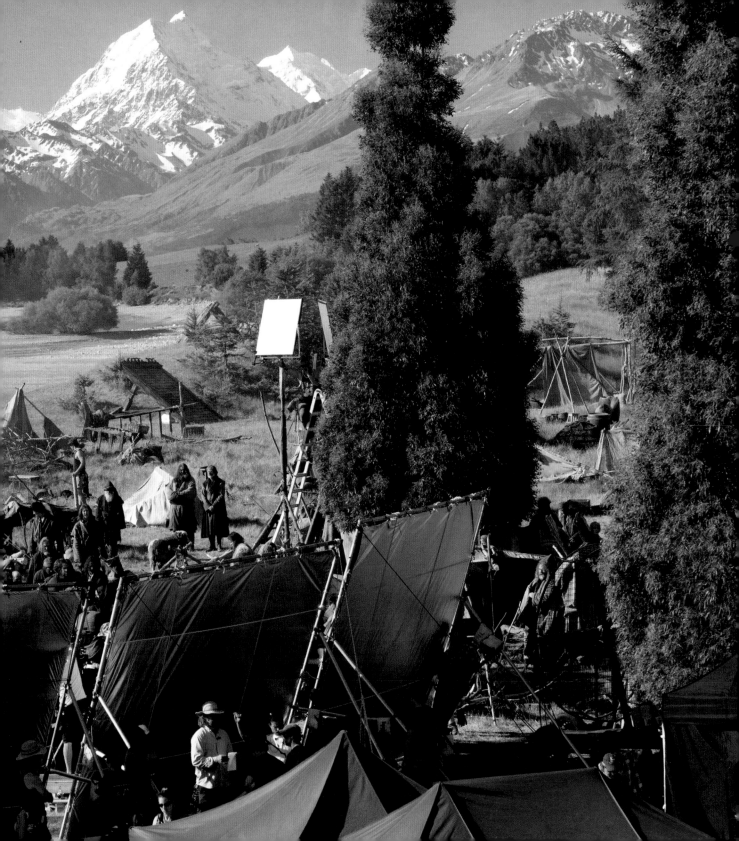

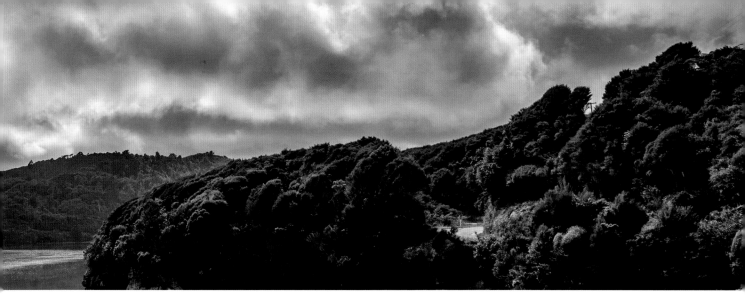

Published in 2014 by:
Harper Design
An Imprint of HarperCollins*Publishers*
195 Broadway
New York, NY 10007
Tel: (212) 207-7000
Fax: (212) 207-7654
harperdesign@harpercollins.com
www.harpercollins.com

Distributed throughout the world by
HarperCollins*Publishers*
195 Broadway
New York, NY 10007

ISBN 978-0-06-220091-4
Library of Congress Control Number: 2014946677

Front cover images: Warner Bros. Pictures (top) and Ian Brodie (bottom); back cover images: Warner Bros. Pictures
Cover design © HarperCollins Publishers Ltd 2014
Internal design and layout by IslandBridge
Printed and bound in China by RR Donnelley
First Printing, 2014

8 7 6 5 4 3 2 1 14 15 16 17

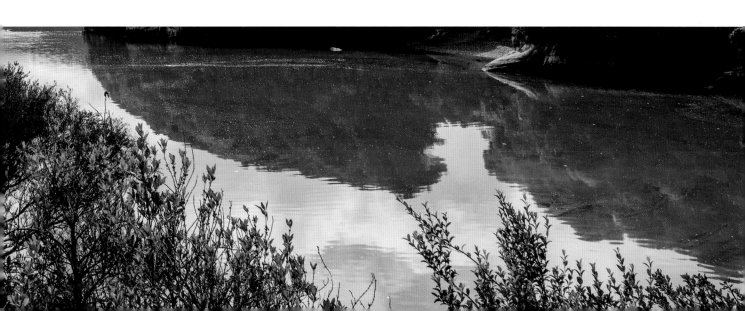

Acknowledgements

This book has only been possible through the help and support of many people and organisations.

Thank you to all of the team at 3 Foot 7 for providing the answers to my many questions, and thank you to those that allowed me to interview them specifically for this book. Thanks to Judy Alley for organising and helping me with these and to Jared Connon for his location assistance. Special thanks to Sir Peter Jackson for the foreword and to Andy Serkis for the text.

Susannah Scott, Jill Benscoter and Victoria Selover at Warner Bros. have worked tirelessly to provide me with the imagery and final approvals.

Once again, I embarked on my own journey through New Zealand and to all those people who helped me on the road — thank you. In particular, those at the various Regional Tourism Organisations, hotels and attractions that assisted and advised deserve a special acknowledgement.

Pat West, Alfie Speight, Gerry Conlan and Peter Bell from Glacier Southern Lakes Helicopters provided so much and just believed.

Once again, thanks to Toby and Rachael Reid at Reid Helicopters Nelson and Mark Hayes at Heliworks.

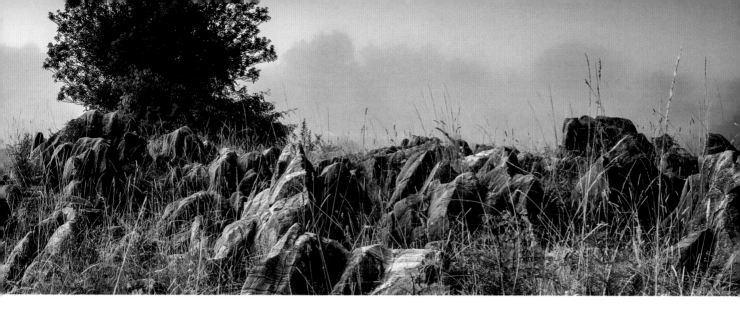

Thanks to Warwick and Suzie Denize, Lisa Bankshaw, Mike Stearne, Nicole Andrews, Rita Davies, Janet Morgan, the Chartres family, Brent and Anna Gillespie, Tina Hocevar, Russell Poppe, Hamish Saxton and Lynette Deans.

I would like to personally acknowledge the help and support of David Brawn from HarperCollins*Publishers*. A true gentleman and friend.

Thanks to the team, past and present. Tony Fisk, Graham Mitchell, Eva Chan, Arian Vitali, Natasha Hughes, Finlay Macdonald and Shona Martyn.

This book would not read or look as it does without all the help and work of Lorain Day and Graeme Leather.

This book is dedicated to my family: Dianne, Travis, Belinda and Oliver, Sally-Anne and Matthew.

In memory of Mike Turner.

Ian Brodie, Matamata, 2014

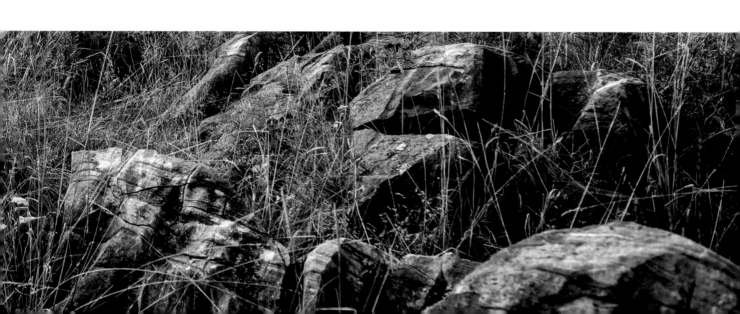

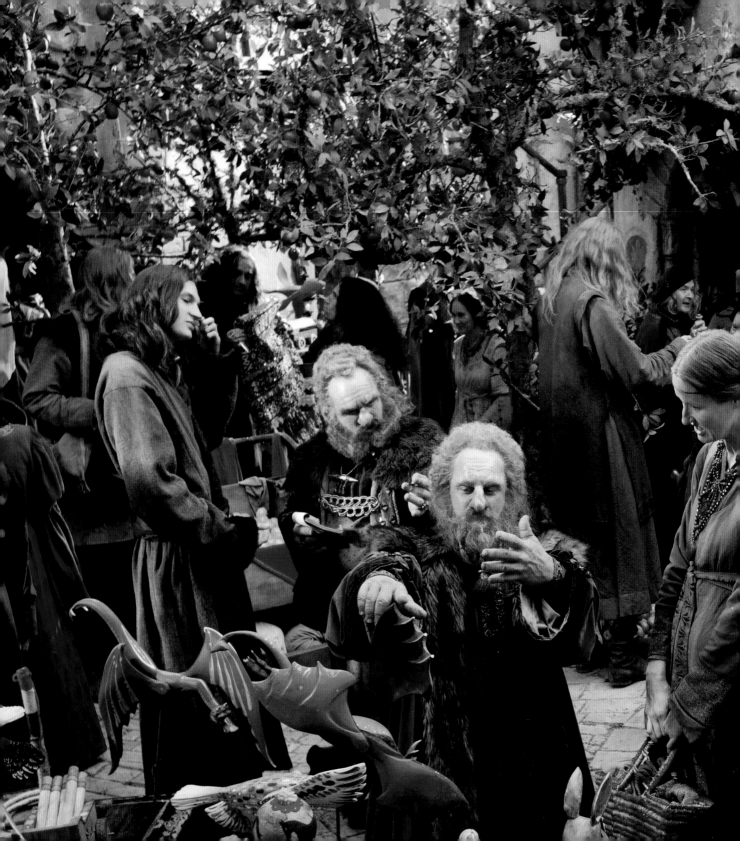

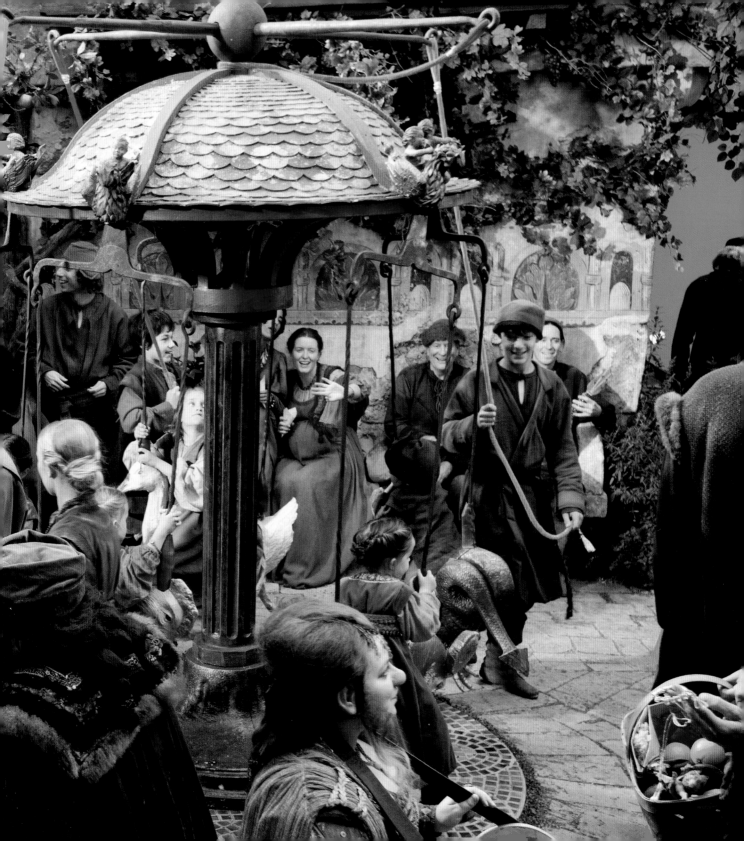

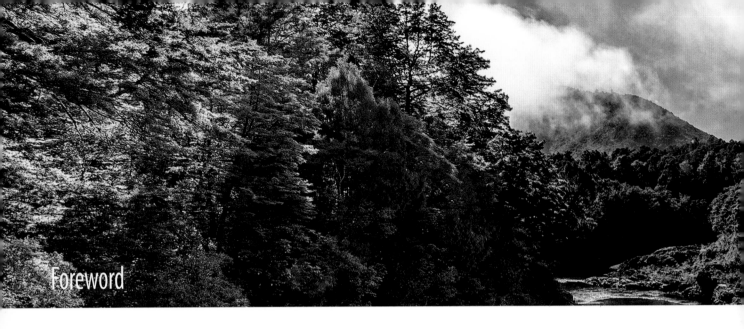

Foreword

The beauty of the New Zealand landscape has always sparked my imagination. When I was 10 years old, Mum and Dad took me down to the Nelson/Golden Bay area for the summer holiday. We had a picnic lunch at the Pelorus Bridge, and the beautiful river with its crystal-clear green water, flowing through the rocky gorge, made an indelible impression. I had fallen in love with the wonderful fantasy films of Ray Harryhausen, and thought it would be the perfect home to the Cyclops or Hydra.

Eventually, that 10-year-old grew up, and got to make *The Lord of the Rings*. In the years since, the New Zealand landscape has come to represent *Middle-earth* in the imagination of millions of viewers all over the world. I understand why that has happened — when you make a movie, some locations become indelibly linked in the mind's eye with the visual world you are trying to create. For me, *Bag End*, *The Green Dragon*, *Bilbo's Party Tree* and the *Mill* at *Bywater* were inextricably nestled within the lee of a hill on a farm in Matamata.

Making the *Hobbit* films was as much about reconnecting with some of

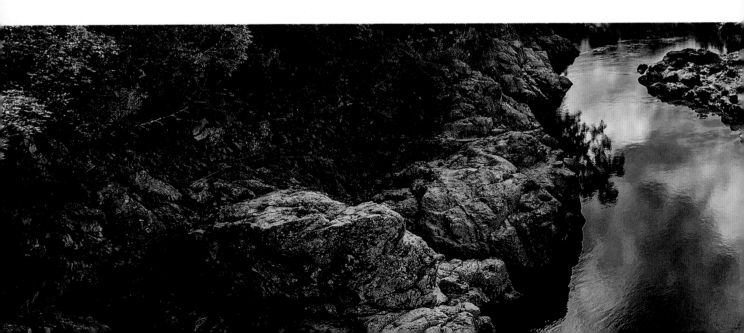

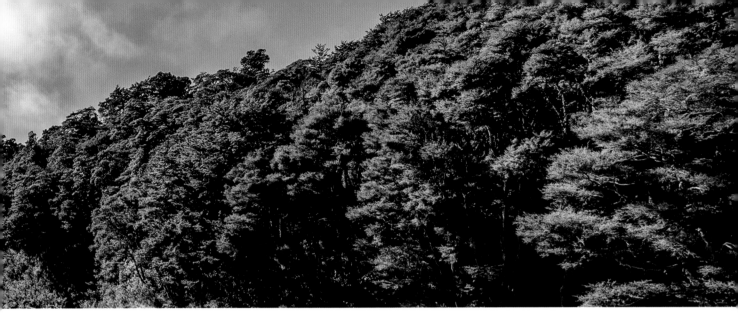

these beloved locations as it was about discovering new ones. The three new films required many different landscapes to unfold in previously unseen parts of *Middle-earth*. So 10 years on from the first trilogy, I found myself seated once again in a chopper with our wonderful locations wizards, Jared Connon and Dave Comer, setting out to search for such mythic settings as *Trollshaws* and *Long Lakes* and *Carrocks*. New Zealand's infinite capacity for surprise didn't let us down.

When we discussed the sequence that sees the dwarves escaping from the *Woodland Realm* by floating down the river in barrels, I was able to say I knew the perfect location — the Pelorus River had remained vividly etched in my mind.

So thank you, Joan and Bill Jackson. Who would have known that picnic from 40 summers ago would have such a lasting impact.

Sir Peter Jackson

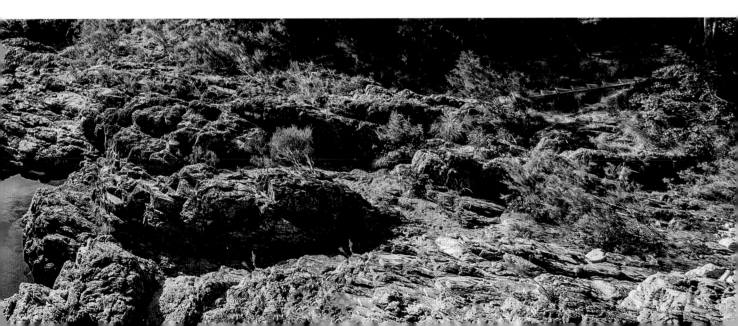

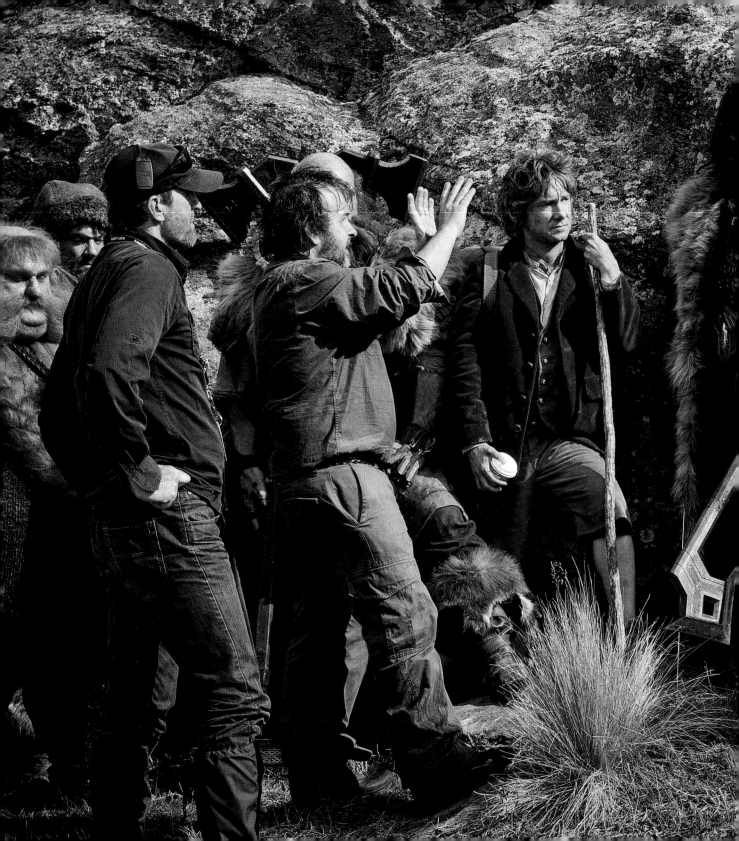

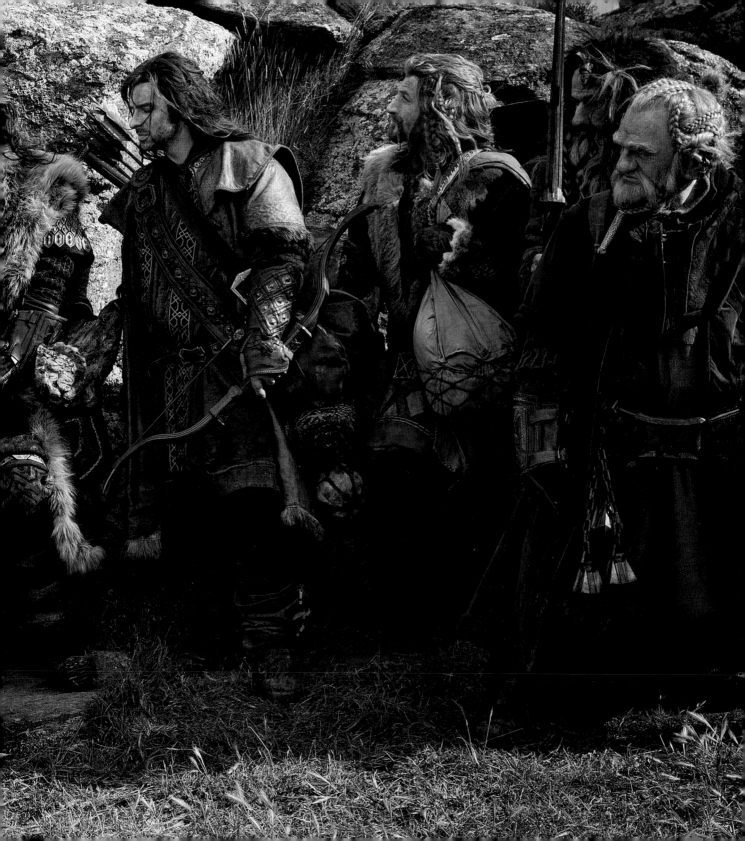

Contents

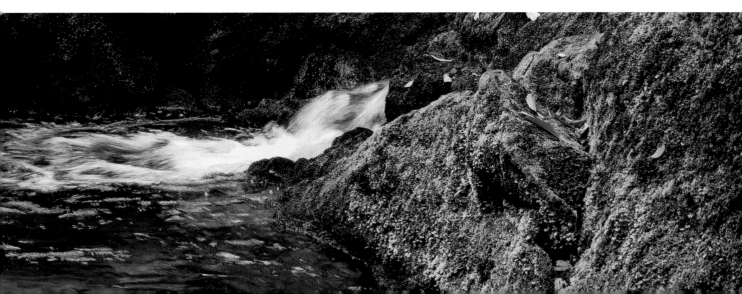

Finding Middle-earth

Jared Connon

Returning to *Middle-earth* with Peter and the team was always going to be a truly unique experience for those of us who were lucky enough to have been part of the original *Lord of the Rings* trilogy. Here we were again, surrounded by so many familiar faces and places, embarking upon another film-making adventure set against a backdrop of New Zealand's stunning landscapes.

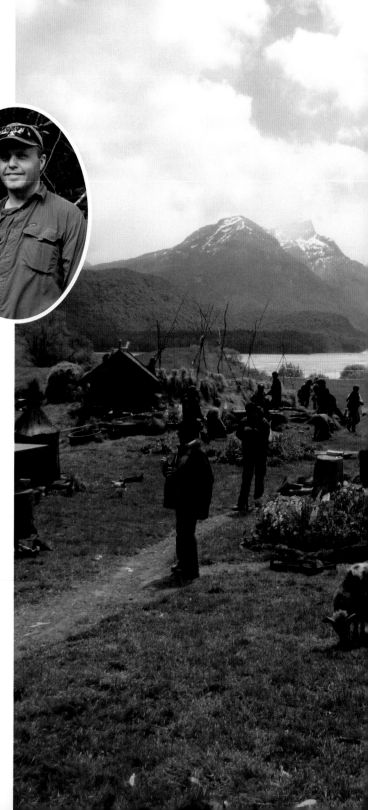

Both Dave Comer and I travelled the length and breadth of the country over a period of 18 months researching and scouting every environment we felt could bring some value to the production. We began with a very open brief — to source all possible locations that could be from *Middle-earth* — but, more importantly, it had to be an absolutely incredible environment. While we had specific script and storyline requirements to fulfil, Peter was always very keen to explore anything unique that could perhaps bring a new level of visual experience to the screen. He was

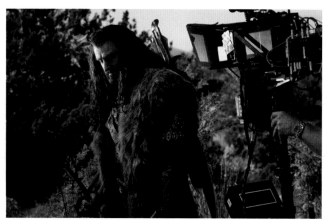

Previous After travelling through caves from the top of the Takaka Hill, the Riwaka River emerges into a green dell at The Resurgence. Ian Brodie

Top Jared Connon Warner Bros. Pictures

Above Thorin is filmed with a Steadicam at Denize Bluffs. Warner Bros. Pictures

Right The perfect location for the house of Beorn, Paradise by name and by nature. Warner Bros. Pictures

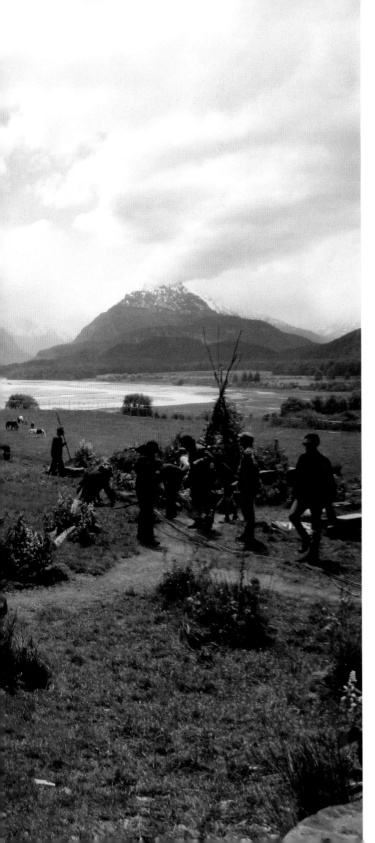

Once again, the snowclad peaks of the Southern Alps would become the Misty Mountains. Ian Brodie

always very clear that the locations should be easily recognisable for the audience, yet he didn't want it to feel like we were just going back to the exact same places again. We needed to find bigger and better locations than what we had for *Lord of the Rings*, which was a daunting task when you consider that those films were shot in almost every amazing landscape New Zealand has to offer.

We literally scouted hundreds of different locations across New Zealand, but Peter was insistent that we kept digging further and further, until we discovered some absolute gems. Eventually, those became the locations that ended up on screen, ready to be shared with the millions of people across the world who were eagerly awaiting a return to *Middle-earth*.

However, one of the most exciting aspects of the project for me personally was the scale of logistics we had to undertake to bring the script to life. Shifting a crew of around 400 people between filming sites and managing the daily operations required to support that number of people in some very remote parts of the country was an absolute thrill for both me and my team. The fact we were running two major film crews at once just made it that much more of a true challenge. While the main unit juggernaut was shooting the principal scenes for the film, we had the incredibly agile second unit team also out on the road shooting stunts, chase sequences, vistas and hundreds of aerial plates, which would showcase some of the most stunning and scenic landscapes imaginable.

It has been an absolute privilege to have once again been able to show the world how diverse this amazing country of ours is through our work, and it still never ceases to amaze me how untouched and truly beautiful it is here. Being able to share that experience with others is what makes location scouting such a great part of every film we make.

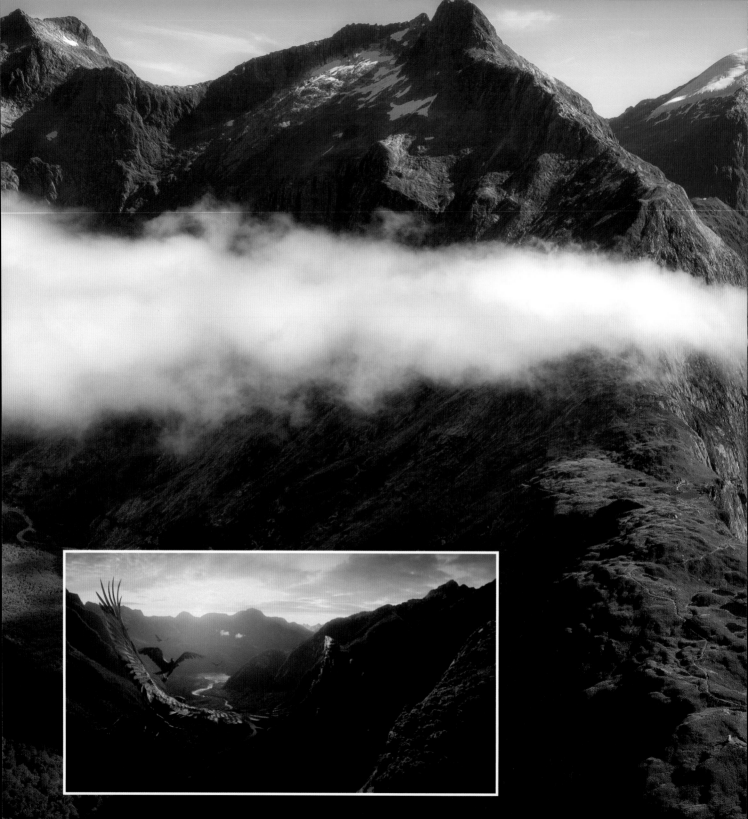

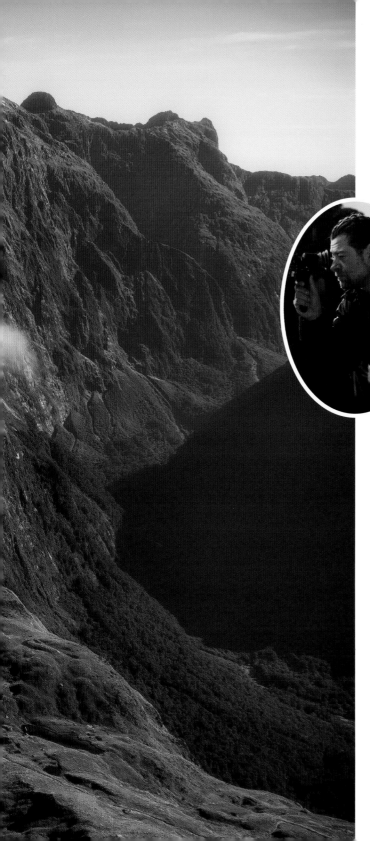

Filming Middle-earth

Andy Serkis, as told to Ian Brodie

Being asked to direct the second unit on *The Hobbit* came as a complete surprise and was a great honour. Through my experiences on *The Lord of the Rings* and *King Kong* I have a lot of history with Peter Jackson and his team, especially our collaboration with motion capture characters and technology. I think Peter's thinking was that with so many cast migrating from main to second unit, they wanted to recruit someone who had experience with performance, and had a natural affinity with the actors. Traditionally the second unit on a film isn't a particularly creative environment — it's much more functionary — and for an actor the shift of focus from story can become very disorientating. Hopefully I could help mitigate the traditional pitfalls and bring a new perspective to the job.

The second unit director had a wide remit, which changed throughout our 200 days of shooting. The previs (previsualisation) Peter had worked through was a starting point, although he told me not to be hemmed in and use it mainly as a sounding board. Our unit was entrusted with aerial photography on location; traditional pick-up shots (when scenes hadn't been completed by the main unit); originating shots for battle sequences; and chases by wargs, etc. I was honoured to work with a vast number of the cast, in particular the dwarves but also *Bilbo*, *Radagast* and *Gandalf*. Second Unit were heavily involved in the prologue battle sequences, entanglements with spiders, travelling through *Mirkwood* and escapes on eagles to the *Carrock* summit.

As we were filming the dwarves travelling across hills and mountains, from the ground and the air, we went on our own tour of New Zealand, starting at *Hobbiton* and winding southwards from Queenstown and the surrounding mountains. I'm pretty sure I was involved in all the aerials — and for the 10 weeks we were on the road, my office was a helicopter.

Above **Andy Serkis.** Warner Bros. Pictures

Left Live helicopter SpaceCam vision of Fiordland National Park is combined seamlessly with the soaring eagles created by Weta Digital. Warner Bros. Pictures

The other memorable scenes Second Unit had a hand in were the 'Blunt the Knives' song when the dwarves first arrive at *Hobbiton* and the sequences of *Radagast*, his sleigh and house at *Rhosgobel*. On *The Desolation of Smaug*, we spent some time with *Gandalf* and *Saruman*, greeted *Legolas*, and rounded dwarves up and delivered them to *Thranduil*. We also had a lot of fun with the troll fight sequence, and *Smaug*'s attack on *Dale*.

One of the challenges was helicoptering individual dwarfs and their entourage (make-up, props and costume wranglers) to vertiginous locations. This work also had some technology limitations and at times we had to land the choppers on very precarious peaks, so that data cards could be reloaded.

A big change since *The Lord of the Rings* was using 48 fps 4K Digital data, which means you can keep the cameras running between takes — Peter always wanted the maximum choice from the actors and as the writing continued into the edit, shooting digitally lent itself brilliantly to this way of working. Communication was also better — files could be transferred more quickly. On location we communicated via Skype, so Peter could view what we were shooting much more readily (on *Lord of the Rings*, assistant directors had to drive for three hours each way with a shot on a small handheld monitor for Peter to approve).

Shooting on location was one of the highlights. As great as it is to shoot on a controlled set, too much green screen can drive you bonkers, and we returned to Stone Street with a heavy heart after experiencing the wilds of southern New Zealand. New Zealand itself is one of the greatest characters in the *Middle-earth* canon. It can't be underestimated in terms of its grandeur, its spirituality and how perfectly it reflects the world that JRR Tolkien created.

One location remains indelibly etched into my memory: Earnslaw Burn. Just south of Queenstown, it is a magnificent, flat-bottomed valley surrounded by cliffs with hundreds of waterfalls, topped by a vast glacier. We shot the dwarves climbing up towards the *Misty Mountains*, both from the ground and the air, and helicoptered a huge crane and 150 crew up to beneath the glacier — an extraordinary adventure. On several occasions the wind became too strong for the choppers, and on the higher locations, clouds and bad weather could close in at an alarming rate, giving cause for some last-minute evacuations.

One of the great benefits in working with a Kiwi crew is their flexibility,

Orcs and dwarves battle it out under the highway bridge at Pelorus River. Warner Bros. Pictures

22

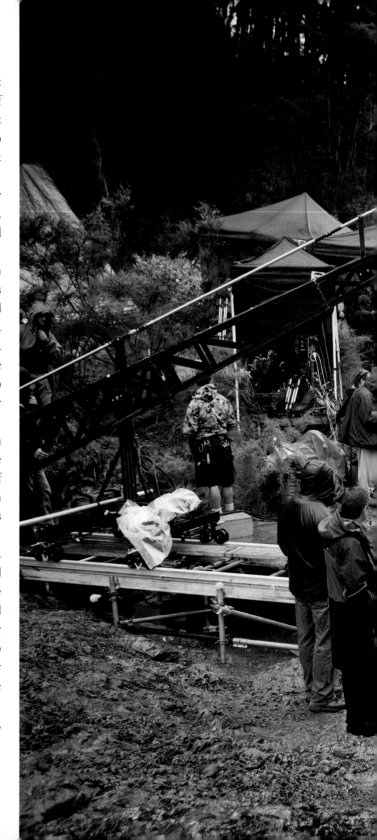

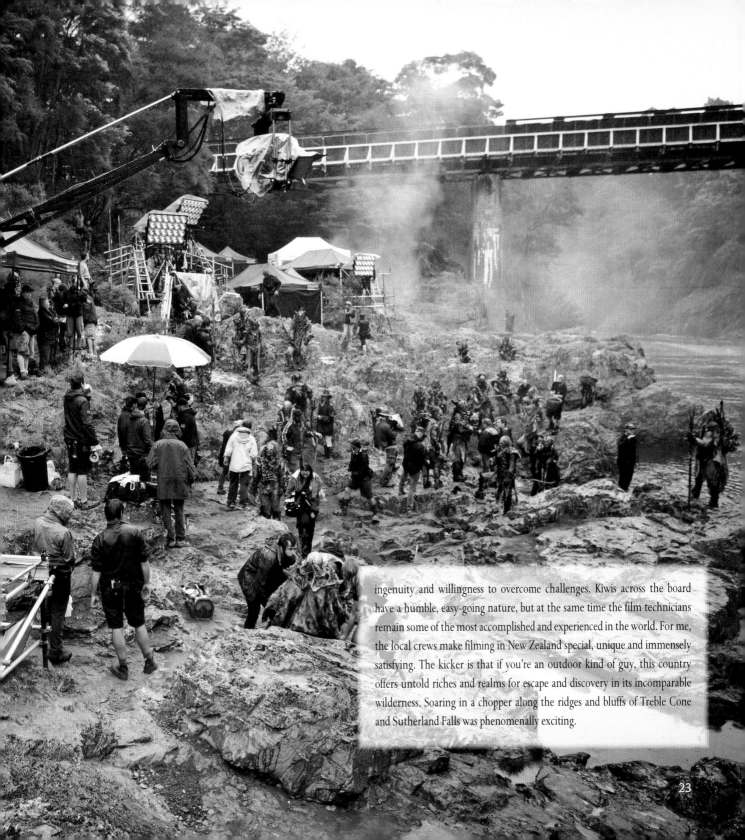

ingenuity and willingness to overcome challenges. Kiwis across the board have a humble, easy-going nature, but at the same time the film technicians remain some of the most accomplished and experienced in the world. For me, the local crews make filming in New Zealand special, unique and immensely satisfying. The kicker is that if you're an outdoor kind of guy, this country offers untold riches and realms for escape and discovery in its incomparable wilderness. Soaring in a chopper along the ridges and bluffs of Treble Cone and Sutherland Falls was phenomenally exciting.

23

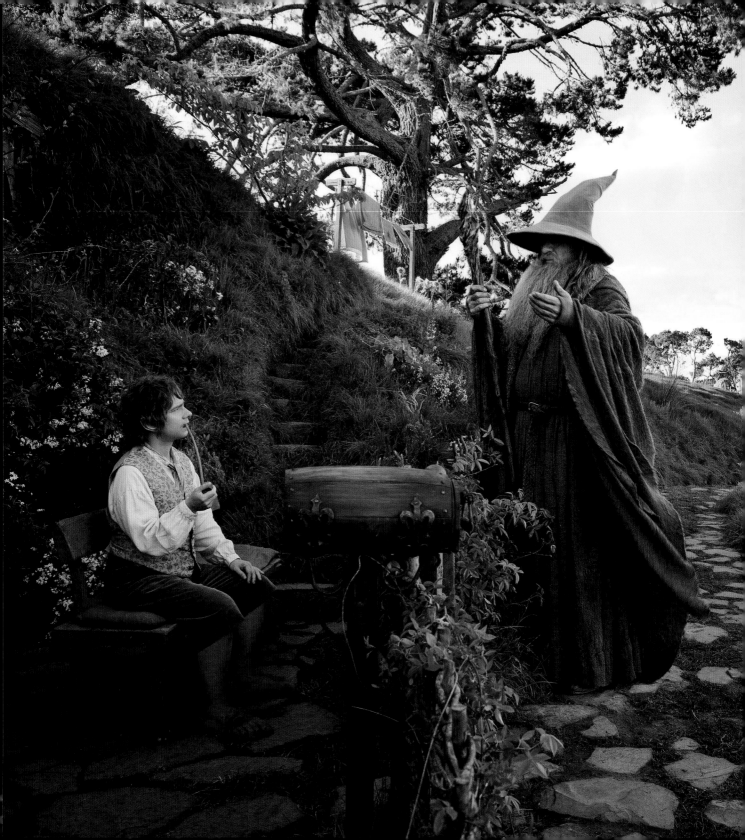

Production designer

Dan Hennah

Having worked on *The Lord of the Rings*, I had already established a working relationship with Tolkien, a familiarity with his language, his style and his storytelling. Written for a younger audience, much of *The Hobbit* is whimsical and childlike. The journey commences in the familiar sun-kissed fields of *Hobbiton* and the ethereal *Elven Empire* of *Rivendell*; for both places we had already established a signature and architecture. Essentially a road movie, the film breaks into new territory once *Thorin* and his *Company* depart *Rivendell* and travel through *Middle-earth* towards their homeland, the grand, mineral-laden, underground kingdom of *Erebor*.

With the passing of a decade between Tolkien projects, one of the more significant changes for the art department was that the majority of the film was shot inside the studios at Stone Street, Wellington. Bottom line for us was this meant more sets and fewer locations.

To erect the 120-plus sets we pulled together a team of nearly 350 people rotating across 24 hours a day, seven days a week. In addition to this, we built a total of 94 models in either 1:16 or 1:25 scale. The models, developed from concept drawings and built as full environments, were a great tool of communication with Peter. Each show-and-tell provided a tactile experience with Peter where we could work closely with him refining detail and establishing exactly which part or parts should be realised as full-scale sets. Time with Peter is limited for everyone, so it was important to establish the most efficient shorthand process possible. For some environments it was necessary to build multiple models; in the case of *Beorn's house* a total of 12 versions were completed.

A relatively small team collaborated during early pre-production on selecting the exterior locations. To conceptualise a location we would glean everything we could from the text, the concept artists, local knowledge from location manager Jared Connon and Peter's expectations and work those

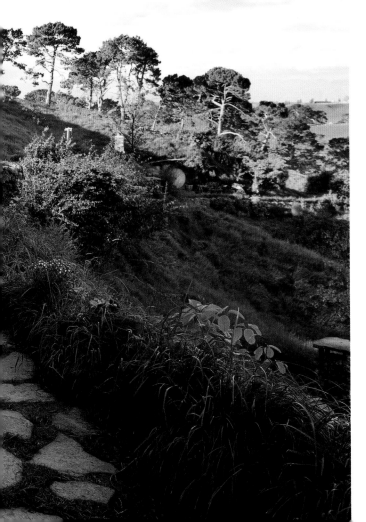

Gandalf is offered a 'Good morning' outside Bag End, situated at Hobbiton Movie Set near Matamata. Warner Bros. Pictures

Inset The natural beech trees were positioned perfectly at Paradise to allow the building of Beorn's house to be completed as if it had stood there for hundreds of years. Ian Brodie

things together until we came up with something that felt right. Google Earth was a remarkable tool for identifying potential sites but every possible option was physically visited by the pre-production team. There were days when we were flying in formation like something from *Apocalypse Now*, concept art folders and iPads tucked under our arms, combing the landscape looking for undiscovered *Middle-earth*. Working with Peter requires an open mind and often we would completely by chance stumble on a location he loved.

Typically each exterior location required some kind of corresponding interior set. The exterior for *Trollshaw Forest* was filmed at Denize Bluffs in the North Island, an area with a distinctive topography and vegetation. The rocks are a unique shape and texture and a huge limestone cliff runs for a couple of kilometres, packed with a unique set of cracks and crevices. We built the ruins of a house on location but then married this with the *Trollshaw* lair and a cave interior in the studio. The piece of ground between the two of them is the location. In order to replicate this landscape we not only photographed each and every detail, but we cast trees and rocks taking 200 square metre silicon moulds back to the studio. Everything we put together from nature was moulded from living or real elements, creating a far more authentic look.

For *Beorn's house* we needed two perspectives: the front entrance and the back of the house. We found the perfect spot at Paradise, Glenorchy in the South Island for the front gate but the back of the house didn't take advantage of the amazing views on offer. The solution was remarkably easy: we split the house in half and built two sets 200 metres apart. One of the sets was constructed in an L shape around a 200-year-old beech tree, four foot in diameter, that Peter was particularly fond of. Unfortunately, a week out from shooting, a massive storm ripped through the area toppling the massive tree. Fortunately for us the tree fell away from the house leaving it unscathed but it left us with an unexpected problem: Peter still wanted the beech tree and it was lying dead and broken on the ground in no fit state to be a film prop. With less than a week before the shoot, using artificial and authentic materials we constructed a new version of the old relic and trucked it to the South Island just in time for filming.

Right The entrance to the caves of the Goblin King created in Wellington without one real rock. Warner Bros. Pictures; Inset Dan Hennah. Warner Bros. Pictures

Overleaf Under the eaves of The Green Dragon, Dan Hennah (centre with white hat) supervises the setting up of a myriad hobbit stalls for Midsummer's Eve. Warner Bros. Pictures

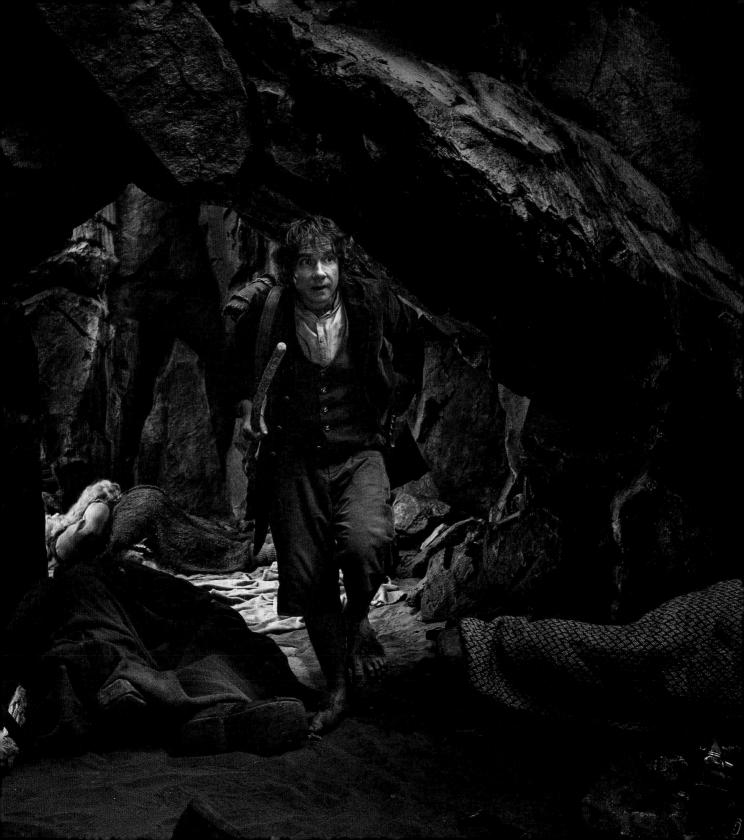

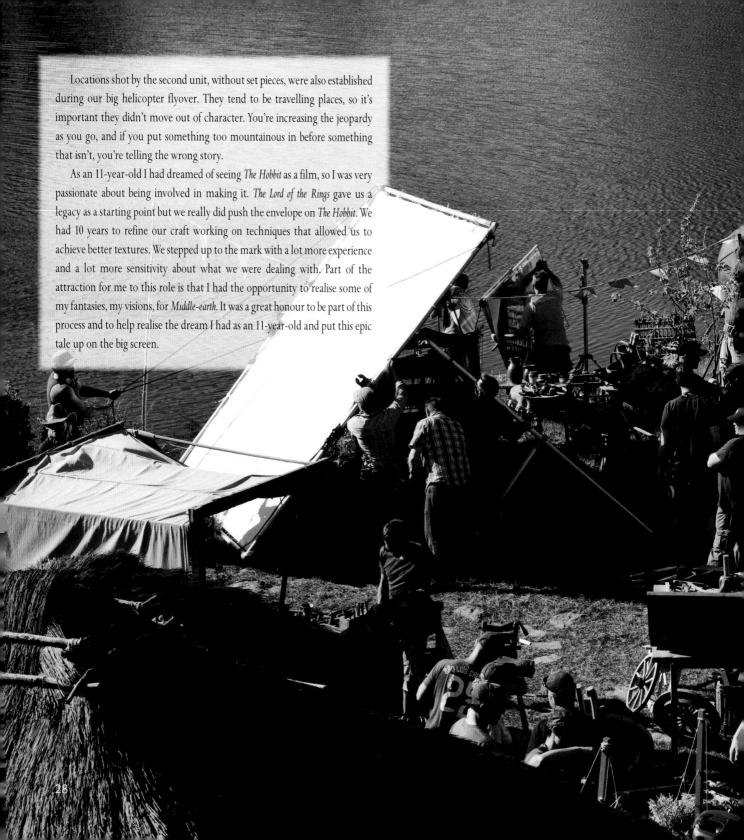

Locations shot by the second unit, without set pieces, were also established during our big helicopter flyover. They tend to be travelling places, so it's important they didn't move out of character. You're increasing the jeopardy as you go, and if you put something too mountainous in before something that isn't, you're telling the wrong story.

As an 11-year-old I had dreamed of seeing *The Hobbit* as a film, so I was very passionate about being involved in making it. *The Lord of the Rings* gave us a legacy as a starting point but we really did push the envelope on *The Hobbit*. We had 10 years to refine our craft working on techniques that allowed us to achieve better textures. We stepped up to the mark with a lot more experience and a lot more sensitivity about what we were dealing with. Part of the attraction for me to this role is that I had the opportunity to realise some of my fantasies, my visions, for *Middle-earth*. It was a great honour to be part of this process and to help realise the dream I had as an 11-year-old and put this epic tale up on the big screen.

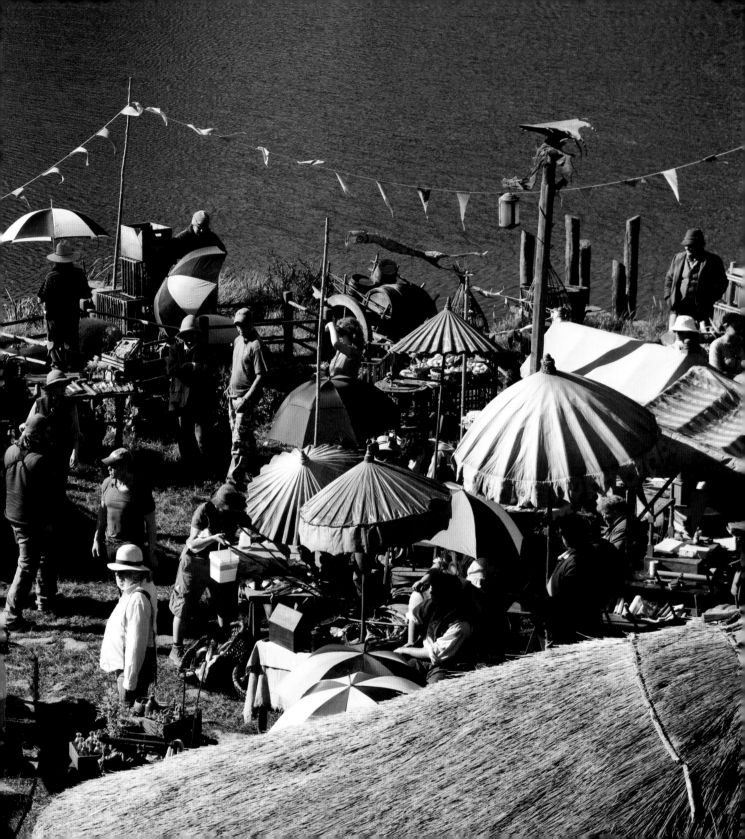

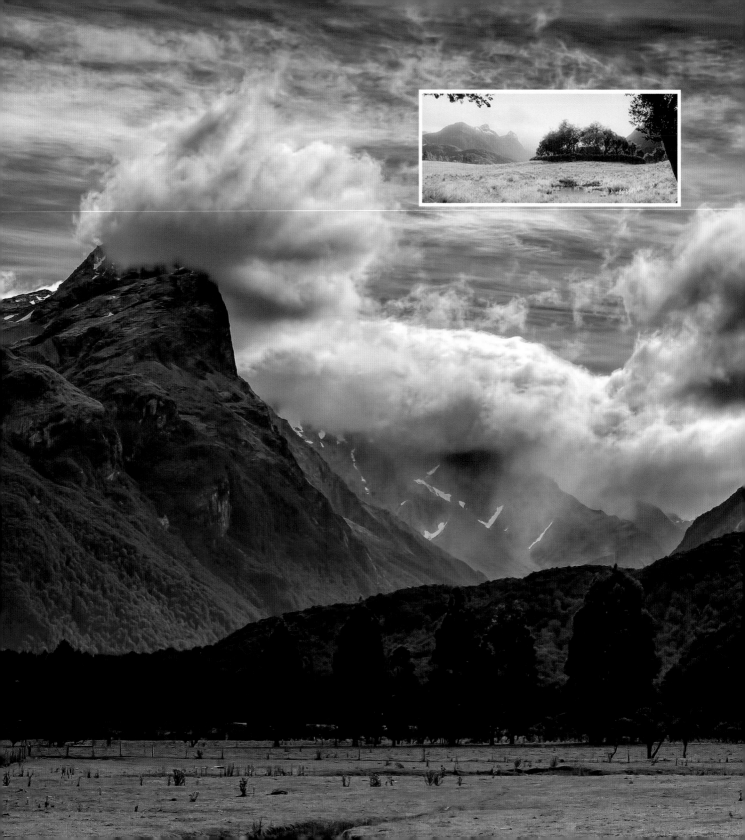

Where in the world *is* Middle-earth?

John Howe

Naturally, for any truly good question, there are several answers. The original *Middle-earth* took shape in the fertile brain and imagination of an Oxford college professor with grandchildren for whom he imagined an entertaining bedtime story. (Of course, Tolkien did not invent the name entirely; like much of his work, its roots are to be found in Norse myth.)

So *Middle-earth* began as a manuscript — notes, scribbled ideas and abrupt turnings — the slow process of building a story and creating an ever-widening world to set it in. For a generation, *Middle-earth* was to be found in a book, *The Hobbit*, with illustrations by the author, published in 1937.

A wider and more complex *Middle-earth*, but still purely a literary creation, followed with the final volume of *The Lord of the Rings* in 1955.

Finally, with Peter Jackson's *Lord of the Rings* trilogy nearly half a century later, *Middle-earth* found a real landscape, a real land, and one at the time little known to the wider world: New Zealand. The role of the movies in the history of New Zealand's modern mythology will one day be appreciated at its full worth. At no other time have two countries — a real place and a fantasy realm superimposed — emerged simultaneously before the eyes of a global audience.

Thus, today the answer to that question is definitively New Zealand. The *Lord of the Rings* trilogy splendidly showcased the country from north to south and firmly anchored *Middle-earth* on these antipodean shores. Now we are back, in the company of a much younger *Bilbo*, but surely we are not going to visit the same places all over again? Rest assured, *The Hobbit* will take you where you've never set foot before. Welcome to *Wilderland*.

Accompanying *Bilbo* on his reluctant journey is to discover above all that if you thought *Middle-earth* had been thoroughly explored with *Frodo* and his companions, you are in for an adventure.

Above John Howe. Warner Bros. Pictures

Left The distinctive peaks of the Southern Alps at Paradise provide the perfect backdrop for Beorn's house nestled amongst the trees. Ian Brodie

Inset The mountains unchanged with the foreground digital addition. Warner Bros. Pictures

This book will take you to all those places — some you know already, some you'd never imagine; places we had the privilege to visit on location scouts, and revisit during the shoot: Denize Bluffs, Strath Taieri, Paradise, the shores of Lake Pukaki … (We also visited a number that did not become part of the story — perfect location for the *Barrow-downs*, for example, tucked away on a farm in the Waikato, or an enchanted river valley on the edge of the *Shire*, hidden on a station nearby.)

Above all, Alan Lee and I made a third trip, a voyage of inspiration and imagination, drawing on New Zealand's landscape to compose many of the wider environments of *The Hobbit* — Fox River, the Rock and Pillar Range, Earnslaw Burn, the Remarkables and many more furnished the memories and the geography upon which we built *Thranduil's Realm*, the *High Fells*, the *Long Valley* and the *Lonely Mountain*, to name only a few.

I remain convinced that places people visit as part of a literary pilgrimage retain something of their respectful passage, that these places are invested in the same manner that they become part of us. I am certain this communion with wild places, this journey to *Wilderland*, gives us strength to preserve and the resolve to protect like places, because we are standing guard over both our natural present and our mythological past. The reverence for nature that was so strongly felt by JRR Tolkien is part of that mythology; it is never outdated or old-fashioned, it is here and now. It signposts our journey and should serve to remind us how precious those places have become. New Zealand, through a fabulous and serendipitous sequence of coincidences and a few narrow escapes, is now part of *Middle-earth*. Not only is *Middle-earth* in the heart of every admirer of Tolkien's tales, now you can truly go there, to a place where the landscape allows you to superimpose your imagination, to overlay a personal vision with a real one, and to take the two, forever interwoven, away with you. The wild and beautiful places everywhere in the world can only benefit. It is also an invitation to discover the mythologies that were born here, when Maui hooked that fish and pulled it towards the surface …

Not so bad for a pair of wayward islands drifting in mid-ocean … Welcome to *Wilderland*. Welcome on an adventure.

Right The landscape of Denize Bluffs with its Middle-earth rocks provided the art department with the perfect palette for the creation of a 'mock' Trollshaw in the (appropriately named) Stone Street studios in Wellington (inset). Ian Brodie/Warner Bros. Pictures (inset)

Overleaf The Mararoa Saddle provided a backdrop for the escape of the dwarves from Erebor, whilst a brief scene in *The Hobbit: The Desolation of Smaug* featured the grass-covered terminal moraine in the Greenstone Valley (inset). Ian Brodie/Warner Bros. Pictures (inset)

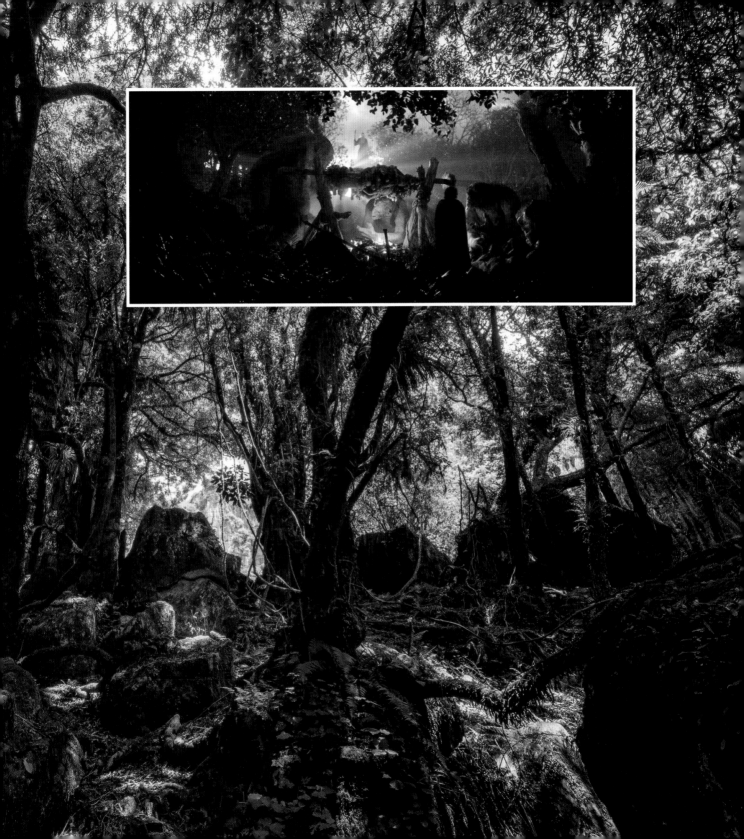

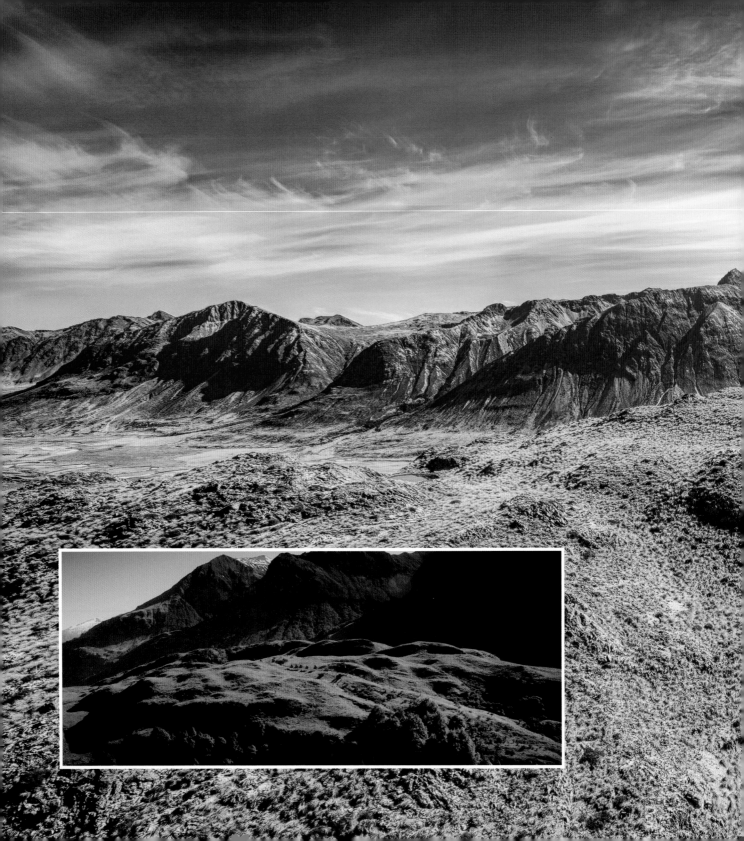

Set design

Helping prepare the locations were Brian Massey, art director; Ra Vincent, set decorator; and Simon Bright, supervising art director. Brian was concerned with location shoots and off-site builds, while Ra was responsible for handing over the polished set. Simon followed concepts from the design department through construction and fabrication, on schedule and on budget.

For Ra, 90 per cent of his job was aesthetic. 'The way Peter and Fran [Walsh] adapted *The Hobbit* provided a huge amount of visual prompts.' His preparations begin once he has visited the set. 'Once the scenic artists pull out their tools and scaffolding, we have an intensive couple of days, making it a believable place. I'll help conceive all the objects, then get our prop makers to construct and position them. It's wonderfully satisfying, being the last one to walk off the prepared set.'

Once the art department is involved, Simon visits the set to monitor progress. At *Beorn's house*, in Paradise in the South Island, 'We modelled the environment, then went down with Peter, staked the front and back doors and took photographs. A couple of days later we built the set.' An hour's drive from Queenstown, the build was challenging, with 12 weeks to make *Beorn's house* look as if it had been there for over a hundred years.

While Brian is careful to have the right crops, Ra notes it's a travelling story. 'With *The Hobbit* we're going far from *Hobbiton* and eventually we're in a different part of the world.' By the time they reach *Mirkwood*, viewers can expect the foliage to have changed.

With the world of *Men*, there's a Tudor influence, as

Insets from top Brian Massey, Ra Vincent, Simon Bright. Warner Bros. Pictures

Right This exterior image of Beorn's house shows perfectly the amount of props that are required to complete the scene visualisation. Warner Bros. Pictures

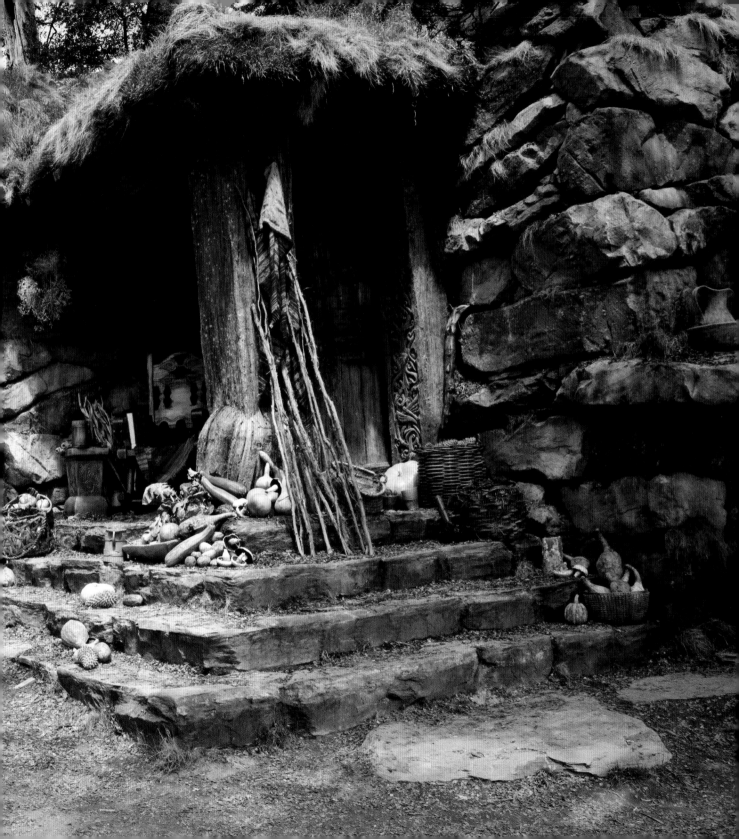

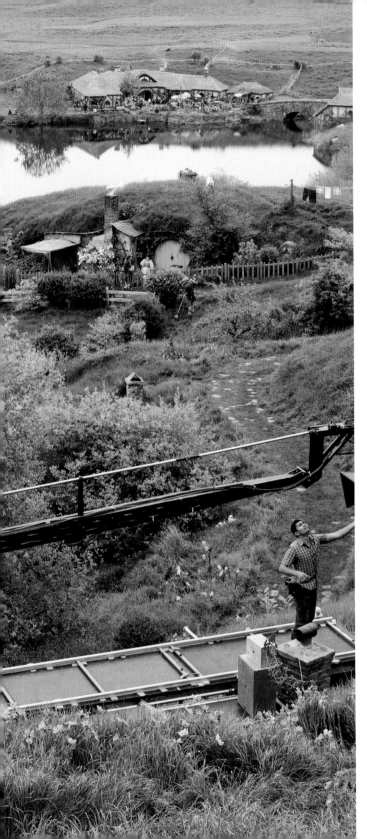

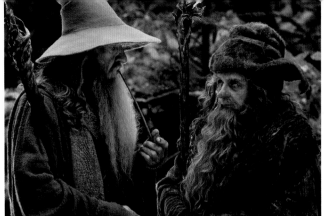

the designers differentiate men, hobbits and dwarves. 'By attaching them to an ethnic origin or time period,' says Ra, 'it helps with the design. We have craftsmen up and down the country — our woven fences came from Otaki, and we use a traditional rake-maker in Oamaru.'

While on location, it wasn't always possible to use their facilities in Wellington, and meant finding local craftspeople. 'Once, we had to drive from Paradise to Glenorchy to have an axehead turned around overnight.'

Theming is one of the ways of achieving an authentic look. 'Someone dressing the fishing village thinks, "What would I need if I was a fishing hobbit? They'd have an eel net, lines, a coracle, a jetty …", and those details go into the final set.'

Planning ahead meant thinking about scenarios they might encounter and throwing things inside support trucks — a chimney, a gate, a hedge, a bit of pig-sty. 'We provided options for altering landscapes — any way we could think of to key our *Company* into their travelling story.'

'You're always going to get a better build by enhancing what's there as opposed to a backlot build, where you impose a landscape location,' says Brian. Sometimes there might be the right foreground but the wrong backdrop. 'It's very hard to transport the background, but easy to transport the foreground.'

Ten days out from shooting in Paradise, the wind blew over a tree that had been in all the previous footage. A 10-metre replica was built — and while having a 200-year-old tree fall down was unforeseen, it meant Ra had plenty of firewood to dress *Beorn's house*.

Left The completed set is then modified to allow a camera jib to be put in place, used and then removed with gardens then carefully rebuilt. Warner Bros. Pictures

Above Radagast the Brown provides Gandalf the Grey with an update at the Trollshaws. Warner Bros. Pictures

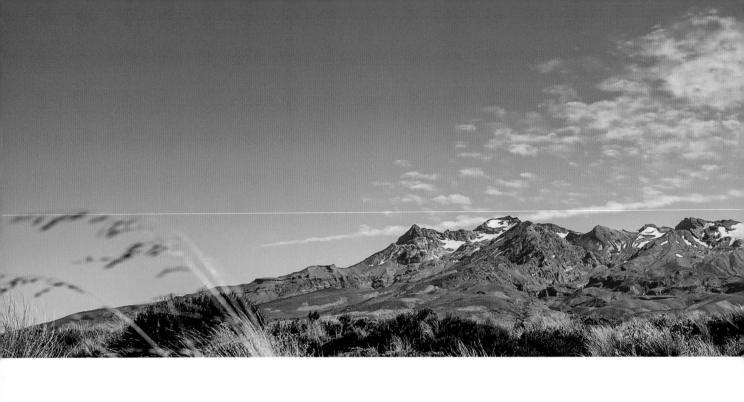

North Island

Introducing Matamata

Auckland: 161 km
Waitomo: 103 km

O-Del-Emz, 33 Arawa St, Matamata

Matamata Central Motel,
42 Waharoa Rd West, Matamata
www.matamatacentralmotel.co.nz

Matamata i-SITE, 45 Broadway, Matamata
www.matamatanz.co.nz

Breathe in the atmosphere of gentle rolling hills covered in soft grass and it soon becomes apparent why *Hobbiton* was created here, thousands of kilometres from Sarehole and Tolkien's rural England. Here, hedgerow-lined lanes provide glimpses of paddocks and grassy downs, which are a vision of the *Shire*, almost as if a part of England has been transplanted. The area's Englishness can be accredited to Josiah Clifton Firth, who emigrated from Yorkshire in 1855 and established a lasting friendship with local Maori. With a strong vision of the area's potential as a leading farming district, he purchased 56,000 acres of swampy marshland. After large-scale drainage he planted vast paddocks of grass, barley, wheat and oats. As his efforts were rewarded, a transformation took place. Hedgerows grew alongside oaks and elms and, as the area prospered, the railway pushed south from Auckland. Today, Matamata is a country service town with another string to its bow, as a centre of international tourism. Thousands of visitors come each year to see the location of *Hobbiton*, the spiritual heart and hearth of both the *Hobbit* and *Lord of the Rings* trilogies.

There are two routes to this town of wide, tree-lined streets: turn off before Pokeno and travel on SH27, or continue on SH1 through Hamilton and turn left towards Piarere.

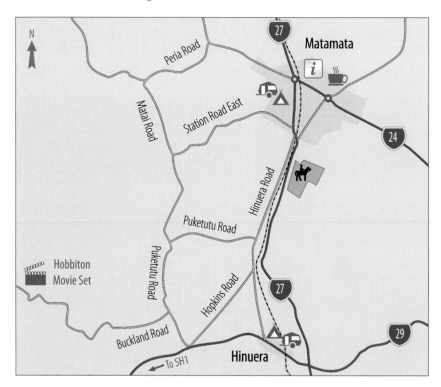

Previous Mt Ruapehu rises from the barren landscape of the Rangipo Desert, in the centre of the North Island. Ian Brodie

Opposite above A spring shower passes along the Kaimai Range, as seen from the drive into Hobbiton Movie Set. Ian Brodie

Opposite below The green rolling hills and typically English treed landscape provide a perfect backdrop for the bucolic setting of the Shire. Ian Brodie

42

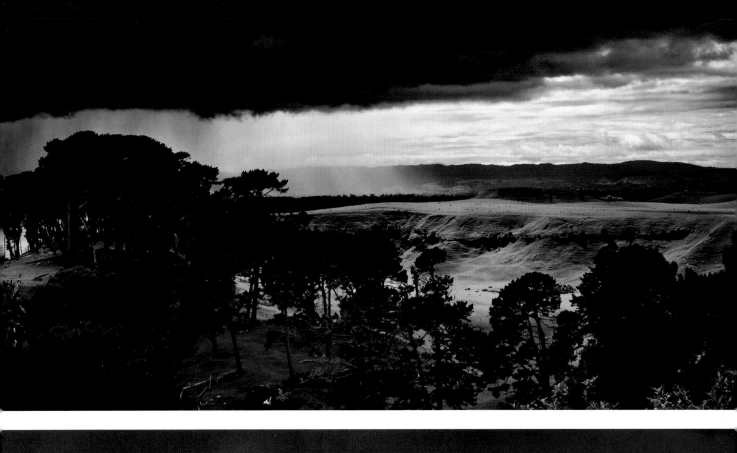

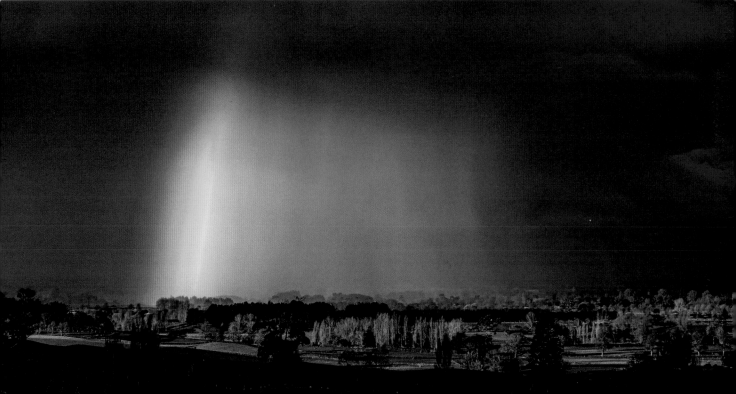

Building of Hobbiton

Brian Massey

In *The Hobbit* and *The Lord of the Rings*, Tolkien himself became our main reference. For a place like *Hobbiton* we're told where hobbit holes need to be, but ultimately when you walk through a finished set you should have the same feeling as reading the book. Tolkien writes of a very beautiful countryside, but not so much cute. It has a rambling, organic beauty — always more difficult to create than straight, structured *beautiful*.

In *The Hobbit*, which takes place 65 years earlier than *The Lord of the Rings*, we were helped by the fact *Hobbiton* is a place of longevity, where hobbits have lived for centuries. It had to feel as if it was a different time from *The Lord of the Rings*, but still be recognisable.

One of the most difficult things was creating an untouched environment that would accommodate a shoot crew for 14 days. Compromises were made, mostly unseen — gravel under grass, for example, in areas the film crew use. It's no good having a fantastic set that is trashed after the first day, and it's no good having a functional set which doesn't look as it should, so there was some sleight of hand. Part of the planning involved half an acre of rolled turf, ready in case areas became muddy and boggy — everything had to be perfect for the cameras.

A lot of plants were cultivated in advance, and then planted around and grown onto buildings,

Below As hobbit holes are constructed in the background, the greens team apply grass turves and stonework to the area where Bilbo will be seen rushing from Hobbiton to start his adventure. Ian Brodie

Opposite above At Hobbiton Movie Set, it's all about the detail. Intricate hobbit hole designs are hand-carved from designs provided by the art department. Ian Brodie

Opposite below Steel foundations provide structural integrity for the brickwork to be placed on the bridge leading to The Green Dragon. Ian Brodie

Overleaf A hive of activity at The Green Dragon as ancient thatching methods are revived thousands of miles from their origin to cover the modern building framework. Ian Brodie

Overleaf inset Concreting in the base plate which will eventually hold the ancient oak that resides above Bag End. Ian Brodie

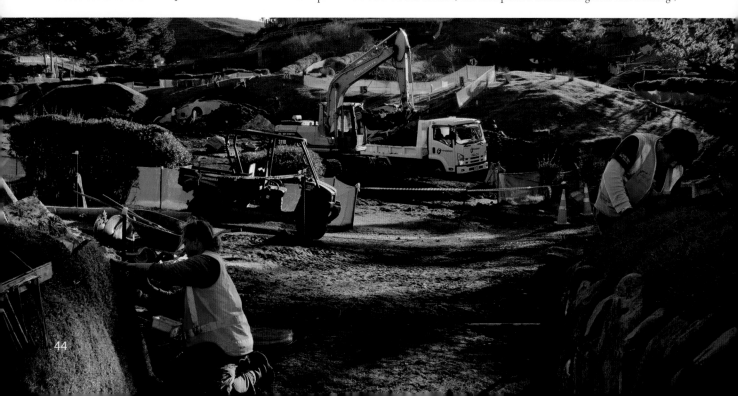

44

fences, posts, etc. This had the effect of anchoring the buildings and fences to the landscape, rather than feeling like they had just been built and placed there. Planting details included thousands of small flowers, both artificial and real, which were spread amongst the grass to give a 'summer meadow' feel to what actually was lush spring grass.

Hobbiton covers a large area, so the art department imagined a whole community. Someone who was too fond of drink would end up in one of the damp holes on the shady side, while another hobbit hole in the sun almost looked prissy. The little dark valleys became the low-rent district, with minimal gardens, while in better-off areas they had really good crops. By carrying that all the way through, the viewer wasn't looking at 44 identical hobbit holes. It wasn't a design thing; it came from the land itself. Even if you might not pick it up consciously, subconsciously it wouldn't ring true if you did it otherwise.

At *Hobbiton*, a small number of hobbit-scale hobbit holes were made larger, so when normal-sized actors stand in front of them they are reduced to hobbit size — such as *Bag End* and *Bagshot Row*. To sell that scale, not only does the hobbit hole have to be a different size but so do the fence and the plants.

Although it depicted summer, *Hobbiton* was shot in late spring, with extra-colourful potted flowers added each morning. To enhance the look of high summer, façades and doorways were painted just that little bit brighter, and all the fabrics were vivid and colourful.

The end result provided a more joyous and slightly more naive *Hobbiton* than the one first seen in *The Lord of the Rings*.

Well, you can just look and see . . . there's no having to finish the illusion. It's just here.
Elijah Wood

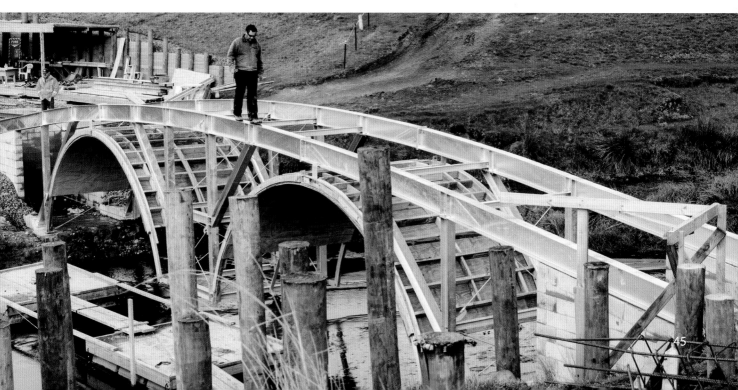

45

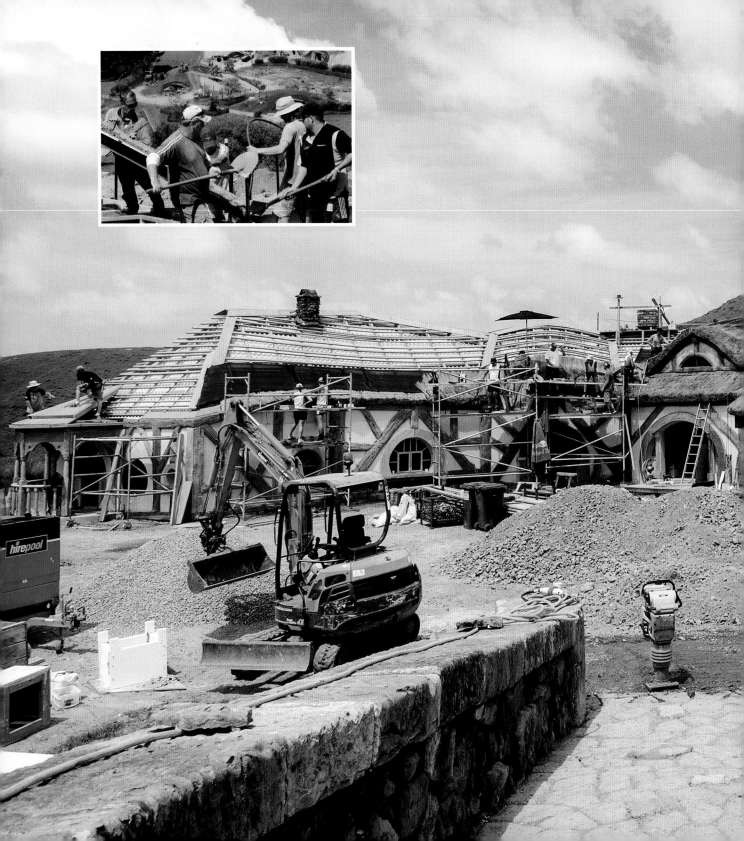

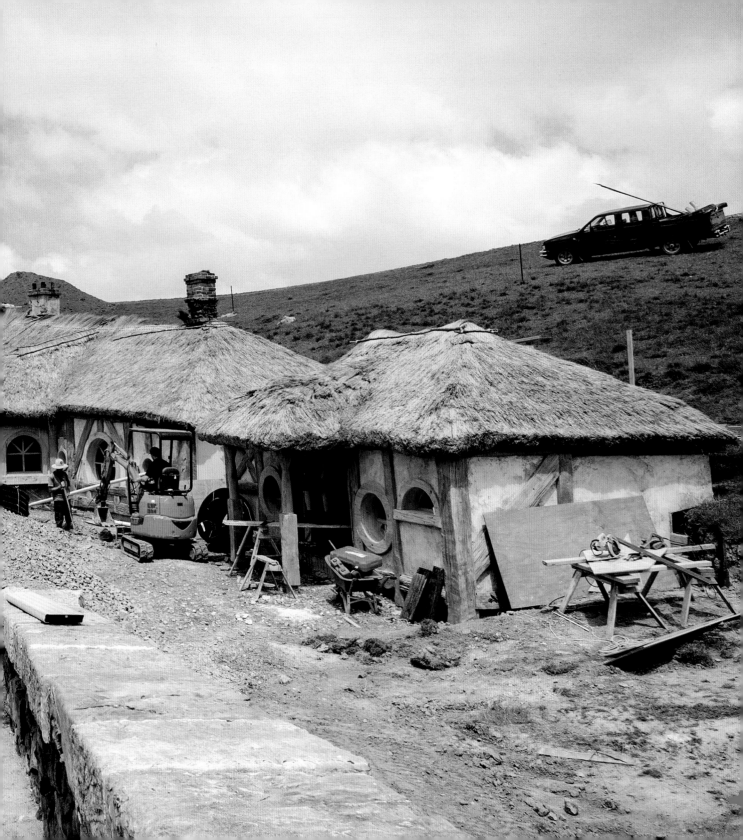

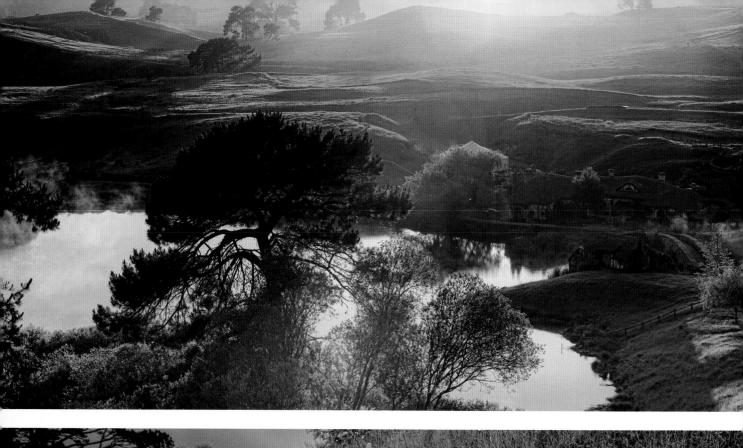
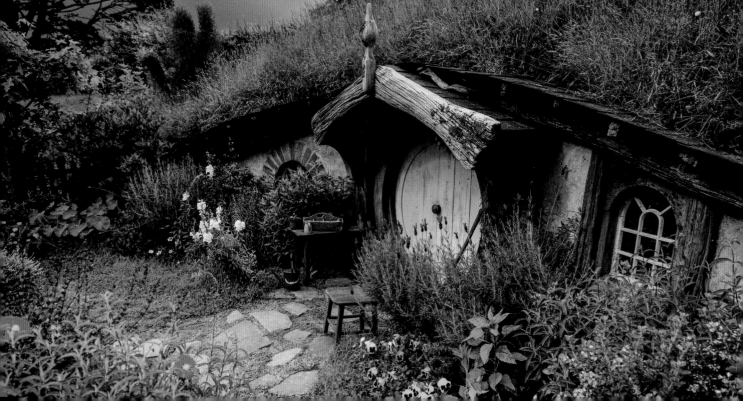

Hobbiton

Hobbiton Movie Set was completely rebuilt for filming of *The Hobbit: An Unexpected Journey* and is the only remaining set left standing. Initially scouted and filmed for the *Lord of the Rings* film trilogy, the set was partially destroyed — all that remained were white façades, left as a visitor attraction. In 2010 a team of builders, artisans and gardeners began the rebuild, and an adjacent area was used as the main construction base, with a joinery and brickworks.

Construction of each hobbit hole followed a similar routine. Earth was removed and strong retaining walls and a wooden-framed roof erected. Large beams were carved using chainsaws and Skilsaws (for ageing). Often, individual motifs and characters were hand-carved onto the round doorframes.

Once the initial framework was complete, earth was used to cover the hole and the fun began. Grass swathes were dug from around the farm and rolled over the roof to complete the classic hobbit hole. This was quite an art and specific wooden tools were handbuilt by the greens team to help mould and shape the turf.

Wooden-framed walls were plastered, slate added to roof edges and small windows added in the grass nearby to give the impression the hobbit hole stretches back into the hill.

Bricks were used for much of the walls — all constructed on site from a combination of moulded materials, baked in the resident kiln. They were made to fit around corners on the wooden framework to give the impression of a brick-constructed hole.

Concrete stones was also made and aged at the same plant, then used to construct chimneys. Another team spent the winter creating retaining walls for all the paths the hobbits would use.

The art department then had to age a brand-new hole into something that looked as if it was built 500 years ago. Multiple layers of paint were applied and distressed, as well as plaster put over bricks then rubbed clean in places, to give the idea of age.

Window frames were also made in the joinery, and a special glaze used to fill them. Little dainties were carefully placed on wooden shelves to be admired from the outside.

Each hobbit hole has a garden, with flowers, herbs and vegetables. Roses ramble around the frames of some, cosmos shows her bright-red face everywhere, nasturtium spreads an edible goodness from cracks in the stones, and the hobbits' love of beautiful gardens oozes from every corner.

The work of the greens team is very subtle. Although the vegetation looks as if it's been there for centuries, two years before they started the area was a sheep paddock.

Hedgerows framing the lanes were transplanted, complete with resident honeysuckle, their gaps creating a perfect view, whether it be across the *Party Field*, or a glimpse of *The Green Dragon Inn*.

Because the set is now permanent, a more detailed planting scheme has been developed. Filming

Auckland: 177 km
Waitomo: 88 km
Rotorua: 73 km

The Shire's Rest Café
(at entrance to set on Buckland Rd)

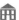
Farmstay accommodation available at local farms
www.hobbitontours.com

Hobbiton Movie Set Tours
501 Buckland Rd, Hinuera, Matamata
Phone 07 888 1505
www.hobbitontours.com

> The highlights have definitely been watching *Hobbiton* from the air . . . which is something I don't think was done on *Lord of the Rings* . . . Seeing it like this kind of living model village is just extraordinary. **Andy Serkis**

Opposite above A golden sunrise over the lake that was originally dammed in the 1950s to provide irrigation to the Alexander farm. Ian Brodie

Opposite below The holes at Hobbiton are created in different scales and are used depending on the scene. The flowers and vegetation reflect the occupation and fastidiousness of the occupiers. Ian Brodie

Overleaf The Green Dragon Inn is a tribute to the hundreds of craftsmen that worked tirelessly to translate the vision of Tolkien into reality. The result is remarkable. Ian Brodie

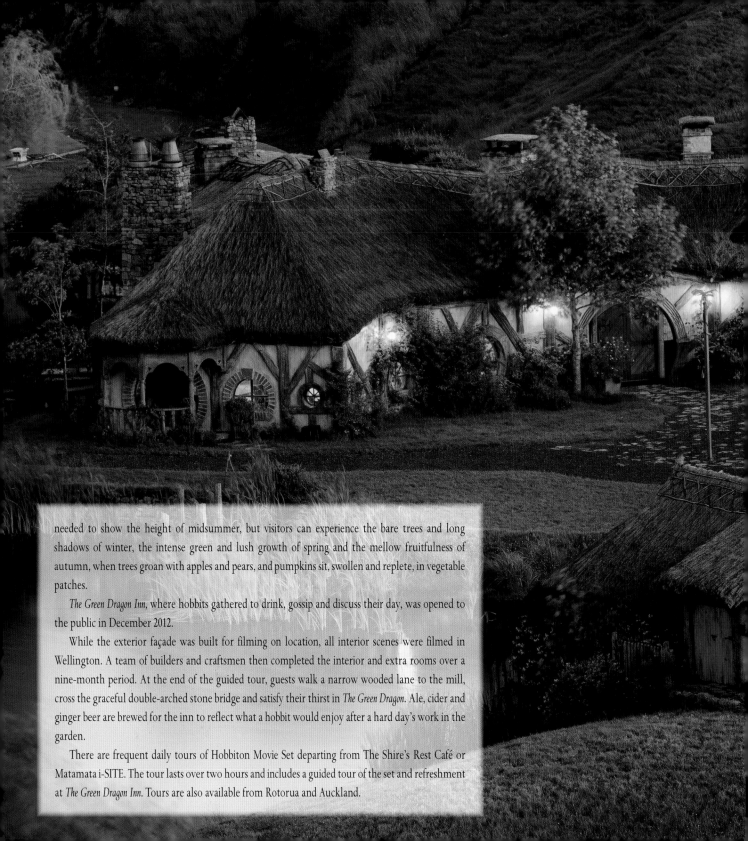

needed to show the height of midsummer, but visitors can experience the bare trees and long shadows of winter, the intense green and lush growth of spring and the mellow fruitfulness of autumn, when trees groan with apples and pears, and pumpkins sit, swollen and replete, in vegetable patches.

The Green Dragon Inn, where hobbits gathered to drink, gossip and discuss their day, was opened to the public in December 2012.

While the exterior façade was built for filming on location, all interior scenes were filmed in Wellington. A team of builders and craftsmen then completed the interior and extra rooms over a nine-month period. At the end of the guided tour, guests walk a narrow wooded lane to the mill, cross the graceful double-arched stone bridge and satisfy their thirst in *The Green Dragon*. Ale, cider and ginger beer are brewed for the inn to reflect what a hobbit would enjoy after a hard day's work in the garden.

There are frequent daily tours of Hobbiton Movie Set departing from The Shire's Rest Café or Matamata i-SITE. The tour lasts over two hours and includes a guided tour of the set and refreshment at *The Green Dragon Inn*. Tours are also available from Rotorua and Auckland.

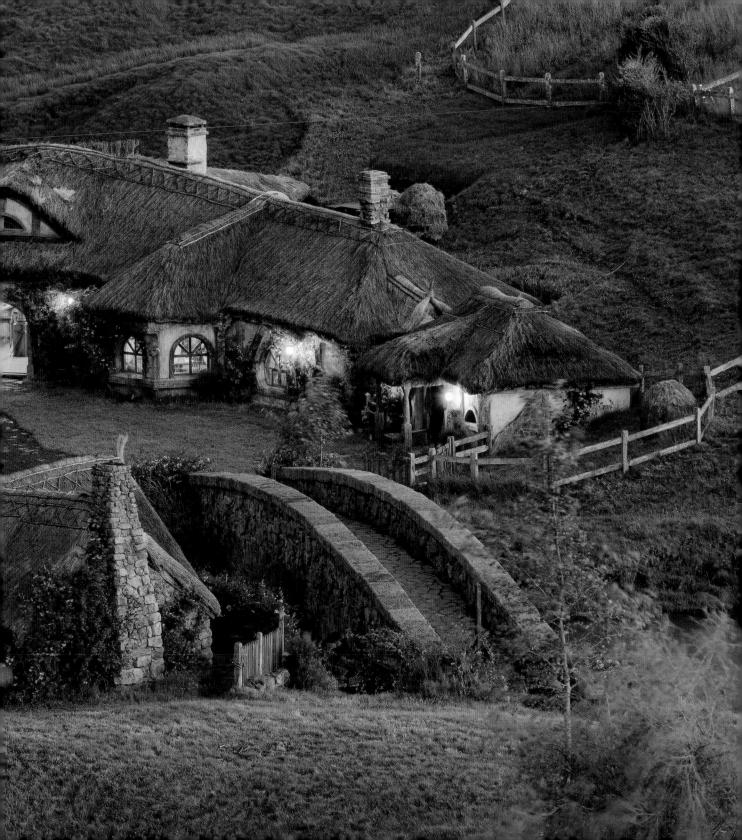

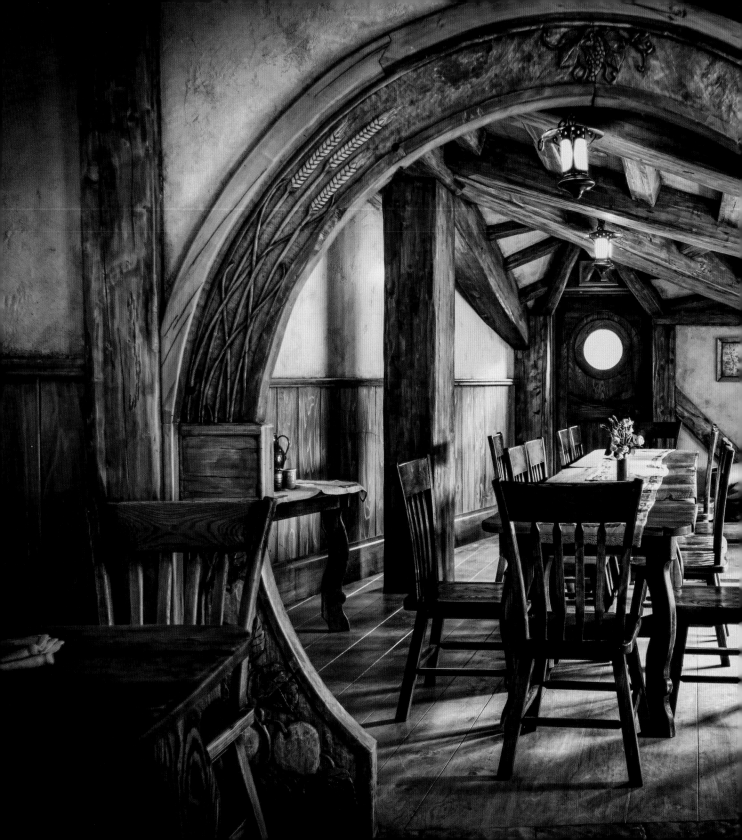

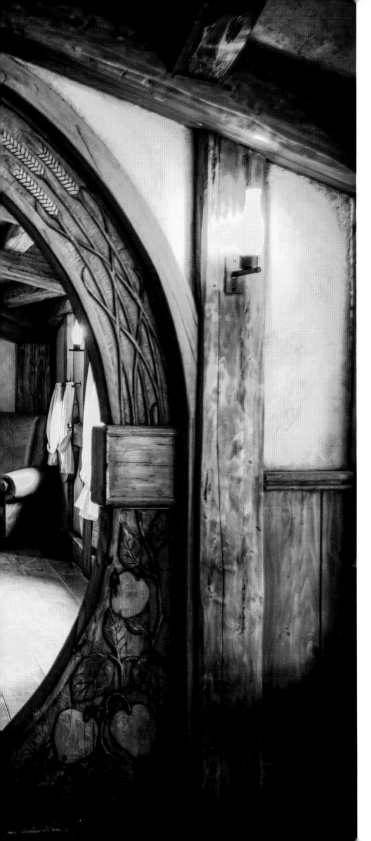

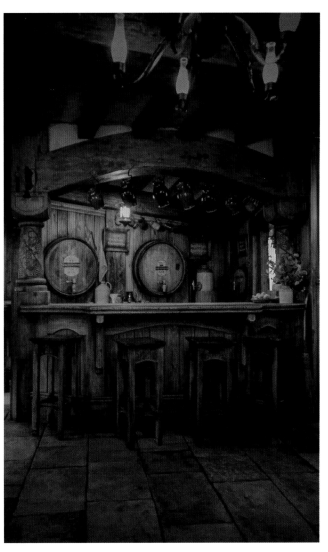

Left The richness of the snug complete with a leather chair for a tired hobbit to relax in after a hard day's work outside. Ian Brodie

Above The Green Dragon awaits its next round of visitors who complete their tour of the Hobbiton Movie Set with a welcome drink at the bar. Ian Brodie

Te Waihou Walkway

Matamata: 30 km
Aratiatia Rapids: 87 km

Leslie Rd car park:
38° 02' 06.18" S, 175° 50' 53.11" E

Rhubarb Café, 6 Arapuni Rd, Arapuni

Te Waihou Walkway, Whites Rd, Putaruru
www.hamiltonwaikato.com

Off SH1, near Putaruru, is one of the most beautiful walks in the area — while it was not used as a location, it's worth a stop. High in the Mamaku Ranges, water from small springs and streams spends a century flowing through aquifers to become the Waihou River. This long, slow process creates the most intense blue-green water, which emerges at a rate of 42 cubic metres (9240 gallons) per minute.

The walkway follows part of the river and is 9.4 km return from the main car park at Whites Road — you can also visit the spring from a car park 3.6 km along Leslie Road.

The landscape is the epitome of *Middle-earth*. Clear, pure water flows through an intensely green valley interspersed with native bush, where the stream tumbles over small waterfalls amid moss-green rocks. Lush reeds grow in the deceptively deep stream, where they wave and twist with the water. Watch for trout, which appear suspended as they swim upstream.

Within New Zealand, there's every chance of tasting water from the Waihou — a pumping station along the walkway supplies many different water bottlers.

Below The rich colours of the Waihou River range from the deepest green to the most amazing blue. Ian Brodie

Opposite After leaving the open spring area the walkway plunges through a swathe of bush with glimpses of the Waihou rushing along its course. Ian Brodie

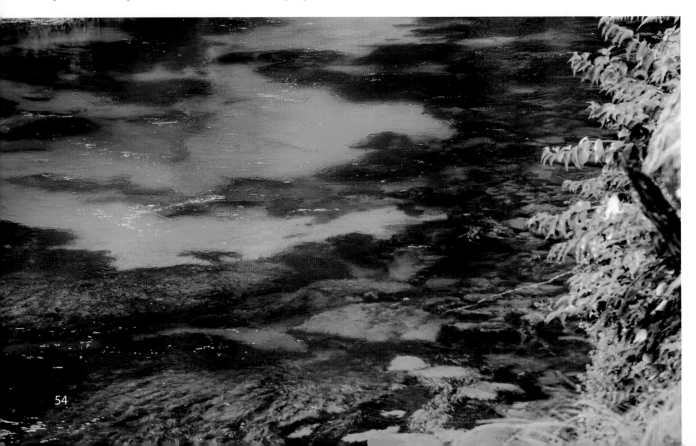

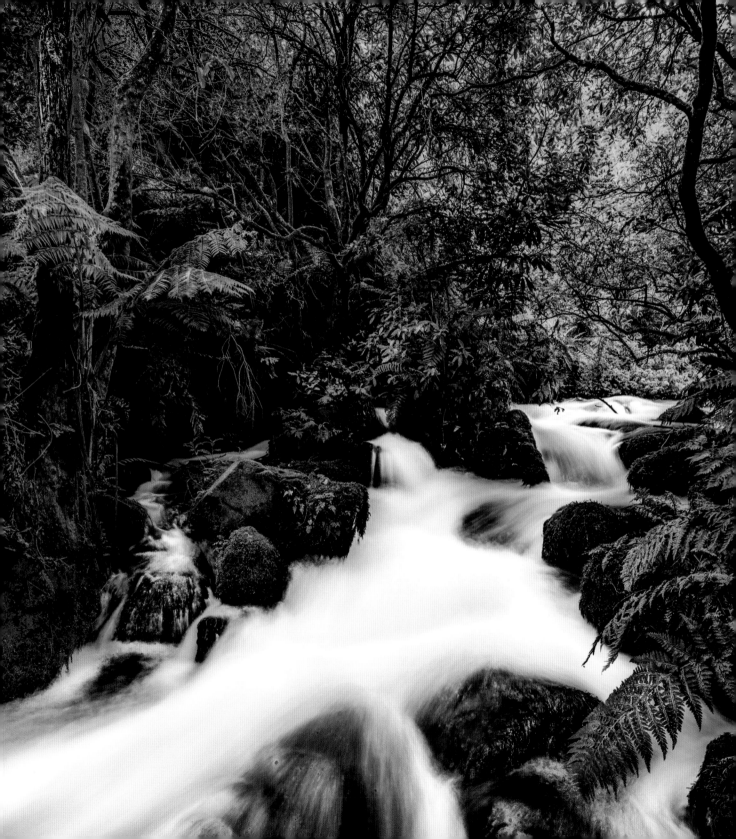

Aratiatia Rapids

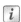
Aratiatia car park:
38° 37' 07.19" S, 176° 08' 35.52" E

Rapids Jet, Nga Awa Purua Rd (off Rapids Rd),
Aratiatia
www.rapidsjet.com

No actors or stunt crew were forced into the barrels to venture into the extreme conditions. I think we would have had some issues with OSH [Occupational Safety and Health] if that were the case.
Melissa Booth, Unit Publicist

The Waikato River is the longest in New Zealand, stretching 425 km from the eastern slopes of Mt Ruapehu, via Lake Taupo through the Waikato region to the Tasman Sea at Port Waikato. The river's present course was formed around 1800 years ago, during the great Lake Taupo eruption, when volcanic debris forced it to move north. Its original trail to the sea near Thames can be seen near Hinuera, where moulded cliff faces were used in a scene from *The Lord of the Rings: The Fellowship of the Ring*.

Power generation is a major feature of the river, with eight dams and nine power stations. One of these is at Aratiatia, where the waters are released several times daily to power the turbines, creating the largest rapids in Australasia — sections of scenes showing the *Company* rushing down the river towards *Lake-town* were filmed here.

The flow of water is extreme, so rest assured no dwarves (or hobbits) were used in the filming. Large barrels (and one smaller one) were painted pink and brought up by truck from Wellington. Over a period of four days the crew ejected empty barrels into the water to coincide with the floodgate release.

Water is released four times daily in summer (10 a.m., 12 noon, 2 p.m. and 4 p.m.) and less frequently in winter. There are several vantage points, and I suggest arriving 20 minutes before to allow time to walk to one.

Opposite above The Waikato River in full force, after the opening of the floodgates at Aratiatia, was used to portray the falls on the River Running. Warner Bros. Pictures

Opposite below The view from the bridge over the Waikato River as the water rises. Ian Brodie

Overleaf There are numerous picnic spots on the road between Taupo and Tongariro and they all make ideal places to have a summer barbecue and relax on the sandy foreshore of the lake. Ian Brodie

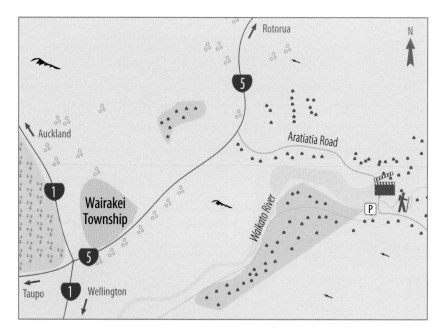

An alarm sounds three times, then the water flow slowly increases from a trickle to a raging torrent. Over the space of one kilometre the river falls 28 metres, and in full flow is impressive. One can easily imagine bruised dwarves being battered and bashed as they escape the *Elvenking*.

Another more exciting way to view these rapids is from the river itself. Rapids Jet operates very exhilarating jet-boat rides through the Waikato River's narrowest canyon.

Travelling upstream through Nga Awa Purua rapids might seem exciting, but the high-speed return down through the rapids allows you to experience a little of what it must have been like for the hapless dwarves.

After completing this adventure there are a number of walking tracks and picnic areas, and for those with a penchant for fishing, and a licence, trout abound. There is also a two-hour trail (walking or biking) following the river from Aratiatia to Huka Falls.

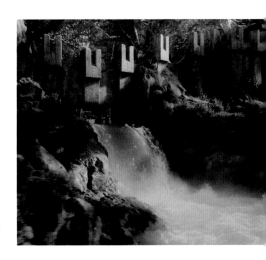

57

Taupo

The Central North Island is an area of distinctive geography and contrasting scenery — from peaceful rivers, lakes and pastoral greenery to a blasted landscape of lava and volcanic ash. This was once one of the world's most prolific volcanic areas, and Lake Taupo formed as a result of the largest eruption in the last 70,000 years. The shape of the lake was created by the Oruanui eruption 26,500 years ago, then in AD 181 an explosion produced a column of pumice, ash and rock fragments 50 km high and seen as far away as Europe and China.

Sitting beside New Zealand's largest lake (619 sq km), Taupo is an ideal base for visiting the Volcanic Plateau, including Rotorua, the world-famous fishing area of the Tongariro River, or the mountainous Tongariro National Park.

Home to bubbling mud, geysers and pristine lakes, Rotorua is one of New Zealand's most popular tourist destinations and one hour to the north.

South of Taupo is Tongariro National Park, our first national park and a world heritage area. The park was created in 1887 when local iwi Ngati Tuwharetoa gifted three volcanoes — Ruapehu, Ngauruhoe and Tongariro — to the people of New Zealand.

A lot of the world's impression of New Zealand is that landscape. You know, the rolling hills and the mountains and the fjords. It's got everything . . . Martin Freeman

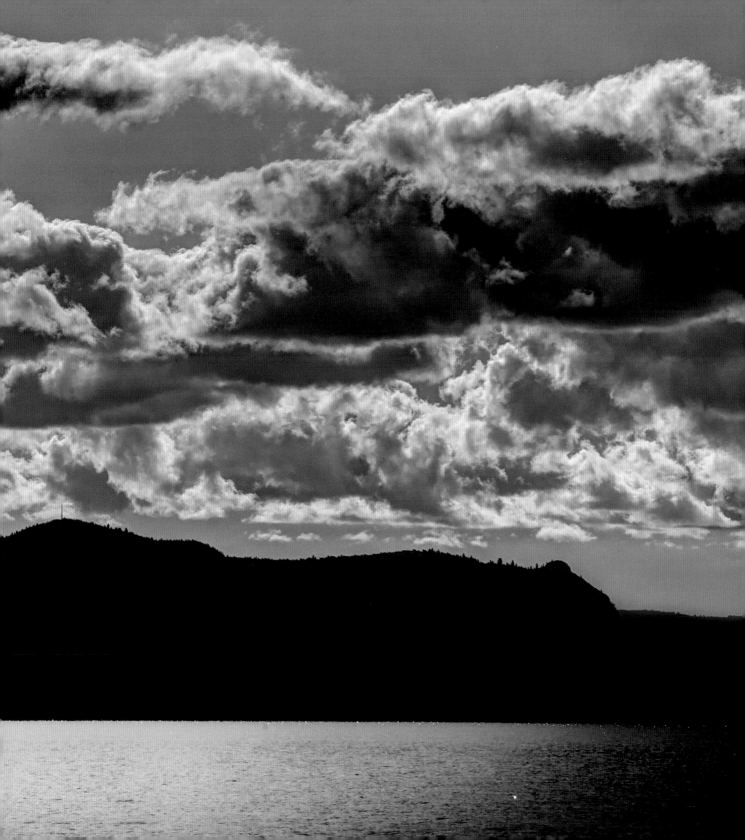

Tongariro National Park

Tongariro National Park sits astride the centre of the North Island and offers a diverse landscape, centred on the three volcanic cones. To the east, the main highway leaves Turangi and its lake and river towards a very different scene, as the well-named Desert Road traverses the Rangipo Desert towards Waiouru.

To the west, a state highway carries you through pine forests and small lakes before reaching the Chateau Tongariro, a hotel and small village sitting in splendid isolation on the slopes of Mt Ruapehu. Continue through Ohakune before reaching Waiouru. In winter, the slopes of Mt Ruapehu are a mecca for skiers and snowboarders, who travel here from all over the North Island.

A round-trip from either Turangi or Ohakune around the mountains provides an amazing journey of discovery with majestic views, rushing rivers, desert, and movie locations. This can be completed in a day but to fully explore the area, I recommend your journey is broken for at least one night. The weather has a major impact on this road, which can be closed because of snow in winter.

Commencing in Turangi, head south on SH1 towards Waiouru. The road descends into folds of beech forest before climbing into the highlands of the Rangipo Desert. Disregard the stunning mountains briefly and look at the barren tussock and sand foreground. This landscape was merged as middle ground into the final image in *The Hobbit: An Unexpected Journey* of *Erebor*, the *Lonely Mountain*. To see the foreground you need to travel many kilometres south, to Takaro Lodge, near Te Anau (see page 150).

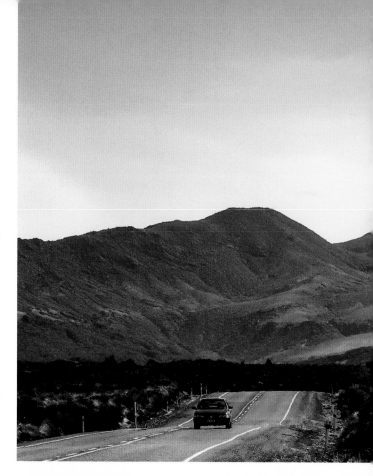

Right above In summer, the volcanic cone of Mt Ngauruhoe appears as the perfect representation of Mt Doom, although it never appeared in the *Lord of the Rings* film trilogy. Ian Brodie

Right below Snow grass and tussock are the only vegetation that can survive and actually grow in the ashen landscape that has a high number of frosts, snow cover and is frequently battered by strong winds. Ian Brodie

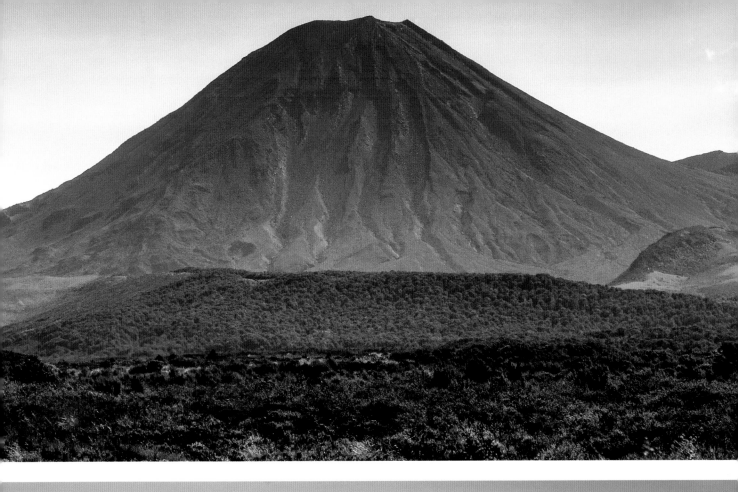

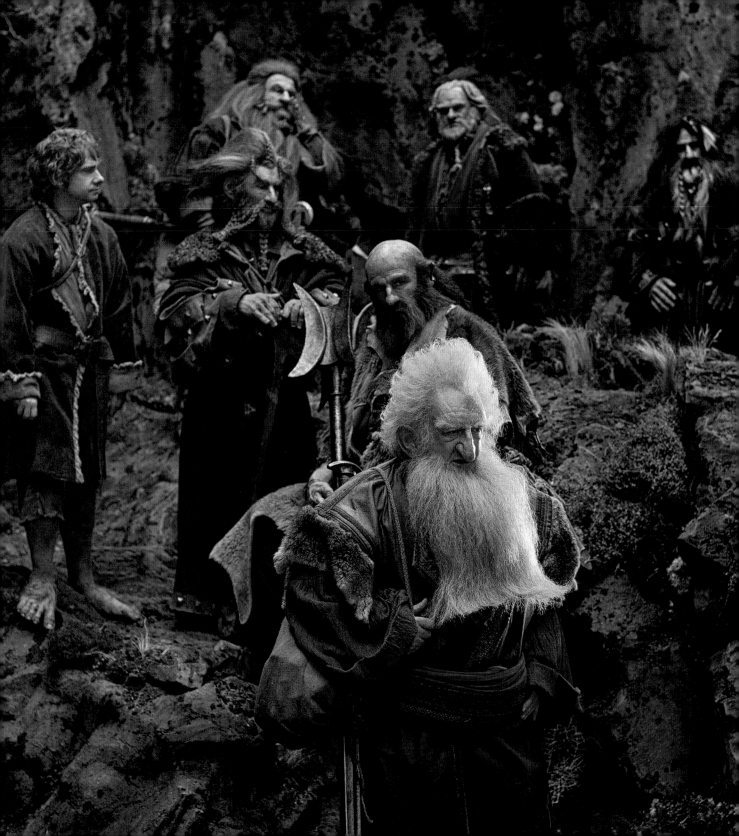

Ohakune

A two–three-day stay in Ohakune is my recommendation, as there are a number of special activities to immerse you into an area not only rich in landscape, but strong in heritage. The nearby Whanganui River is one such place. The river, running from its source on the slopes of Mt Tongariro to the sea at Whanganui, is 290 km in length and the country's third longest. Settled by Maori in the early 1100s, the area was one of the most densely inhabited in the region, and the arrival of European settlers saw Whanganui River become a major trade route and tourist attraction. The river featured in a 1913 documentary (now lost) by French film-maker Gaston Méliès. Whether you wish to paddle, jetboat or drive, a day tour (or longer) is highly recommended. Another fascinating tour is travelling the historic decommissioned Okahukura-to-Stratford railway line by rail cart. There are four tours available, allowing you into one of the remotest parts of the region through tunnels, over bridges and into townships time has forgotten.

This small town is no stranger to Hollywood, being used as a base during filming of *The Lord of the Rings*. This time the crew returned to Ohakune to film scenes in two new locations. The first, showing the group leaving the *Shire* on horseback with *Bilbo* catching them up, is on private land and not accessible to the public.

The second is located on Turoa ski field and can easily be reached with a short drive from Ohakune township. To reach the location of the secret door into the *Lonely Mountain*, travel up the Turoa Ski Field Road (also known as the Ohakune Mountain Road) to its end at the ski field itself. This location was filmed in the early summer of 2011 and can only be seen as it appeared in the film during the summer months, when there is no snow.

The actual filming location is visible from Car Park 3 at the Turoa ski field. The area is very rough with jagged rocks and loose scree. During filming, a special scaffolding walkway was built by production to allow the cast and crew access to the site without damaging any of the ancient moss growing in the area. One day was spent filming here, and at 1500 metres it was the main unit's highest base camp and filming location. This part of the North Island is spectacular, especially in the summer. Rugged Mt Ruapehu towers over the location and often mist is attracted to the top of the peaks, creating a mystical shroud over the area. The view in the opposite direction is astounding. The rolling hills and valleys of the King Country seem to reach forever, disappearing into a gold haze. And on a clear day Mt Taranaki/Mt Egmont can be seen in the distance, rising like a perfect New Zealand rendition of the *Lonely Mountain*.

Opposite Dwarves and a hobbit ponder the meaning of Durin's Day and a hidden keyhole in the studios in Wellington, an exact replica of the rocky, sloped area filmed on Turoa ski field. Warner Bros. Pictures

Overleaf A converted golf cart makes an ideal mount for a Steadicam during filming amidst the ancient beech trees near Ohakune. Warner Bros. Pictures

Taupo: 135 km
Piopio: 159 km
Taumarunui: 78 km

View of location:
39° 30' 95.19" S, 176° 52' 42.63" E

Powderhorn Chateau

Powderhorn Chateau
194 Mangawhero Tce, Ohakune
www.powderhorn.co.nz

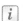
www.visitohakune.co.nz
www.whanganuiriveradventures.com
www.forgottenworldadventures.co.nz
www.mtruapehu.com

Filming on Mt Ruapehu was just incredible.
Adam Brown

So this is my favourite location. It is beautiful. There is a mountain, there is a waterfall, there's a beautiful view across the valley there. It's one of the sort of archetypal Kiwi places that you think, 'God, New Zealand has such amazing landscapes.' Martin Freeman

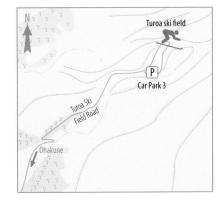

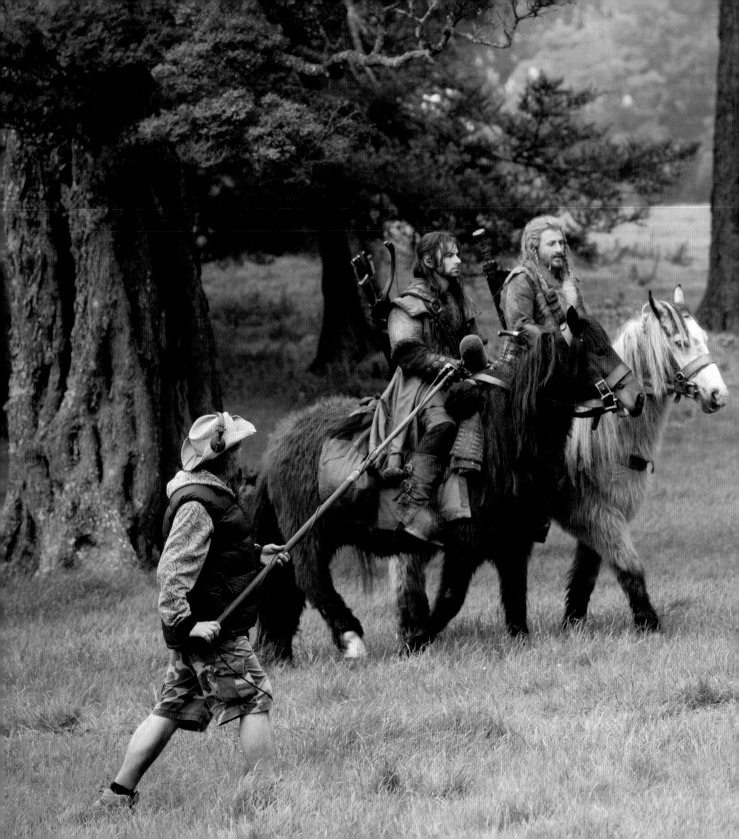

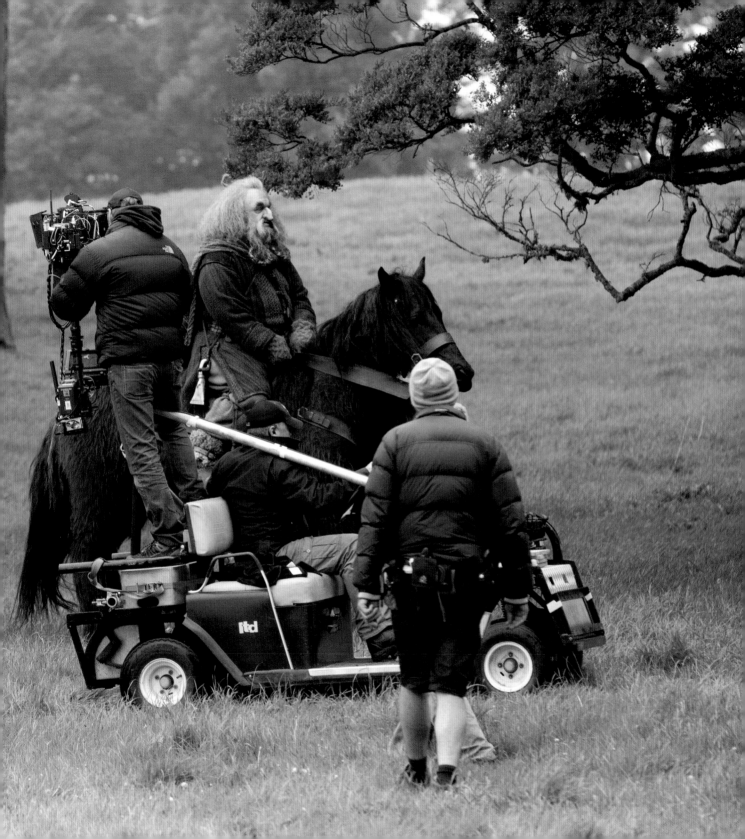

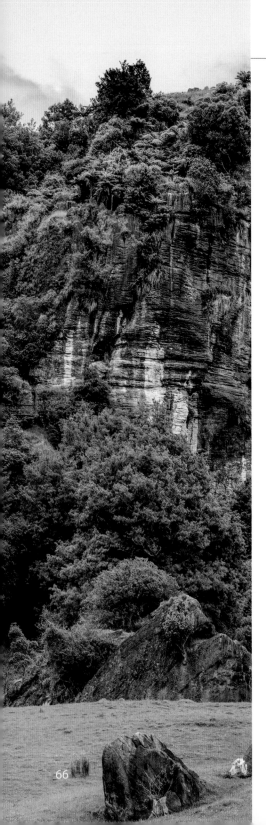

Introducing the King Country

During the New Zealand Wars in the 1860s, followers of the Kingitanga, or Maori King movement, came to this region to escape colonial forces invading the Waikato. The King Country stretches south from Otorohanga to the upper reaches of the Whanganui River. With its rugged hills and extensive karst formations, the area was portrayed in the movie as the *Trollshaws*.

Worthy of a stop as you travel south, Otorohanga is the Kiwiana capital, with displays and stories about the unique social institutions and cultural icons defining our country. Park at the heritage-listed railway station and walk into the main street via the Ed Hillary Walkway and learn all about Buzzy Bees, Marmite, number 8 wire and other Kiwi institutions — and you can have a great coffee at the railway station afterwards.

Nearby is the Otorohanga Kiwi House, where you can see live kiwi, as well as many other native birds, and the tuatara, a small contemporary of the dinosaurs.

Continuing south on SH3 a further 8 km, you come to the turn-off to Waitomo Caves (SH37).

Denize Bluffs and the tour of the Trollshaws is a must for any *Hobbit* film tourist. It was also a favourite among many of the cast and crew. Ian Brodie

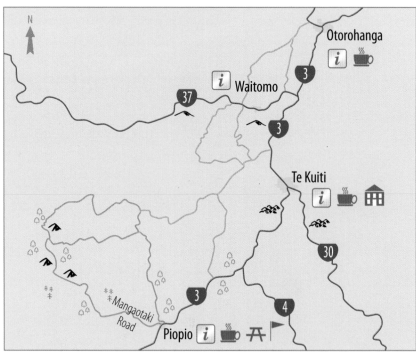

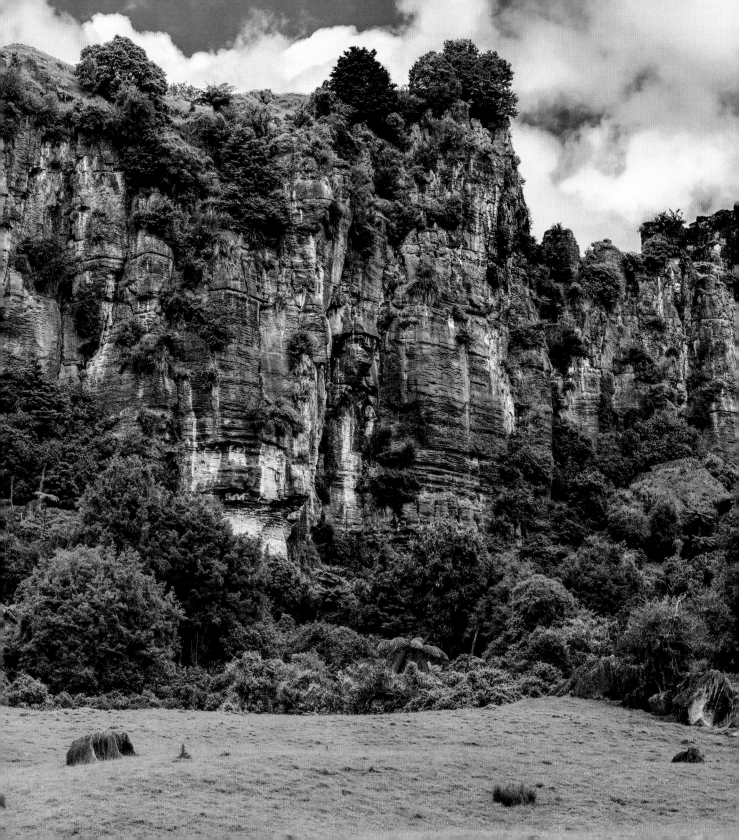

Waitomo Caves

Waitomo Caves offer underground caverns so beautiful they rival Tolkien's *Glittering Caves of Aglarond*. The word *tomo* means sinkhole in Maori, so be extra careful off the beaten track as there are more than 300 limestone caves in the region.

Millions of years ago, seas covered the land, and over time the remains of marine animals settled on the seabed. Volcanic and geological activity over 30 million years lifted the limestone, separating it into rocks filled with crevasses. Water flowed into these cracks, with erosion gradually forming the caves.

At Waitomo the most well known are the Glowworm Caves. The boat tour is well worth taking to see the caves lit with underground stars. If you feel more adventurous, try the Lost World abseil tour. Secured by a guide, you slowly rappel 100 metres through a lush, green entrance into a cavern — and feel as if you're in *Gollum's Cave*.

Parts of these caves were used for the *Hobbit* films — but not for the scenery. Sound specialists recorded a number of different audio tracks to replicate the voices of the *Company* in the goblin caves.

Below The sculptured limestone that appears to be forced out of the green landscape is a distinctive feature of the Waitomo region. Ian Brodie

Right The 15-metre Waitanguru Falls near Denize Bluffs. After the falls the Mangaotaki River becomes much broader and contains an extensive length of fishing water, especially in the middle reaches, that is ideal for the novice fly-fisherman. Ian Brodie

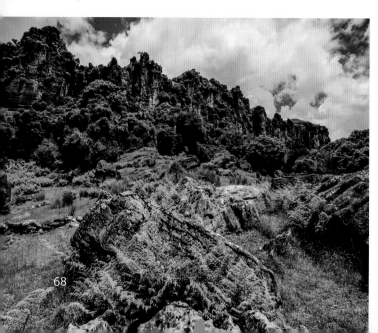

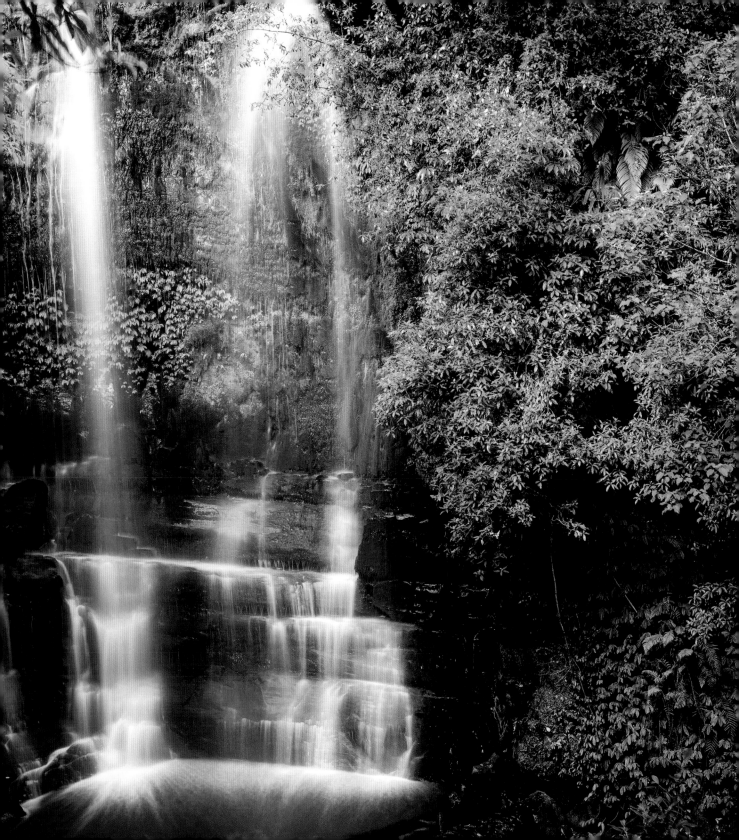

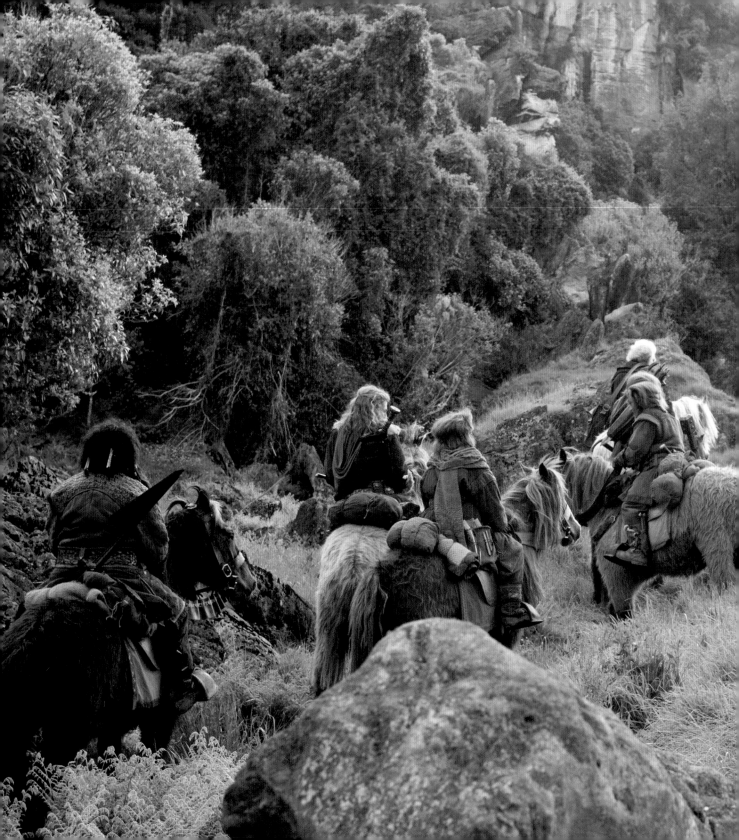

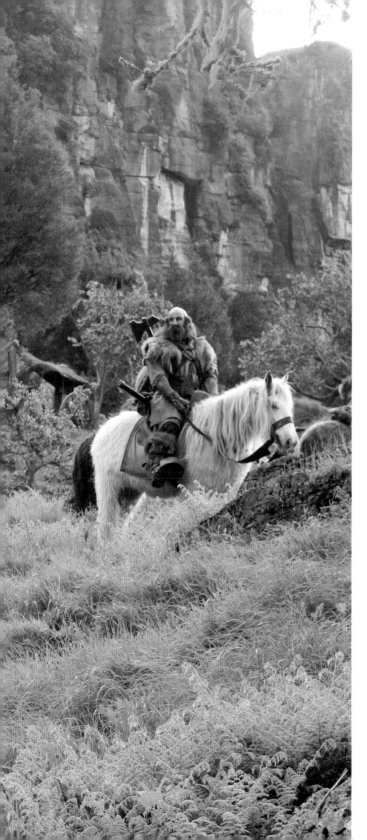

Piopio

The stone trolls, the *Company*'s first adventure in *The Hobbit* as they travelled towards *Rivendell*, were filmed at Denize Bluffs in an unbelievable landscape. As well as the location, there are a number of places to visit, including a tour of the site itself which operates twice daily.

Heading south through Te Kuiti, continue to the village of Piopio, turning right as you leave, onto Kaka Street and then left onto Mangaotaki Road. The road descends into a narrow valley with limestone outcrops, then startlingly large cliffs begin to appear. Mangaotaki Rocks is very popular for rock climbing. During filming, the cast and crew stayed in local homes so everybody could remain close by.

As well as visiting the location, fuel up at the Fat Pigeon Café in Piopio and head off on an adventure. Stop at the Mangaotaki Scenic Reserve and take the 20-minute loop track down to the river. It's an easy walk with magnificent native trees and river views.

The walk to Waitanguru Falls, with steep boarded steps, leads down to a bridal veil of mist and water as the sylvan falls tumble off a cliff, surrounded by intense-green native bush.

> It seemed ancient. There were lots of moss on all the great rocks. It seemed incredibly old. **Sylvester McCoy**

The tour at Denize Bluffs allow you to walk in the footsteps of the Company through the limestone landscape as well as into the surrounding bush (below). Warner Bros. Pictures (left)/Ian Brodie (below)

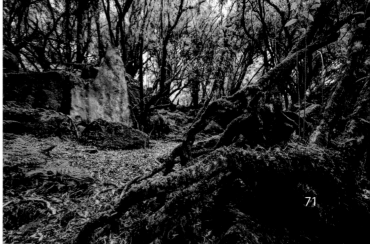

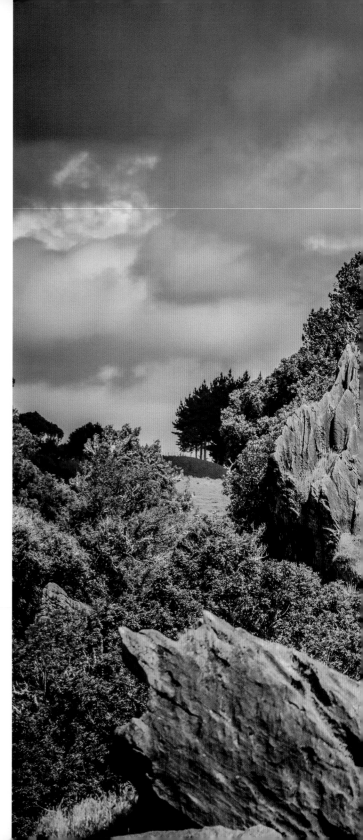

Denize Bluffs

The area around Denize Bluffs is unexpected, with a rare combination of geography and botany. Large cliff faces tower over a valley pockmarked with rock columns, seemingly growing straight out of the grass. Walk down into an area of exquisitely beautiful native bush and you might have been transported directly into *Middle-earth*.

Your tour will travel to base camp, along a road built by the production company, then continue on to the main filming areas. *Staddle Farm* was created here, to be destroyed by the trolls. A team of set designers created this set at the same time as *Hobbiton*, travelling between the two.

Walk down into the native bush to a small *tomo*, where *Bilbo* received *Sting*, and *Glamdring* and *Orcrist* were discovered. While the interior was created in Wellington, the cave entrance was filmed here, where you can sit on a carpet of dry leaves and watch shafts of sunlight illuminate the mossy rocks.

Walk a little further to where *Radagast the Brown*, with his rabbit-drawn sled, warns the *Company* of approaching peril. Here, the steep landscape helped the difficulties caused by different-sized races. The much taller *Istari* were placed further down the slope, making artful use of forced perspective.

Spend as much time as you can as your guide recounts tales about the filming while you enjoy a walk among the striking yet subtly calming landscape.

ℹ️ Hairy Feet Waitomo, 1411 Mangaotaki Rd, RD1, Piopio
www.hairyfeetwaitomo.co.nz

> There are beautiful rock formations. And then down, down, down into the most incredible bush. **William Kircher**
>
> It looked like Jurassic Park. **Graham McTavish**

Right Each tour group is limited to a maximum of nine people to ensure a personalised experience. It also allows you to get striking images without a clutter of other visitors blocking the view! Ian Brodie

Overleaf Bilbo makes his way warily towards the entrance to the troll cave, while Kili and Nori also look uneasy in this mysterious environment. Warner Bros. Pictures

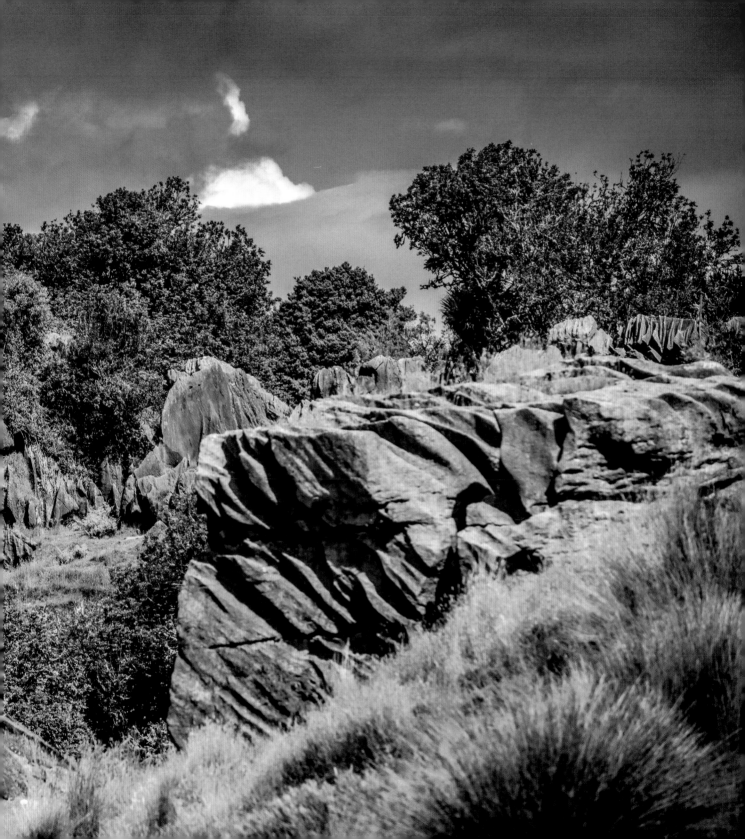

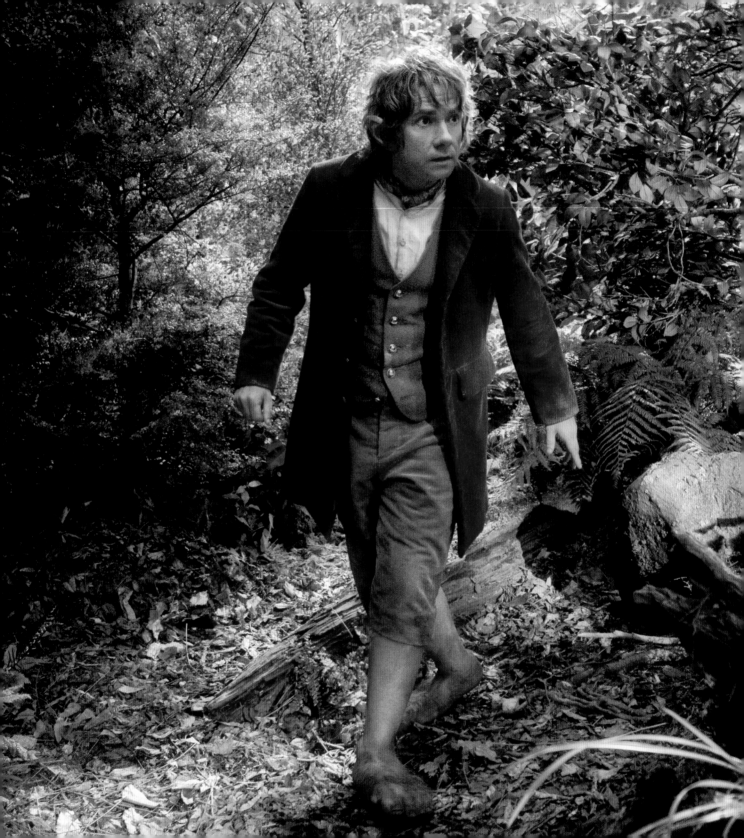

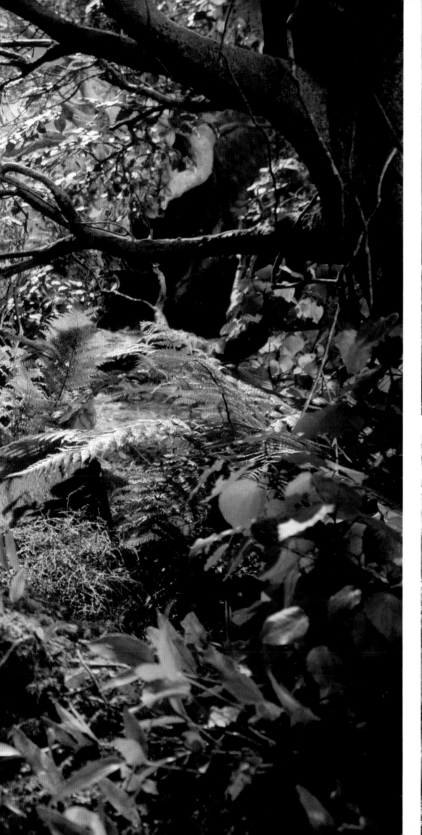
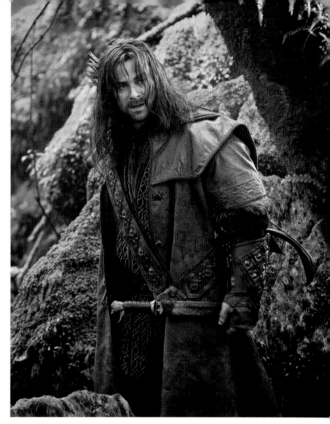

Ohakune: 286 km
Auckland: 649 km

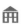

Logan Brown, 192 Cuba St, Wellington
www.loganbrown.co.nz

Museum Hotel, 90 Cable St, Wellington
www.museumhotel.co.nz

i Wellington i-SITE, corner Victoria and Wakefield Sts,
Wellington
www.wellingtonnz.com

i Te Papa Tongarewa, 55 Cable St, Wellington
www.tepapa.govt.nz

i New Zealand Film Archive
www.filmarchive.org.nz

i Wellington Cable Car, Lambton Quay
www.wellingtoncablecar.co.nz

i Carter Observatory, Kelburn
www.carterobservatory.org

i Wellington Rover Tours
www.wellingtonrover.co.nz

i Weta Cave
www.wetanz.com

i Welly-moot
www.welly-moot.com

Introducing Wellington

While Wellington and its magnificent harbour is our nation's political and cultural capital, to any die-hard fan of the *Lord of the Rings* films the city is Wellywood, home to Sir Peter Jackson, 3 Foot 7, Wingnut Films, Weta Workshop and Weta Digital. An added advantage is that the compact downtown area lends an immediate intimacy for the visitor, uncommon in other cities.

Kupe, the great Polynesian explorer, is credited with discovering Wellington Harbour around the tenth century, and the region's earliest name, Te Upoko o te Ika a Maui (The Head of Maui's Fish), relates to a legend in which the demigod Maui fished up the North Island. English settlers in 1839 named it Wellington, after the famous Iron Duke, and on 26 July 1865 it hosted the first session of Parliament as our new, central capital.

The area is prone to earthquakes and many early wooden buildings were destroyed by the subsequent fires, but for those with an interest in early architecture the 1858 Nairn Street Cottage (68 Nairn Street) is a survivor. Also worthy of a visit is the Old Government Buildings on Lambton Quay; designed to look like stone, it is constructed entirely of wood. If politics appeals, Parliament House and the Beehive offer daily tours, while the Backbencher Pub nearby displays large fibreglass puppets lampooning prominent New Zealand politicians — the early work of Sir Richard Taylor and Tania Rodger of Weta fame.

Flat and intimate, downtown Wellington is a walker's paradise, so join the locals and explore on foot. An excellent starting point is the Museum of New Zealand — Te Papa Tongarewa — on Cable Street, site of a spectacular launch party for *The Lord of the Rings: The Two Towers*. Praised for its up-to-date interactive approach, the museum has several 'hands-on' exhibitions. Admission to the museum is free, but charges apply for some exhibitions.

If you're into movies, the Film Archive on the corner of Taranaki and Ghuznee Streets is well worth a look. Nearby at 10 Kent Terrace is the Embassy, Wellington's grandest cinema and venue for the world premiere of *The Hobbit: An Unexpected Journey*. The Embassy features many grand and glorious features from times gone by, with beautifully detailed restrooms, elegant staircases and the country's largest screen. With the cinema's superb digital sound and comfortable seats, watching a movie here is a thoroughly enjoyable experience.

If you want to get up into the hills, take the short but spectacular Wellington Cable Car from Lambton Quay to the Kelburn lookout. A short walk away is the Carter Observatory, featuring a digital full-dome planetarium and multimedia exhibition.

Wellington Rover and Flat Earth provide guided tours to film locations from *The Lord of the Rings* and *The Hobbit* — the recommended way to see the many places which were transformed into *Middle-earth* in this amazing little city.

Weta Cave

The Weta Cave Workshop Tour is a movie-based visitor experience in the heart of Miramar, Wellington. A 45-minute guided tour starts and finishes in the famous Weta Cave and provides a unique behind-the-scenes glimpse into the workings of Weta Workshop.

The story of the creative process is told by members of the talented crew from the workshop floor using the props, models and weapons they helped make for the movies. They may even reveal some of the secrets behind the movie magic ...

Through a number of windows opened into the heart of Weta Workshop, you can actually see the work being done inside one of the world's leading concept design and physical effects manufacturing operations.

The Weta Cave Shop — a cavern of creativity in its own right — boasts a range of limited edition sculptures handcrafted by the artists at Weta, unique Weta-designed clothing, jewellery and books, mugs and other collectibles. Every 20 minutes their exclusive behind-the-scenes film features interviews with Weta Workshop co-founders Peter Jackson, Richard Taylor, Tania Rodger and Jamie Selkirk.

Enjoy an exclusive insight into the creativity and imagination that goes into crafting the props and physical effects of Weta Workshop. No visit to Wellington is complete without a peek into the Weta Cave.

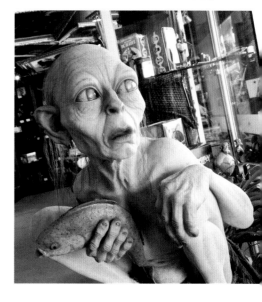

Above A life-sized Sméagol casts his eye over visitors as they enter the Weta Cave. Weta Cave

Below The workshop tour gives an insight into the many projects that the Weta team have worked on and sometimes a sneak preview to future collaborations as well. Weta Cave

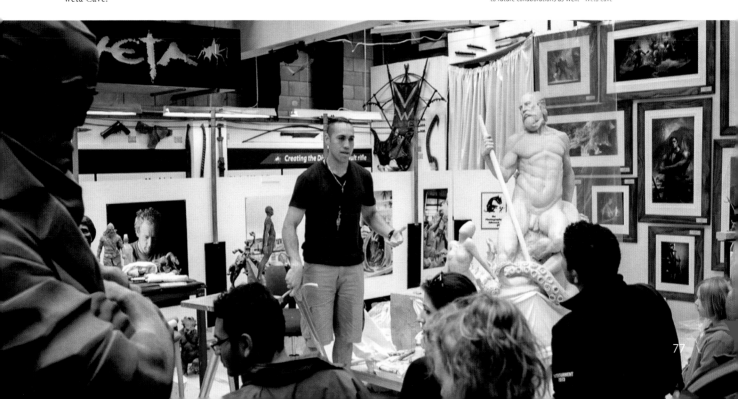

Dale

The township of Dale was built into the slopes of Mt Crawford in Wellington. Totally removed after the completion of filming, nothing now remains of this beautiful set. This incongruous image shows the ancient town against the skyline of modern Wellington. Warner Bros. Pictures

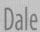

Dale was situated on the **River Running** between the **Lonely Mountain** and the **Long Lake**. A fine city, it traded food and other supplies with the dwarves of the **Lonely Mountain** in return for craft, and especially toys. In **TA 2770** the dragon **Smaug** destroyed the city and killed most of its residents, including **Girion**, the last **Lord of Dale**.

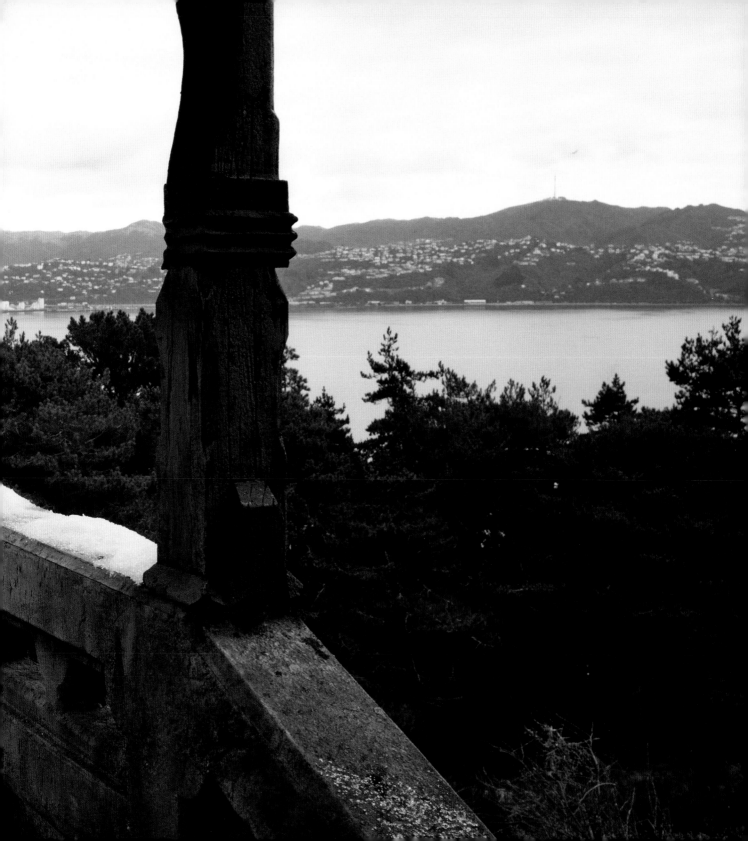

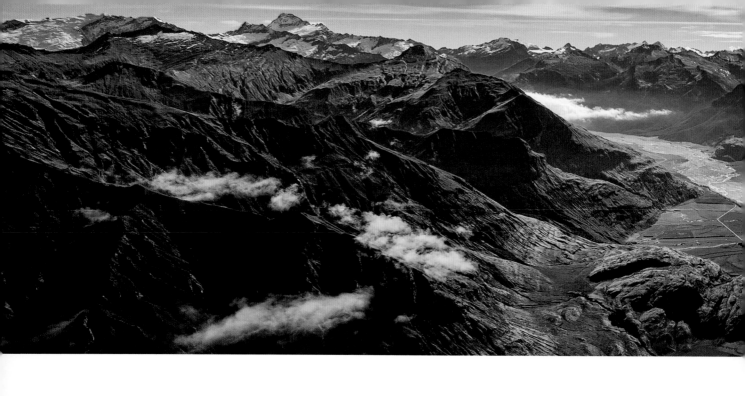

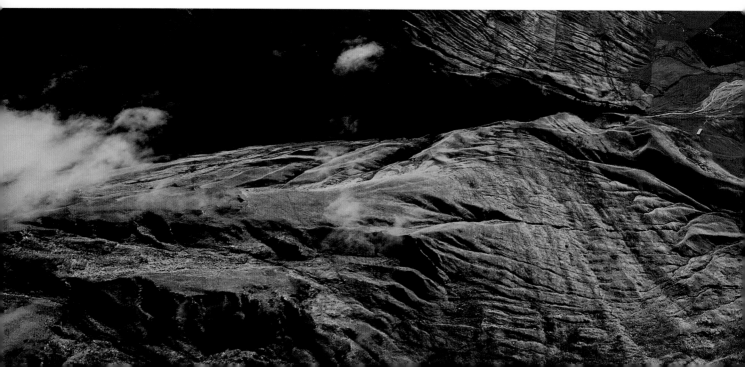

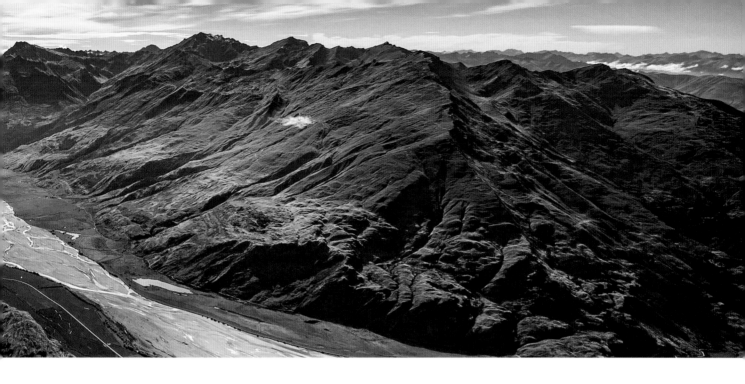

South Island

Introducing Havelock

Picton: 33 km
Blenheim: 41 km
Pelorus Bridge: 20 km

The Mussel Pot, 73 Main Rd, Havelock
www.themusselpot.co.nz

Havelock Garden Motels, Main Rd, Havelock
www.gardenmotels.com

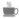

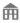

www.havelocknz.com

The tiny fishing port of Havelock is an ideal place to stop as you drive towards Pelorus Bridge. Nestled at the head of Pelorus Sound, this laid-back village is also the green-shell mussel capital of the world and offers fine food, relaxing accommodation and the opportunity to unwind as you enjoy the sunshine and the marina.

Havelock was born in 1858 and an early gold rush in 1864 saw the town grow. The village was also home to some remarkable Kiwis. Ernest Rutherford (the Lord Rutherford of Nelson) attended school here before studying at Canterbury College. His research into the nuclear structure of the atom resulted in a Nobel Prize and he is known as the father of nuclear physics. Another alumnus of Havelock School was Sir William Pickering, who became a senior NASA luminary and head of the Jet Propulsion Laboratory. Yet another was Harry Orsman, who over 40 years compiled the *Oxford Dictionary of New Zealand English*.

Contemplation of physics, space flight and lexicography requires sustenance and a must-visit is The Mussel Pot café on the main street. There's nothing more divine than sitting in the sun-drenched courtyard with a bowl of fresh mussels and a glass of wine from an award-winning local vineyard.

Previous The magnificent view up the Matukituki Valley near Lake Wanaka with the iconic Mt Aspiring just visible top left. Ian Brodie

Below The delectable flavour of freshly grilled mussels cooked in white wine and smothered with blue cheese followed by a lemon and honey posset dessert make The Mussel Pot a must visit! Ian Brodie

Opposite Brightly coloured buildings adorned with flowers and murals in the main street of Havelock. Ian Brodie

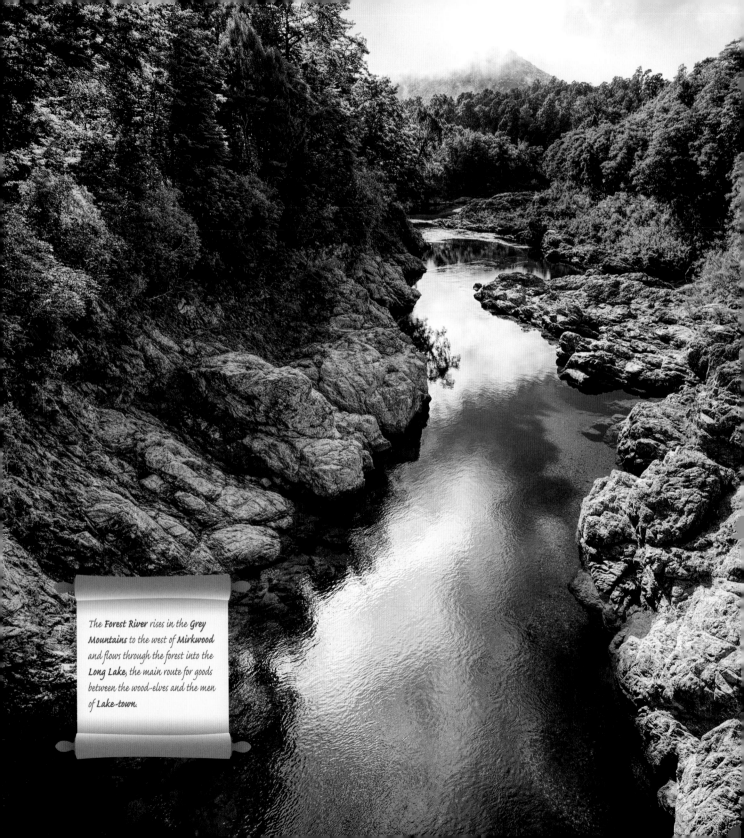

The **Forest River** rises in the **Grey Mountains** to the west of **Mirkwood** and flows through the forest into the **Long Lake**, the main route for goods between the wood-elves and the men of **Lake-town**.

Pelorus Bridge

The short drive from Havelock to Pelorus Bridge follows the Pelorus River via the picturesque village of Canvastown. As you approach the bridge, the road dives into one of the last river-flat forests in Marlborough and you are surrounded by towering beech, rimu and kahikatea. Just before the bridge is a large car park on your right, where you should start your exploration.

This location was where 13 dwarves and one bedraggled hobbit were washed ashore after their capture by *King Thranduil* and subsequent escape down the *Forest River*. With the crystal-clear water of the Pelorus River contrasting perfectly with the dark-green trees, you could indeed be on the edge of *Mirkwood Forest*.

Known by Maori as Te Hoiere, the area was named in 1838 after the Royal Navy brig HMS *Pelorus*, and the first bridge was built in 1863.

There are two places to visit. Walk onto the bridge and look downriver to the beautiful view of the trees and water, before coming back and descending via the path beside the bridge on your left. It was here that we saw the orcs desperately trying to stop the dwarves during their wild barrel ride escape from the *Halls of King Thranduil*.

A sequence of the barrels floating down the *Forest River* came to a rapid conclusion when the weather took a turn for the worse. The crew hastily packed their equipment as the river rose to a dangerous level in the space of a few hours.

For those travelling with a tent, the Pelorus Bridge Campground gives you the opportunity to stay at the second location, used as the *Forest River*. It's a superb, intimate location with a family atmosphere, great facilities and a beautiful outlook. There is an adjacent café serving nice big cups of coffee and the most delicious homemade custard squares and venison pies.

The river where the dwarves were filmed being washed ashore and climbing out of their barrels flows past the campground. Preparations were made well in advance, with stunt crews planning how the actors could float down the river safely. Scaffolding was built to allow cast and crew easy access, especially important for the dwarves, with their prosthetics and bulky clothing.

Two large plastic pools situated above the site augmented the flow of the small waterfall and when action was called, floods of water were released.

There are a number of other walks around this area, in particular the 30-minute Totara Walk, as well as the 45-minute Circle Walk. Both are easy, flat treks, leading through ancient forest with glimpses of the river and worn river terraces, which provided a striking and accessible location.

If you wish to experience the area from the water, like the dwarves, Pelorus Eco Adventures offers a gentle ride on inflatable canoes past the waterfall and down the river itself, where these scenes were filmed.

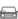
Nelson: 54 km
Motueka: 100 km

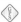
41° 17' 56.39'' S, 173° 34' 29.81'' E

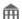
Pelorus Bridge Campground
www.doc.govt.nz

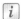
Pelorus Eco Adventures, 48 Main Rd, Havelock
www.kayak-newzealand.com/p/the-hobbit.html

Working in the café during filming, campground operators Steph and Craig were startled to be approached by an orc in full battle costume. He was lost, and asked for directions. According to Craig, it was one of the most surreal moments of having *The Hobbit* cast and crew stay.

Our location shooting came to a pretty dramatic end because the police arrived and said they were about to issue a severe weather warning. I've never seen a crew pack up their gear so quickly. The very next day, everywhere where we were standing . . . was under floodwater. The rise of the river level was, like, twenty or thirty feet. **Peter Jackson**

Opposite The view from the Pelorus Bridge looking down onto the area that portrayed the battle between orcs and dwarves (see pages 22–23). Ian Brodie

Overleaf A group of happy smiling dwarves near the banks of the Pelorus River; they don't look too stressed after their ordeal! Warner Bros. Pictures

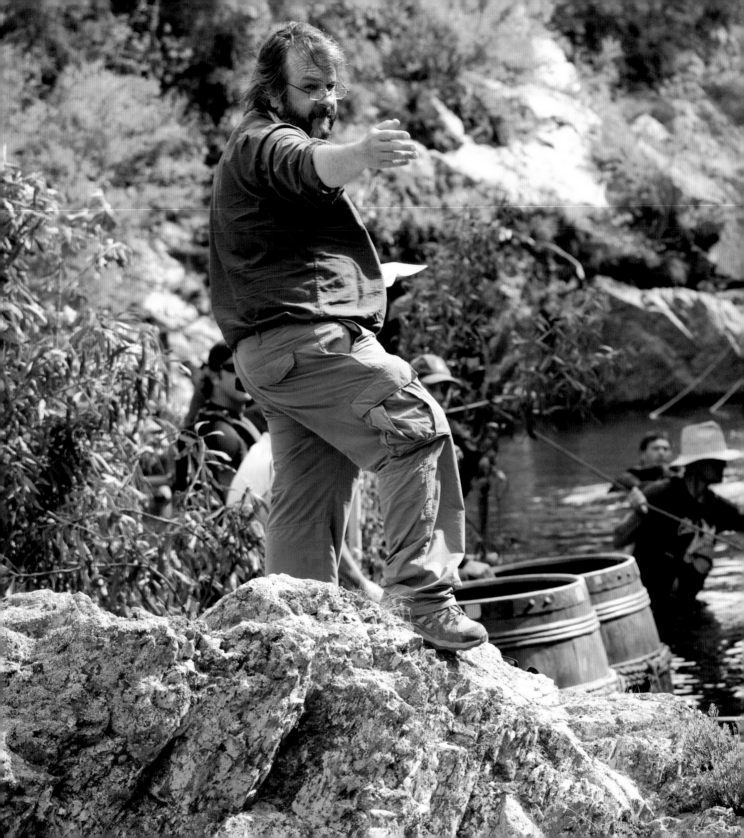

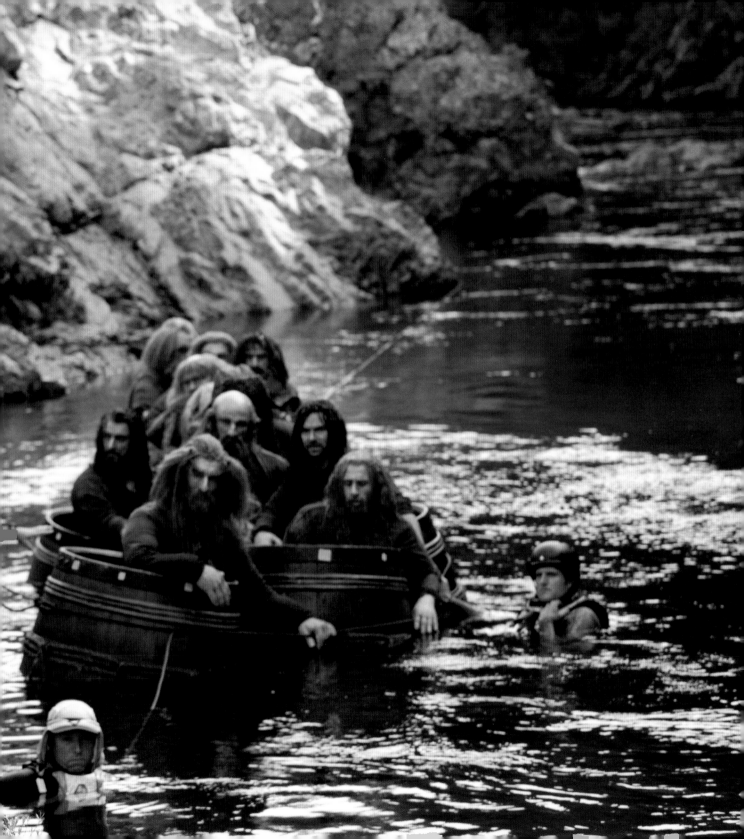

Introducing Nelson

With a mild Mediterranean climate, Nelson is known for beautiful beaches and bush-clad mountains and as a centre for crafts, food and winemaking. Home to three national parks, Nelson gets visitors all year round who come to tramp, walk, sail and taste. The cast enjoyed their time here, making the most of idyllic beaches and calm seas.

Nelson was first named Whakatu by Ra Kai Hau Tu, and in later years Matangi Awhio pa was established on the edge of the harbour. In the nineteenth century settlers created a slice of Victorian England, with fine old villas in streets named Hardy, Bronte, Haven and Wakefield. It was also the site of New Zealand's first official rugby game.

The national parks offer diverse landscapes. Abel Tasman National Park, with its golden sand beaches, is New Zealand's only coastal park. You can experience sea kayaking, sailing, cruising and walking the popular Coast Track. Nelson Lakes National Park is mountainous — it includes the northernmost peaks of the Southern Alps — with two gorgeous mountain lakes, and visitors can go on bush and alpine walks, horse treks and fishing trips. In winter, you can ski the Rainbow Valley, which provides ski touring and alpine climbing. Kahurangi National Park is the largest remaining area of natural land in the northwestern South Island.

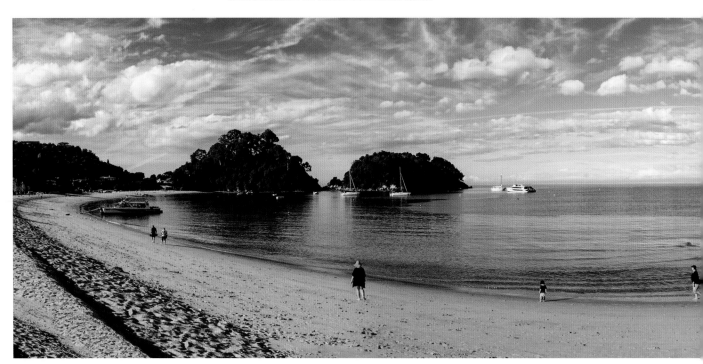

Nelson City

With over 300 artisans living and working in the region, *The Hobbit* prop department was spoilt for choice. Harrington Brewers in Richmond brewed a special beer for the cast, Hobbit Stout Lite, with an alcohol content of 1.1 per cent — with so many takes to perfect a shot, anything stronger could have had disastrous effects. The result is a fine-tasting ale, and over 20,000 litres were provided. The brewery is open to the public.

Each year the World of Wearable Art Extravaganza in Wellington showcases unique artworks centred on the proviso that finished designs must be original and able to be worn. The World of Wearable Art and Collectable Cars, close to Nelson Airport, features some of these innovative fashions, many designed by artists who worked on costumes for *The Hobbit*.

Jens Hansen The Ringmaker, tucked away on Trafalgar Square in central Nelson, has one design which now eclipses all others. After submitting a design for the *One Ring*, Jens made 40 rings, one almost 16 cm in diameter, with a similarly scaled gold chain. Sadly, he died before he saw his masterpiece on screen but his son Thorkild continues the family tradition. One of the original rings is displayed, and Thorkild will craft copies in both 9 ct and 18 ct gold.

 Nelson
www.nelsonnz.com

 Jens Hansen The Ringmaker
www.jenshansen.com

The beaches of Abel Tasman National Park are some of the most beautiful in the country. Here at Kaiteriteri Beach you can literally leap from your car straight onto the golden sands. Ian Brodie

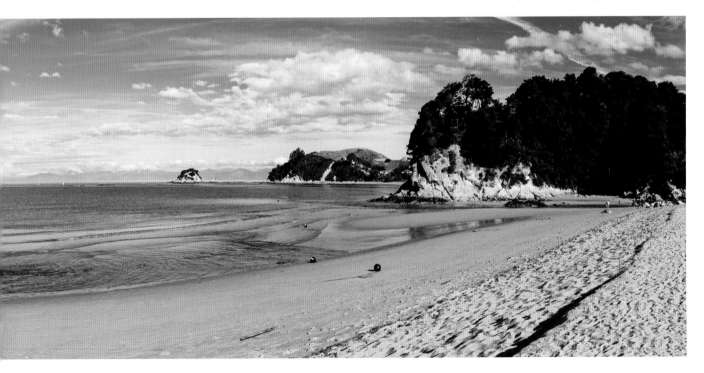

Mt Owen

Mt Owen in Kahurangi National Park appeared in *The Lord of the Rings: The Fellowship of the Ring* and was again filmed to depict the eastern exit from the *Mines of Moria*. A number of different areas around Mt Owen were filmed but these scenes were not included in the final films. Reid Helicopters Nelson operates tours to both here and Mt Olympus, which are highly recommended.

[i] www.helicoptersnelson.co.nz

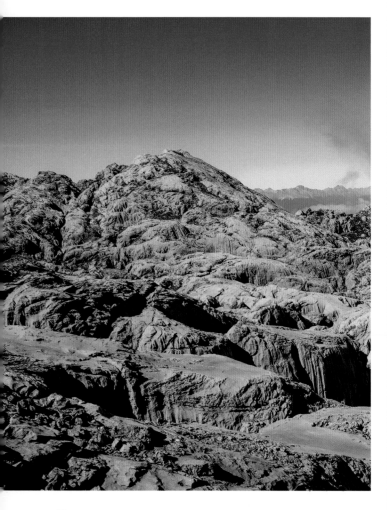

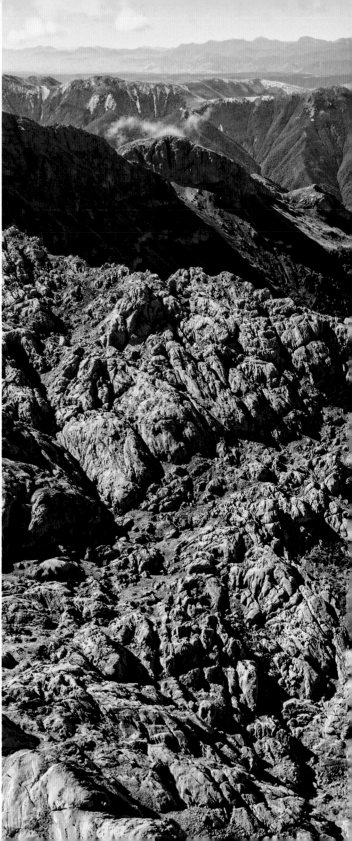

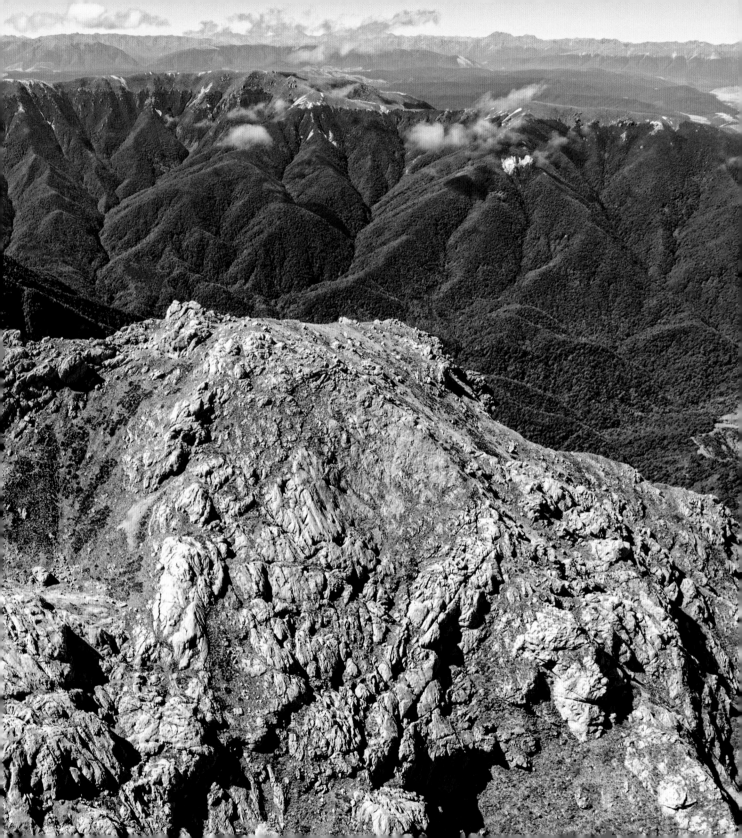

The Resurgence

Nelson: 47 km
Motueka: 18 km

Apple Shed Café, Shed 3, Mapua Wharf
www.appleshed.co.nz

Motueka Top 10 Holiday Park, 10 Fearon St,
Motueka
www.motuekatop10.co.nz

www.doc.govt.co.nz

www.motuekaisite.co.nz

The first place to stop on your drive towards Motueka is Höglund Art Glass, about 20 minutes from Nelson. Ola Höglund and Marie Simberg-Höglund's blown glass is exquisite and sought after by collectors around the world. The studio features a rainbow array of their work, also available for purchase, and you can see the artists at work.

Further on is the road to Mapua, a small town beside Tasman Bay, with wonderful sea views and delicious food. It's a popular holiday spot and over summer many holidaymakers descend to swim, fish, boat or relax. Small boutique shops sell local artisans' work and the Apple Shed Café, situated on the water, is perfect for refuelling.

Motueka, a pleasant country town in Tasman Bay, is an entrance to both Kahurangi National Park and Abel Tasman National Park. A vibrant artistic community makes the most of the blue skies and extraordinary light. In late summer the surrounding orchards are laden with fruit, and close by are the golden sands of Kaiteriteri Beach, one of New Zealand's best.

Departing towards Takaka, pass through Riwaka, the start of a *Middle-earth* experience encompassing

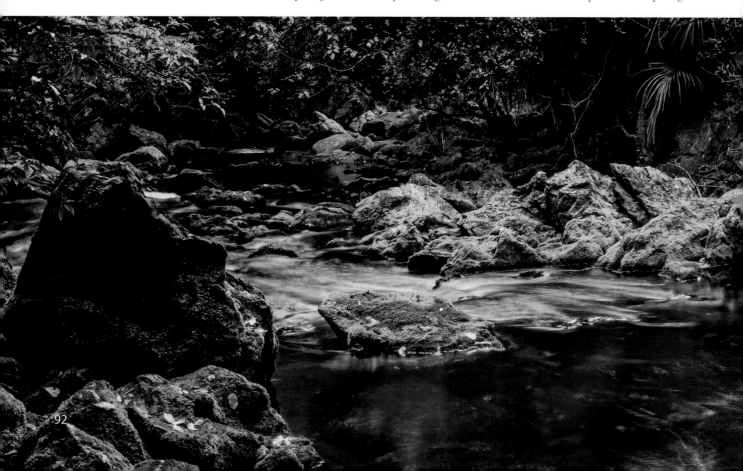

a number of locations and diverse scenery. A short distance away, on a no-exit country side-road, are the crystal-clear waters of what is known as The Resurgence. Although not a *Middle-earth* location, it is one of the most beautiful places in the country.

Over millions of years, water dripping through the marble of Takaka Hill disappeared underground, emerging as a spring in a mossy dell. The spring feeds a bubbling stream of pure clear water, which becomes the Riwaka River, flowing through bush to the sea.

Follow the river as you drive up the valley to the car park at the end of the road. The picnic area is an ideal place for eating alfresco — especially apples from a local orchard. From here it's only 15 minutes' walk to The Resurgence. Te Atiawa and Ngati Rarua visit regularly to cleanse themselves and be close to their ancestors.

The first part of the walk through native bush finishes at the Crystal Pool, where turquoise water bubbles over moss-covered rocks. If tempted to swim, be warned — the water is freezing! The track climbs well-worn steps and as you enter the bush, the spring appears, with deceptively deep water. Be careful, as the steps can be very slippery.

 After passing through Riwaka, watch for Riwaka Valley Rd on your left after 4.5 km — the car park is at the end of this road.

 The Resurgence Luxury Eco Lodge, 574 Riwaka Valley Rd www.resurgence.co.nz

 Höglund Art Glass, 52 Lansdowne Rd, Appleby www.hoglundartglass.com

Relax in absolute luxury at The Resurgence Luxury Eco Lodge, set on 50 acres with over 5 km of walking tracks (including The Resurgence), where the actors who played *Gandalf*, *Bilbo* and the dwarves stayed during filming.

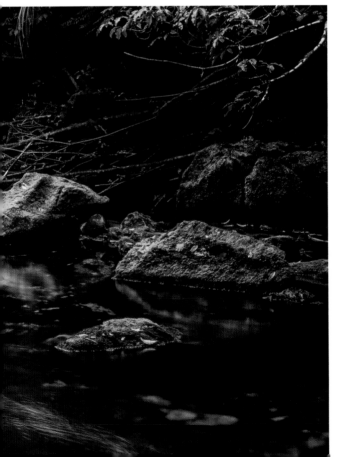

A green pool that Sméagol would love, at The Resurgence. Ian Brodie

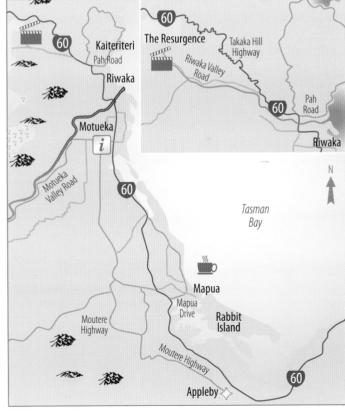

Canaan Downs

Ngarua Caves, Main Rd, Takaka Hills
www.ngaruacaves.co.nz

The road to Canaan Downs continues on SH60 after the detour to The Resurgence. The road is windy and can be narrow, so care is required. As you reach the summit of the Takaka Hill you enter another world with receding bush giving way to grass and stone. With parking available as you approach the summit, it's worth a stop — there's a great view across the sweeping arch of Tasman Bay to Nelson and the surrounding area.

Limestone karst and marble define this landscape. Karst landforms develop when water erodes soft rock, creating fissures in the limestone. Enclosed hollows can be formed too, some hundreds of metres in diameter. These geological features also appear in the North Island near Waitomo and Piopio, and this was used to advantage in *The Hobbit: An Unexpected Journey* as both locations became the outer reaches of the *Shire*.

To reach this location, turn right onto Canaan Road (no exit) at the top of Takaka Hill. As Canaan Road is gravel, take care. There's a camping ground on private land very close to the locations (8 km) and I suggest you travel to here. The karst outcrops are readily apparent on both sides of the road and before long you enter tracts of forest, where a scene from *The Hobbit: An Unexpected Journey* was filmed.

The narrow valley that the party rode through on their way towards Staddle Farm and the Trollshaws is reached after a short walk from Canaan Road (refer map). Ian Brodie

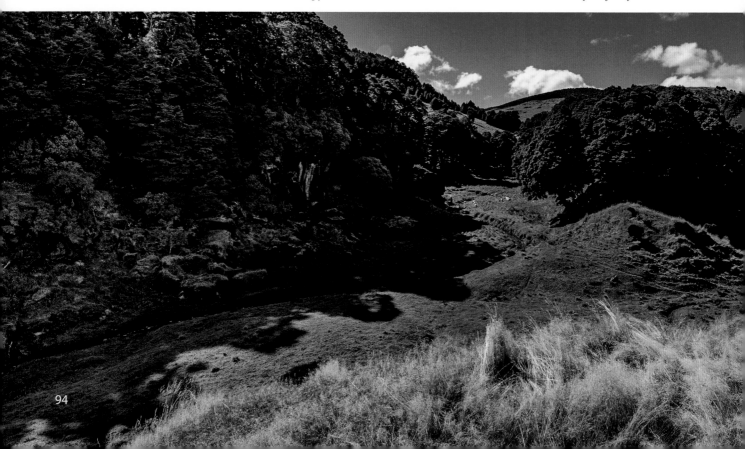

As the *Company* leave the rolling hills of the *Shire*, they enter an uplifted land which grows wilder and more rugged, as seen at Canaan Downs. As you drive into the camping grounds, the trees on the side of the road are where scenes were filmed showing the *Company* on horses (and a pony). The scene then cuts to Collingwood (see page 98) before returning to Canaan Downs and the next location.

Gandalf leads the party through a narrow valley with large limestone karst rocks looming overhead as they approach the *Trollshaws*. Although this scene was filmed in the North Island, at Denize Bluffs, its geographical similarity is readily apparent.

Park just after the first cattle stop and walk — the track is signposted — and please make a donation in the box at the start. Keep to the track, as there are dangerous sinkholes in the area.

After following the (usually) dry streambed you approach bluffs on your left. As you round the corner, you'll see the exact location. On a hot summer's day the bluffs provide a nice shady picnic spot. In the perfect remoteness you almost expect to see dwarves or a wizard trudging towards the comfort of a warm fire and comfy bed.

Filming was also undertaken in a number of other places where the tussock seems to lap up to the edge of the trees like a form of golden sea. In *The Hobbit: An Unexpected Journey* we see the party riding through the beech forest as they approach the *Trollshaws*. In *The Hobbit: The Desolation of Smaug* the same area of trees was used as the party ran to the relative safety of *Beorn's house*.

The best way to appreciate this area of karst stone, native bush and tussock is to camp in the area at the Canaan Downs Collective camping ground. For a small donation you can pitch a tent and take in the solace that can be enjoyed when you have no need to rush, or indeed any pressure other than what/when dinner should be enjoyed. Take the time to take a quiet ramble through the various locations and have your camera ready as the sun descends towards the west, illuminating the tussock and sending long shafts of light through the trees.

Despite all the planning, when all the horses arrived in the South Island for a sequence involving the dwarves travelling into the *Lone-lands*, all the saddles had been left in the North Island. Given we only had riding dwarf doubles who weren't necessarily 'actors', we made up an entire scene of the dwarves dismounting and setting up camp because we couldn't do anything else! Andy Serkis

The Canaan Downs Collective maintains and makes accessible this unique land for cultural and community events as well as providing a magical visitor experience for all. The Collective embodies ecological mindfulness in its role as guardians of this iconic site.

For further information visit
www.canaandowns.org

Visitors are welcome; all donations go towards maintaining the land; overnight camping by permission. Email info@canaandowns.org

Above and overleaf It was down this hillock that the orcs were seen pursuing the party as they sprinted towards the relative safety of Beorn's house. Ian Brodie (above)/Warner Bros. Pictures (overleaf)

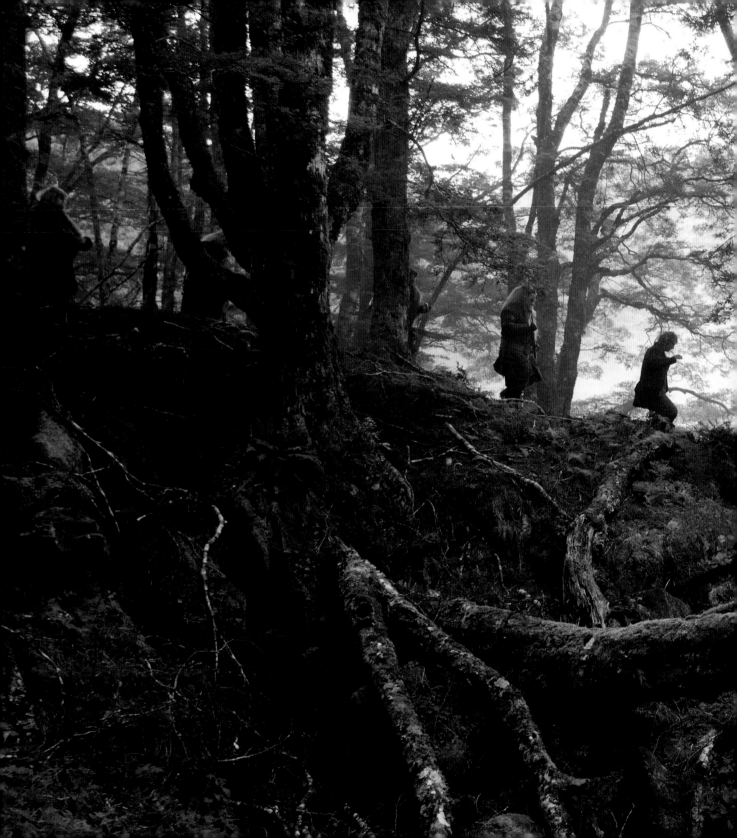

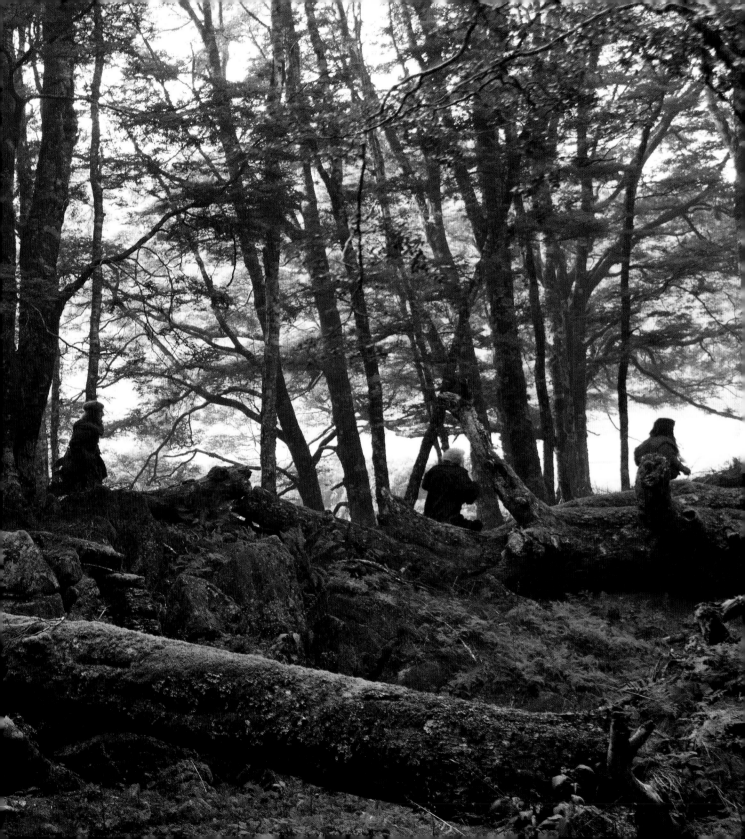

Introducing Collingwood

Descending the Takaka Hill and driving towards Collingwood is an unexpected journey of geographical differences. There are so many wonderful and varied landscapes that at least two days are recommended in the area, using Collingwood as a base, to explore them all.

Gold created the town, named after Admiral Cuthbert Collingwood, Lord Nelson's second in command at the Battle of Trafalgar. The excitement of the goldrush, coupled with rapid population growth in the 1850s, led to enthusiastic suggestions of it becoming New Zealand's capital. When the gold rush moved south, so did all the enthusiasm, and now this small seaside town basks in the gold of tourism and the reflection of the golden sand beaches on its doorstep. One of its most famous inhabitants was Frederick Tyree, and an exhibition of his amazing photographs of early settlement housed in the small museum in the main street should not be missed.

However, this region is much more than beaches. Rocky windswept escarpments frown over ancient kanuka trees, hunkering down against the westerly winds, contrasting with quiet estuaries, shelter and feeding grounds for diverse sea birds.

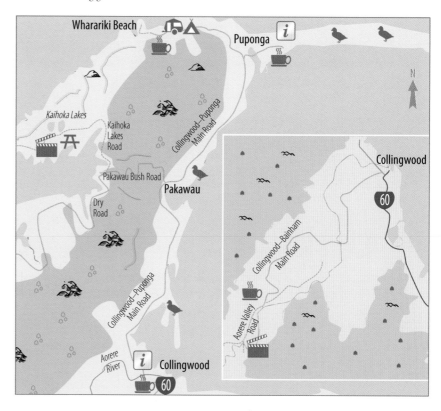

The region provides a number of organised activities, including a safari to the northernmost tip of the South Island at Farewell Spit, or a gentle horse ride across the sandhills of Wharariki Beach.

As well as visiting the location, it's well worth continuing along to the entrance to Farewell Spit, at Puponga. At full tide the road appears to be a narrow sliver just inches above the water and the view across the sea to the sand of Farewell Spit is another photographic moment.

Here a café serves homemade pies, and combined with coffee and a slice of chocolate cake, will provide you with the fortitude for your next journey.

Wharariki Beach is described as one of the most beautiful in New Zealand, justified if you like your beaches wild, studded with arched islands and with lots of fine white sand. Proceed to the car park (signposted from Puponga) and put on some walking shoes. In season a caravan coffee shop is situated under the trees. Remember that — it will be your friend when you return.

The 20-minute walk winds around undulating hills and through patches of shady bush before plunging towards the sea. Here the track turns from gravel to sand and as you climb over the last ridge you will be rewarded with a perfect crescent beach with the striking Archway Islands just off shore. Take your time and walk along the sand to see the arches, drink in the view, rest your legs and enjoy the unspoilt beauty.

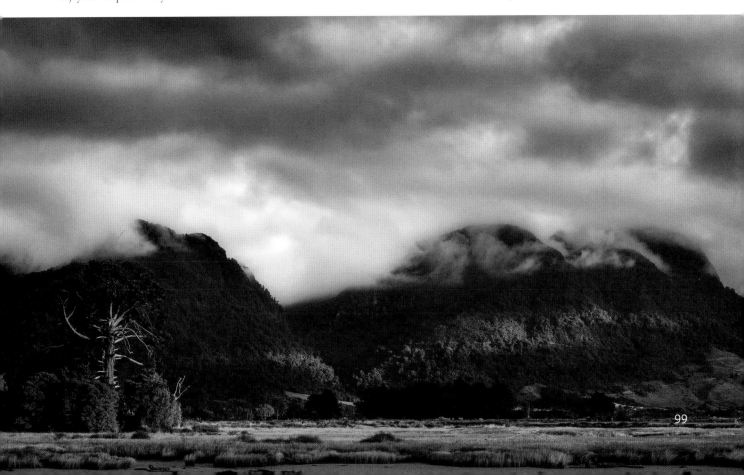

A land of diversity: salt marshes, English trees, native New Zealand bush and high peaks — all seen from the outskirts of Collingwood. Ian Brodie

Kaihoka Lakes

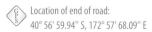Location of end of road:
40° 56' 59.94" S, 172° 57' 68.09" E

As the party leave the peaceful *Shire* and travel through an increasingly wild land, *Bilbo* is also heading towards his first adventure, the meeting with the trolls in the *Trollshaws*. The main location for this scene was filmed at Piopio (see page 71) but there is also a glimpse of a wild and rocky land as the party descend around a rocky outcrop. This small but important scene was filmed near Kaihoka Lakes and while the location appeared in the movie for only three seconds, a trip to the location and surrounding area is worthy of a day trip and highly recommended.

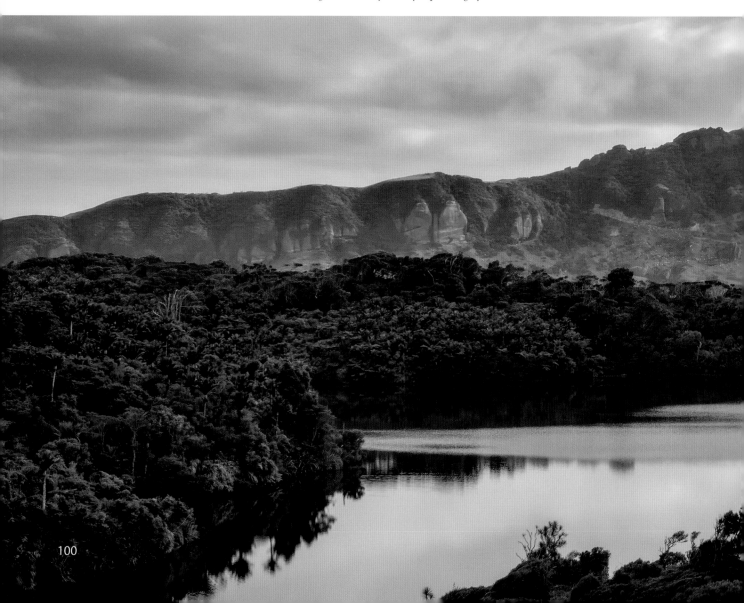

Depart Collingwood towards Farewell Spit and at Pakawau turn left onto Pakawau Bush Road. After 5.2 km turn right into Kaihoka Lakes Road. Despite the proximity of this valley to the sea, the mountains and rocky outcrops keep it hidden from view. Millennia of wind and rain have removed the soft outer layers, and the amazing shapes of the peaks are an absolute photographic gem. The actual location used in the film is not accessible, but the journey to the end of the road at a locked farm gate is well worth it.

In the foreground lie the Kaihoka Lakes while against the craggy background peaks the party were briefly seen leaving the Shire.
Ian Brodie

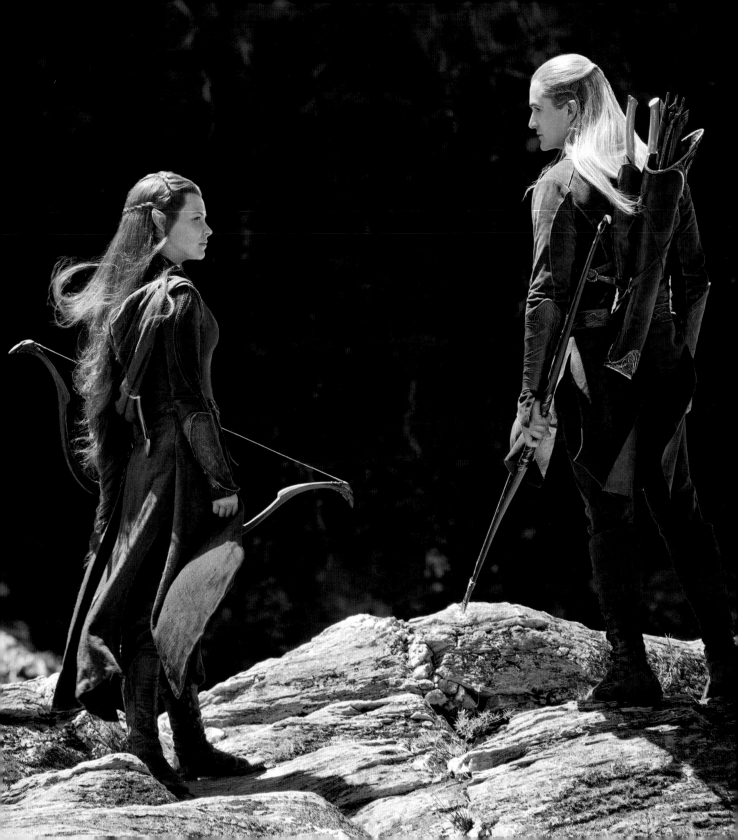

Aorere River and Salisbury Falls

The diverse landscapes of *Middle-earth* so vividly described by JRR Tolkien seem somewhat fantastical, but in New Zealand they are brought to life. This is apparent in all *The Hobbit* films and it is a credit to the director and his team that, despite the challenges of remote locations and lack of facilities, the cast appear to be transported to the extraordinary places Tolkien imagined. One of these is Salisbury Falls. To reach the location follow the road (Collingwood–Bainham Main Road) marked Heaphy Track off the main Takaka to Collingwood highway (refer map page 98) and follow this for 18 km. Don't worry about second breakfast on this somewhat remote road, because there is an absolute treasure waiting just before you reach the falls. The historic Langford Store has been standing for over 80 years and harks back in time to more gentler and quieter days. Inside the tiny store rich treasures clutter the shelves and climb the walls. A stop for coffee here is a must and in celebration of times past, buy a postcard, write a real letter and use the local post box to send a special gift to a friend.

The road to Salisbury Falls is marked just past the store (Aorere Valley Road) and is reached after a further 5 km. As you cross the bridge, the view below is as spectacular as it is surprising. Carved through the rural landscape is an unexpected river, surrounded by granite guardians directing the water through the narrow channel.

The walk to the falls is approximately five minutes on a well-formed track. Despite the distance between Aratiatia in the North Island and Pelorus and Salisbury Falls in the South, the geographical formations are strikingly similar. This allowed the film-makers to seamlessly meld together the *River Running* from the *Elvenking's Gate* through to the *Long Lake*.

Location of Salisbury Falls car park:
40° 80' 23.31" S, 172° 53' 24.49" E

The Langford Store,
1810 Collingwood–Bainham Main Rd
www.langfordstore.co.nz

We shot my scene and we were working in a canyon; there was a river at the bottom which was just extraordinary. Luke Evans

They found this beautiful river that had a lot of brown and gold and orange sediment that made it look other-worldly.
Evangeline Lilly

Opposite Tauriel and Legolas stand in the sun with a backdrop of the rocky sides of the Aorere River. Warner Bros. Pictures

Below Another view of the same rocks as seen on the opposite page. The hilly background here was removed and replaced with a distant view of Lake-town. Ian Brodie

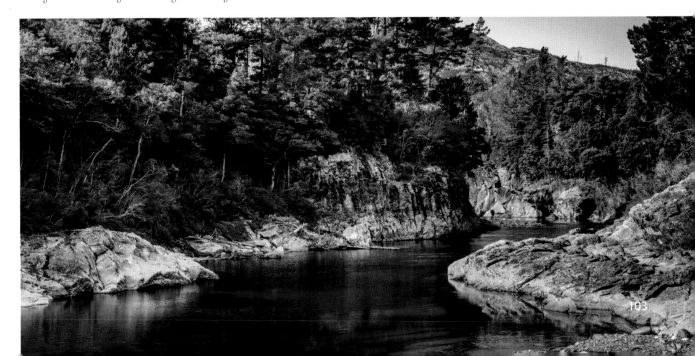

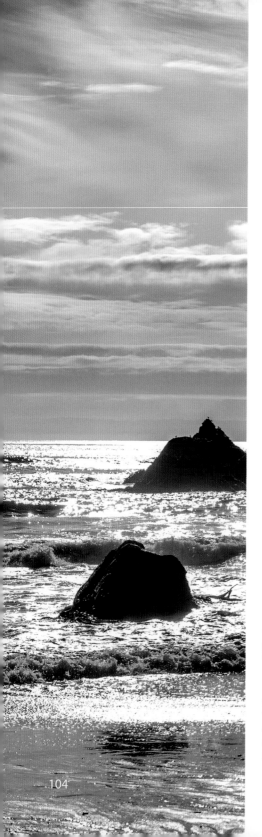

Punakaiki

The West Coast of the South Island is a special place, with spectacular scenery. The mighty peaks of the Southern Alps fall steeply to the wild Tasman Sea and in between is glorious rainforest, like something out of *Jurassic Park*. To fully appreciate the area, enter via the Buller Gorge in the north, travel the length of the coast and exit through the Haast Pass (or vice versa).

A location used in *The Hobbit: The Desolation of Smaug* lies near a unique geological formation — the Pancake Rocks, at Punakaiki. These were formed 30 million years ago from minute fragments of dead marine creatures and plants, which formed layers on the seabed about 2 km down. Immense water pressure solidified the fragments into hard and soft layers — but why remains a mystery. Seismic action lifted the limestone above the seabed, where rain, wind and seawater sculpted the intriguing shapes. The round trip from the visitor centre is a very easy 15 minutes, and time your visit for high tide to see the waves surging through the blow holes.

The Paparoa Ranges, backdrop to Punakaiki, were used in the exhilarating barrel sequence as the party escaped *King Thranduil*. The water sequences were filmed at Pelorus Bridge and Salisbury Falls, but it was decided higher peaks were needed as a vertical counterpoint.

Glacier Southern Lakes Helicopters pilot Alfie Speight spent a week flying through a number of the river valleys, capturing the dramatic cliffs on film, which were seamlessly joined into the main action. There are a number of viewpoints to see these cliffs from Punakaiki. If you are used to driving on narrow unformed roads, Bullock Creek Track will take you through beautiful unspoilt bush with glimpses of the cliffs. The 12 km-long road has a turning point at the end and is closed in wet weather. Alternatively, the Pororari Track follows a spectacular limestone gorge, with huge rocks in deep river pools, and beautiful forest. A gentle 15-minute stroll from the car park brings you to a seat and a lookout, with spectacular views of the river gorge.

 Punakaiki Tavern, Punakaiki
www.punakaikitavern.co.nz

 Hydrangea Cottages, Punakaiki
www.pancake-rocks.co.nz

 Paparoa National Park i-SITE
www.punakaiki.co.nz

Left and right The wild Tasman Sea as seen from Meybille Bay, one of the gorgeous beaches close to Punakaiki. Ian Brodie

Overleaf Like stacked pancakes, the aptly named Pancake Rocks are an easy walk from the visitor centre. If you make your visit close to sunset combined with an incoming high tide, you will be rewarded with visions of the Tasman Sea surging in between the rocks and creating the most awesome water spouts. Ian Brodie

Overleaf inset The Paparoa Ranges appear in the scene where the orcs are hunted down after the dwarves escape the Halls of King Thranduil. Warner Bros. Pictures

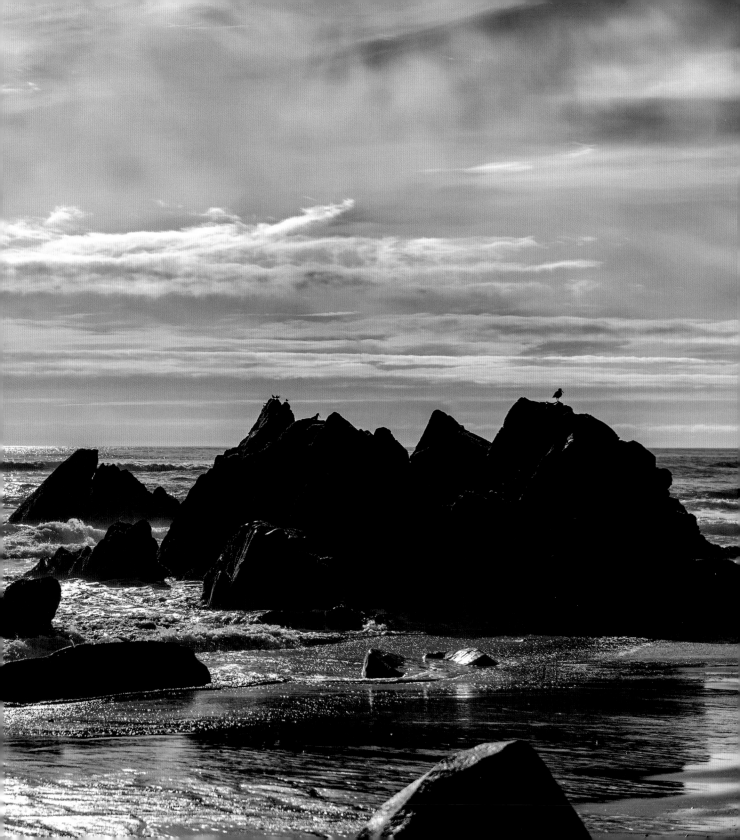

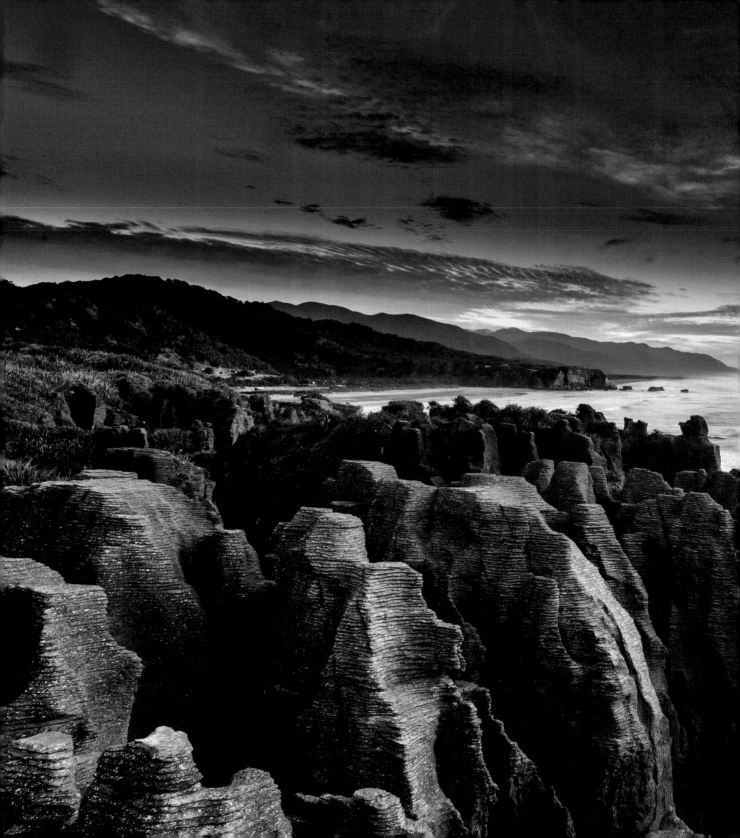

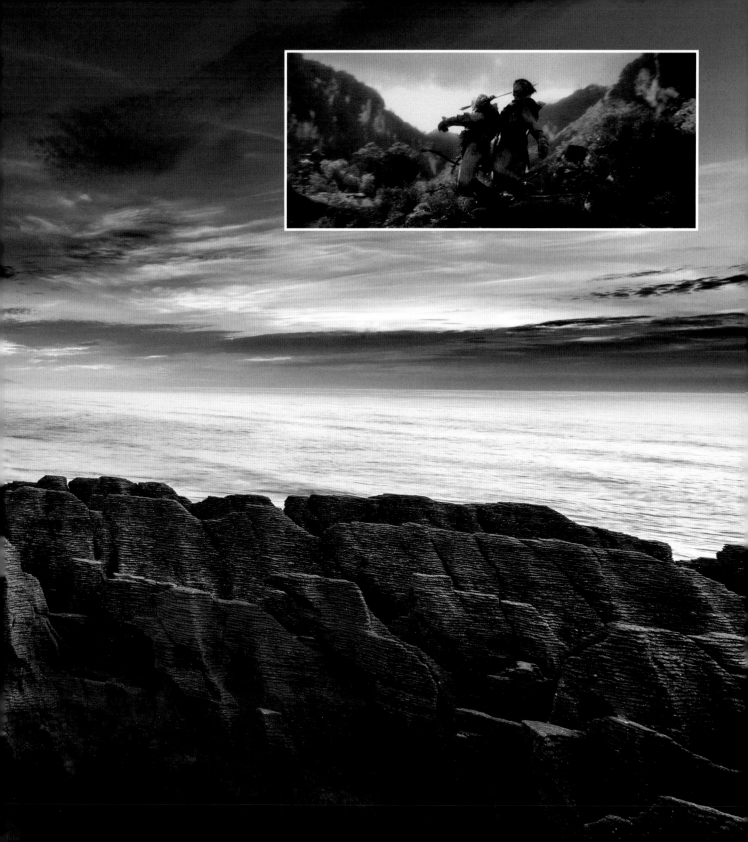

Introducing Wanaka

Lake Wanaka and the surrounding area is a popular holiday destination. The lake itself was formed over 10,000 years ago when glacial ice receded to form a U-shaped valley, pushing the encircling mountains higher and creating the lake. At the same time another glacier was carving a valley just 8 km away, forming the equally spectacular Lake Hawea.

The area features the country's only continental climate, with true seasonal variances. During the summer, holidaymakers come to walk, boat, swim and at the same time sample the excellent Pinot Noir from grapes grown on the rocky hillsides. Autumn glows with gold, while in winter clear sparkling frosty days welcome skiers and snowboarders to the two ski fields. In spring, bright shades of green appear as the trees welcome warmth and snow moves higher up the slopes — truly a place to visit in all seasons.

A popular vantage point of the surrounding area is Mt Iron, situated on the edge of town. The 4.5 km (1.5-hour) walking track starts from a car park (or you can walk from town) on the main road. Rising 250 metres above the valley floor, Mt Iron is a small piece of moraine left behind as the glaciers receded, and could not have been more perfectly placed. The 360-degree views from the summit are astounding, as Lake Wanaka recedes into the distance with a backdrop of the mighty Southern Alps.

Activities here are as relaxing or as adrenaline pumping as you wish. With the diversity of restaurants by the lakefront, choose one with a view of the lake for a long, lazy lunch. If you feel the need to exercise, there are over 750 km of walking tracks in the area (details at the local i-SITE).

Mountain-bike tracks abound around the lake, or if you want to get lost (in the nicest possible way) spend an afternoon in the Great Maze at Stuart Landsborough's Puzzling World.

The swift azure-blue Clutha River flows from Lake Wanaka, and a jet-boat ride across the lake and down the river is a great way to take in the landscape. If you prefer more traditional transportation, cruise the lake by yacht, or for more adrenaline try parasailing across the lake at height and speed!

At nearby Lake Hawea the mountains are a little sharper, with a number of places for a picnic — a favourite is Timaru Creek on the eastern side of the lake. It's set in a small stand of native bush and there's great fly-fishing for salmon or trout.

A wonderful way to end the day is to enjoy dinner and a sunset at the Lake Hawea Hotel, with panoramic views.

 Queenstown: 68 km

 Relishes Café, 1/99 Ardmore St, Wanaka
www.relishescafe.co.nz

 Rippon Vineyard, 246 Mt Aspiring Rd, Wanaka
www.rippon.co.nz

 Lake Hawea Hotel, Lake Hawea
www.lakehawea.co.nz

 Alpine Resort Wanaka, 144 Anderson Rd, Wanaka
www.alpineresortwanaka.com

 Lake Wanaka i-SITE, 103 Ardmore St, Wanaka
www.lakewanaka.co.nz

 Mt Iron
www.doc.govt.nz

 Mountain bike hire:
Racers Edge, 9 Ardmore St, Wanaka

 Jetboating:
Clutha River Jet, The Log Cabin, Wanaka Lakefront

Opposite Autumn with its glorious shades of gold as seen on the road from Lake Wanaka towards Treble Cone ski field. Ian Brodie

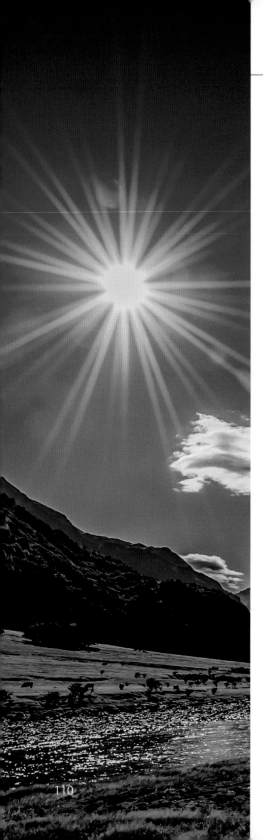

The Matukituki Valley

An hour's drive west from Lake Wanaka, the Matukituki Valley Road crosses river flats until you're literally encircled by the Southern Alps. The road is initially sealed before becoming gravel, with a couple of fords to cross — these are normally not difficult but be aware, as river levels can change dramatically in heavy rain. At the end of the road is a parking area, from where you can try a number of alpine tramps, including the peak of Mt Aspiring, at 3033 metres the highest outside of the Aoraki/Mt Cook region. With no food available on this day trip, I suggest you purchase ingredients for a picnic before you start.

The first stop is Glendhu Bay, a sheltered cove where Lake Wanaka washes onto a sandy shore. The local camping ground is a popular place to stay in summer. Look across the lake to Mt Aspiring and see immediately why it's called 'The Matterhorn of the South'.

As you leave Lake Wanaka and drive around steep buttresses, the Treble Cone ski field appears directly in front, with a dramatic flourish. The top of this peak appears in *The Hobbit: An Unexpected Journey*.

Not far past the turn-off to the ski field the road becomes gravel, as the dramatic scenery just gets better and bigger.

With the glacier-fed Matukituki to your right and snow-capped peaks on your left, there are views of another location filmed for *The Hobbit: The Desolation of Smaug*. In these valleys, the *Company* were filmed leaving the higher dells of the *Misty Mountains* en route to *Mirkwood*.

You are now in Te Wahipounamu (The Place of Greenstone), South West New Zealand World Heritage Area, covering 2.6 million hectares and an area of world significance. Please only ever leave your footprints and respect the area.

As the road branches left towards the head of the valley, you arrive at the Raspberry Creek car park. Many of the tracks here are for experienced mountaineers but for those with average fitness, try the Rob Roy Glacier track. Covering 10 km (return) and taking three to four hours, this follows the river before climbing through a small gorge and entering ancient beech forest. The track climbs (a gradual ascent) above the forest floor onto alpine vegetation, with spectacular views to the glacier.

In this quiet, remote spot, take time to sit and listen. You might hear the ice tumbling off the glacier, or the distinctive sound of a kea, the New Zealand native parrot. This cheeky bird is reputed to be the world's cleverest, as will become apparent as it attempts to share your lunch or steal anything shiny.

 44° 30' 41.23" S, 168° 44' 47.81" E

 www.doc.govt.co.nz

The end of the road up the Matukituki Valley provides the perfect place for a picnic spread on the tussock beside the west branch of the Matukituki River. Ian Brodie

110

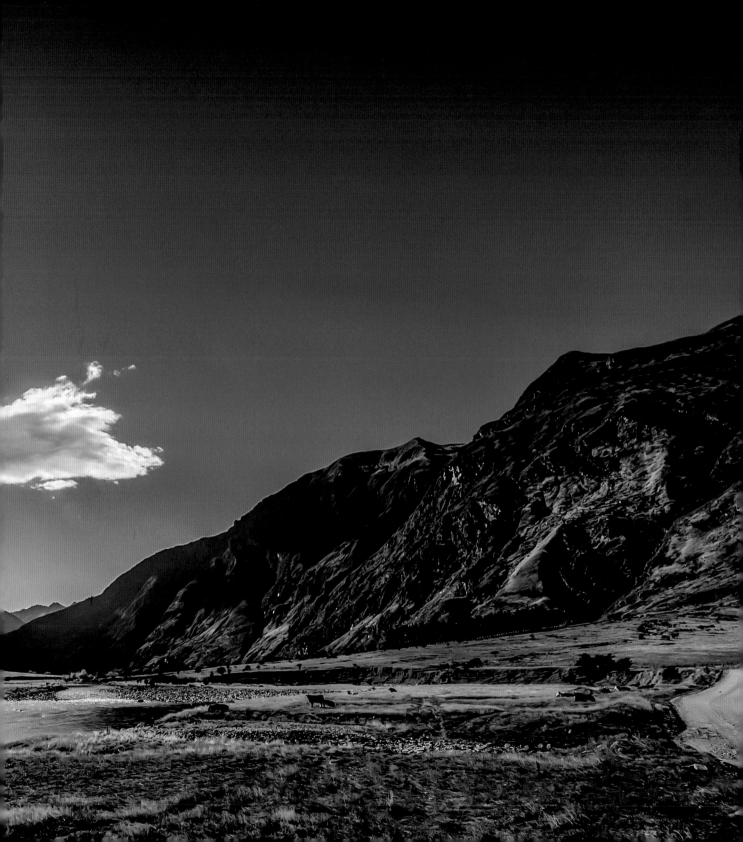

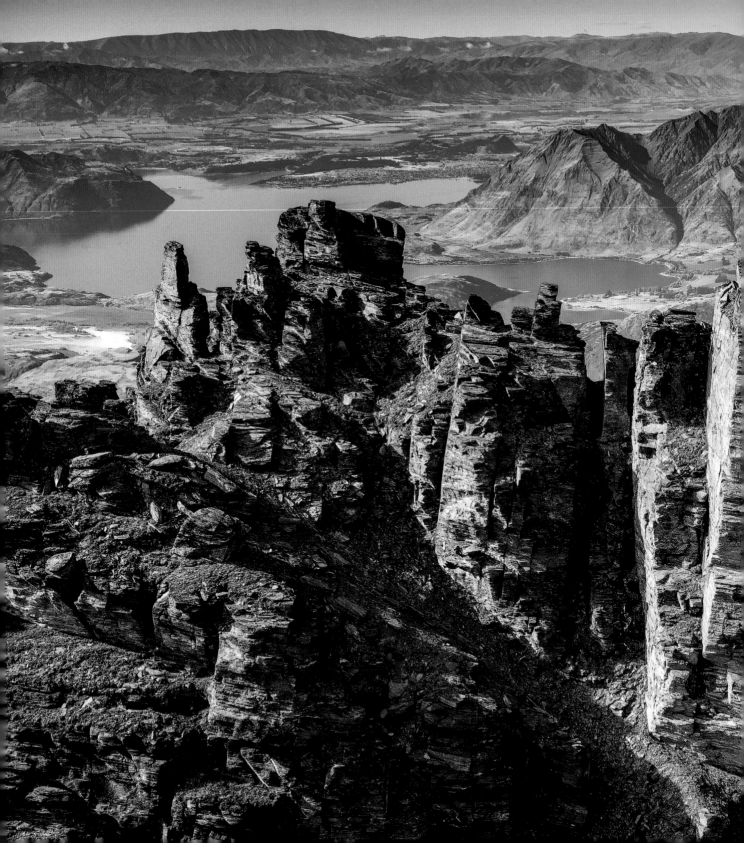

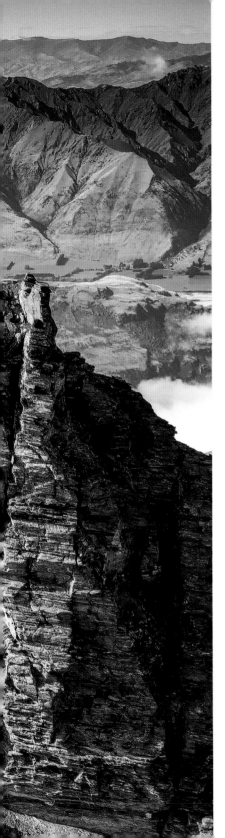

Treble Cone

The northern-facing slopes of Treble Cone ski field are nirvana to powder hounds during the winter months, when visitors ascend the slopes to enjoy the largest skiable area and longest verticals available in the Southern Lakes. No wonder Olympic ski teams from around the world come here to practise before international competitions.

This location was filmed during the summer of 2011 and depicts the *Company* trekking along a ridge crowned with high tors and precipitous drops as they make their way towards the *Misty Mountains* pass.

The location is accessible in summer on a 4WD, heli-hike and walking adventure with Eco Tours Wanaka. To enjoy the view in winter you need to be a capable skier or snowboarder. But if snow sport is not your forte, there are also fantastic views from the base building, and it's still worth the drive up on a crisp winter's day to sit in the café with steaming mugs of coffee or hot chocolate and a freshly baked muffin.

i Treble Cone ski field
www.treblecone.com

i Eco Tours Wanaka
www.ecowanaka.co.nz/misty-mountain

The rocky tors on the top of Treble Cone provided the perfect backdrop as the party climbed ever higher towards the Misty Mountains. Ian Brodie

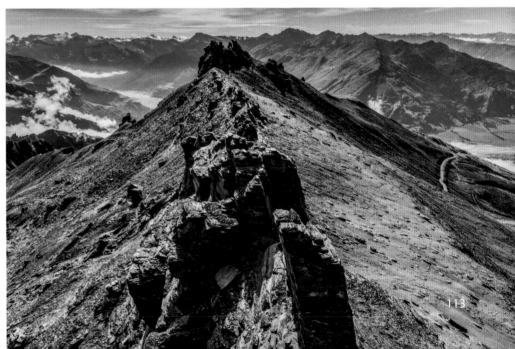

Introducing Queenstown

Wanaka: 68 km
Te Anau: 171 km

Gantleys Historic Restaurant
Arthurs Point Rd, Queenstown
www.gantleys.co.nz

Garden Court Suites & Apartments
Adelaide St, Queenstown
www.gardencourt.co.nz

Queenstown i-SITE, 22 Shotover St, Queenstown
www.queenstownnz.co.nz

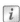
Nomad Safaris
www.nomadsafaris.co.nz

Nestled in a spectacular alpine valley alongside Lake Wakatipu, Queenstown is perhaps our most well-known tourist destination — yet still manages to live up to all the hype.

Maori legend tells of a tipua (demon) who seized a beautiful girl, but while the monster slept, she was rescued by her faithful lover, who then set fire to him. As flames licked his body the demon drew up his knees, but his body fat fanned the blaze. He writhed in agony, his death throes digging a huge chasm. Rain and snow eventually extinguished the fire and the demon was destroyed — except for his heart. Today the lake reveals his outline, while his beating heart causes it to rise and fall.

Cutting their way through thorny undergrowth, the first Europeans to settle were William Gilbert Rees and Nicholas von Tunzelmann. As they grazed their sheep in remote splendour at Lake Wakatipu, they had no idea their peaceful existence was about to change: William Fox discovered gold in the Arrow River, the population exploded and Queenstown became a major service centre.

Tourism is now the goldmine as national and international visitors descend on the 'Adventure

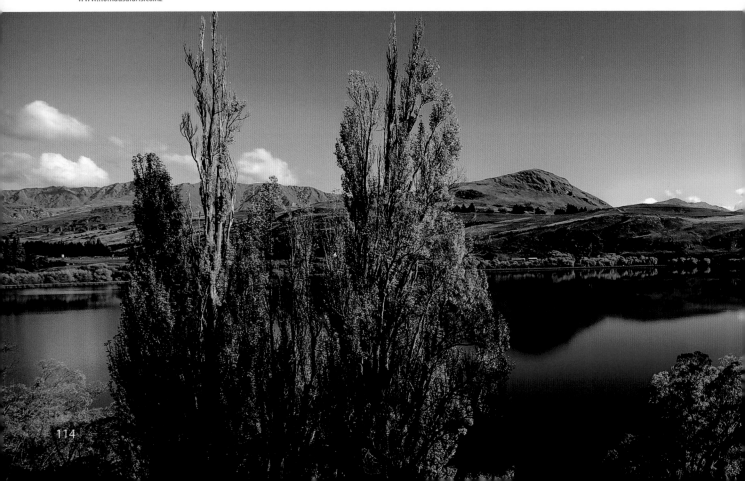

Capital' of New Zealand. Like those who came before them in *The Lord of the Rings*, the cast and crew fell in love with Queenstown, with the dwarves finding time to explore its nightclubs and hotels. With a permanent population of 11,000, Queenstown hosts over one million visitors each year. The main street, closed to traffic, is a mecca for those who like to sit in the sun and 'do coffee', while fish and chips on the lakefront is a must. It's impossible to list every tourist activity, but choices are diverse, with several reservation offices offering excellent advice for all age groups.

The 1912 steamer *Earnslaw* provided transportation from the railhead at Kingston. Just over 50 metres in length and with a beam of 7.3 metres, the stately craft operates a number of tourist excursions on Lake Wakatipu. A trip on the grand old lady of the lake is a highlight — even if you don't go aboard, watching her dock is quite an experience.

Queenstown-based Nomad Safaris offers a number of tours to many of the locations that feature both in *The Hobbit* and *The Lord of the Rings*. If you want a breathtaking view, Bob's Peak has one of the steepest cableways in the world, rising 446 metres over a distance of 731 metres.

Queenstown can be visited and enjoyed year round, with winter snow providing a white blanket to excite skiers, while summer temperatures reach over 30 degrees Celsius.

Below Lake Hayes, near Queenstown, on a typical Central Otago autumn day when the colours of blue and gold just scream serenity. Ian Brodie

Overleaf The view from the Humboldt Mountains looking towards Mt Earnslaw. In the green valley (centre distant) the house of Beorn was lovingly built by the craftsmen at 3 Foot 7. Ian Brodie

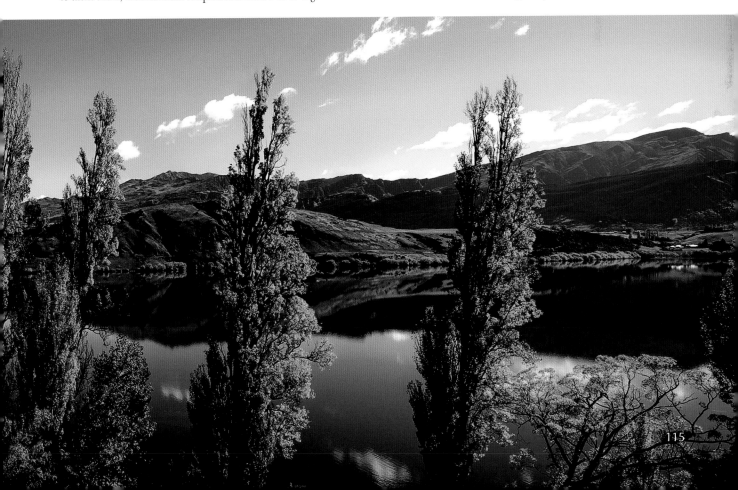

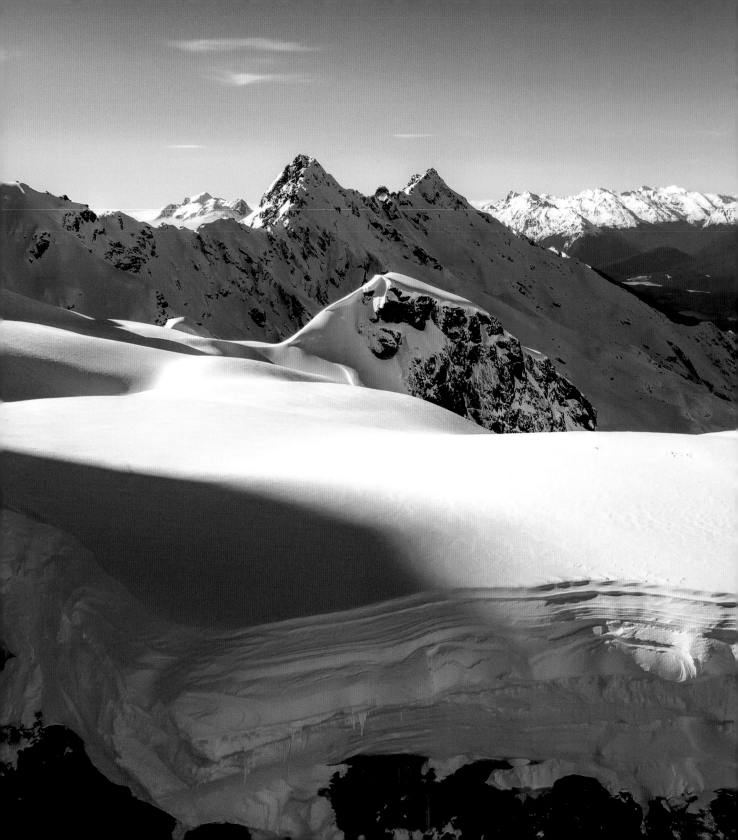

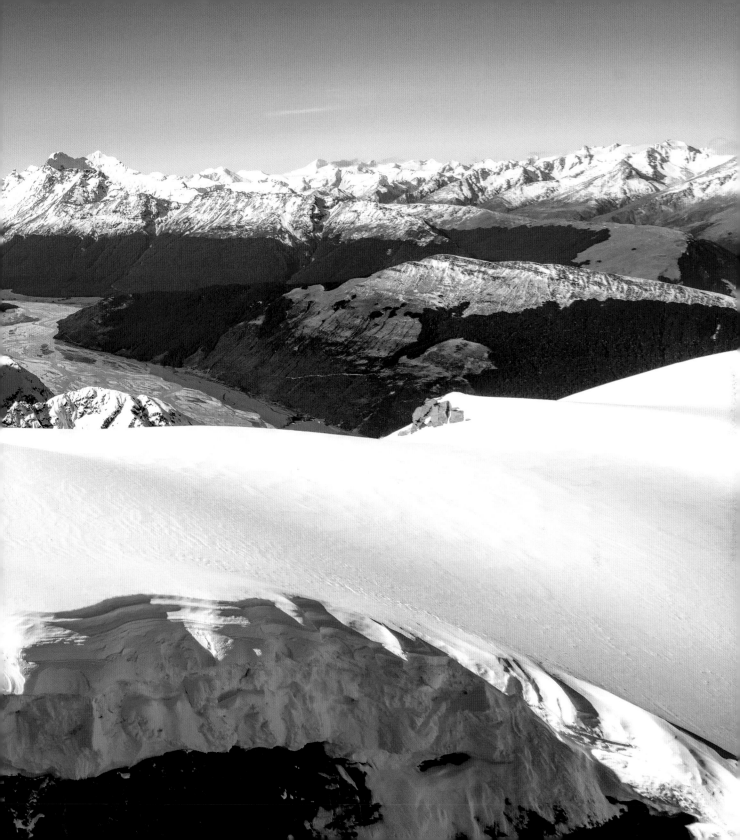

Glenorchy

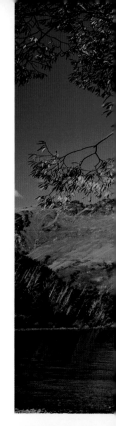
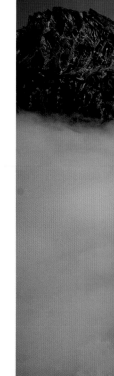

 Queenstown: 46 km

 Glenorchy Lake House
www.glenorchylakehouse.co.nz

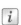 www.glenorchy-nz.com
www.queenstownnz.com
www.dartriver.co.nz
www.dartstables.com

> If somewhere is going to be called Paradise,
> it'd better deliver, and it did. It's beautiful.
> Martin Freeman

At the northern end of Lake Wakatipu, with a spectacular backdrop of the snow-capped *Misty Mountains*, nestles the little village of Glenorchy.

Although known to Maori, who travelled through here in their search for highly valued pounamu (jade or greenstone as it is known locally), settlers didn't arrive until 1862, when the broad river flats made ideal grazing. At the height of the Central Otago goldrush, 3000 gold miners arrived but left soon after, as local yields proved less than in other regions. In the 1890s tourism took advantage of the spectacular natural beauty of the region and a number of guesthouses catered for wealthy and adventurous European visitors travelling up the lake from Queenstown. In 1905 the discovery of scheelite (used in weapons-grade tungsten) began an extraction programme involving some 50 workers, until the 1980s. Today, with a regular population of around 200, Glenorchy has become a premier centre for eco-tourism.

Glenorchy is the gateway to Mt Aspiring National Park, which covers 355,543 hectares and is part of Te Wahipounamu (South West New Zealand World Heritage Area). Its DOC information centre provides up-to-date information on the many outstanding walks, including the Routeburn Track, and the Rees-Dart and Greenstone Caples tracks. Accommodation ranges from backpacker to luxury.

The location used to create the set for *Beorn's house* is on private property but there are still two options to visit the place with an organised tour. Both are equally attractive and also provide different forms of transport into the beautiful area aptly named Paradise.

The first is a jet-boat ride with Dart River Wilderness Jet. Operating daily from Glenorchy (with free transfers also available from Queenstown) this exciting jet-boat excursion will transport you from the Glenorchy wharf deep into the heart of Mt Aspiring National Park on the Dart River. On your river journey you will pause to view the location for *Beorn's house* before continuing further up the river surrounded by the landscape that became the backdrop for the land between the *Misty Mountains* and *Mirkwood*. The return journey by coach will also pause to view this location.

Dart Stables has been operating horse treks into Paradise for many years and provides the ultimate means of exploring this part of *Middle-earth*. It has a number of different treks available and its appropriately named 'The Ride of the Rings' is a great way to see a number of the locations including *Beorn's house*. The ride is walking paced and is suitable for beginner riders, and the ride of a lifetime for film location visitors.

Opposite above The road between Queenstown and Glenorchy must be one of the best drives in the world. Lake Wakatipu laps gently against stone beaches with the ever present Alps in the background. Ian Brodie

Opposite below An eagle's-eye view of Lake Wakatipu from overhead Glenorchy looking back towards Queenstown, a view the cast would have had as they travelled between locations. Ian Brodie

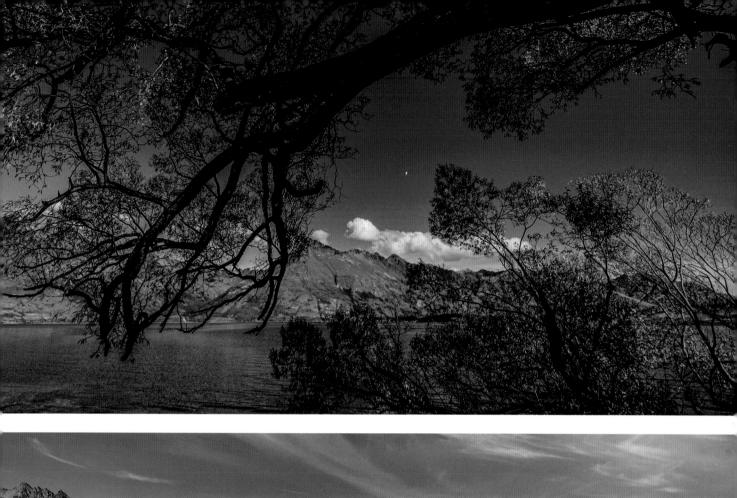
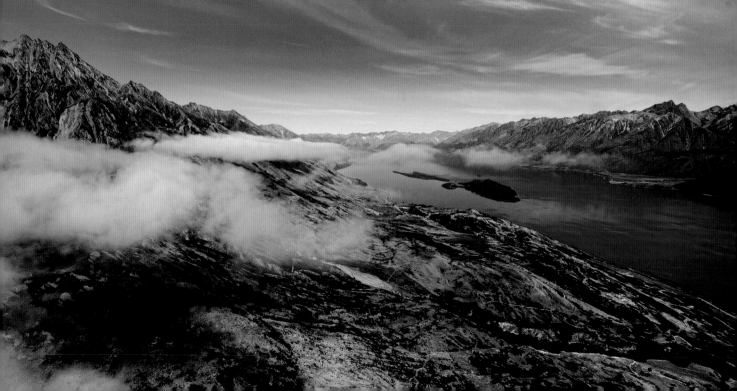

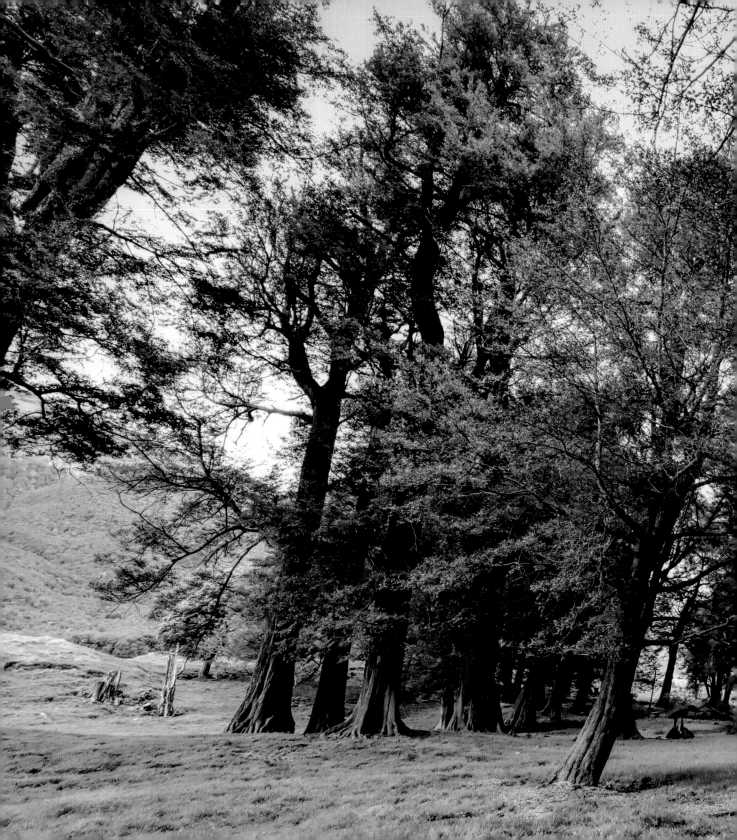

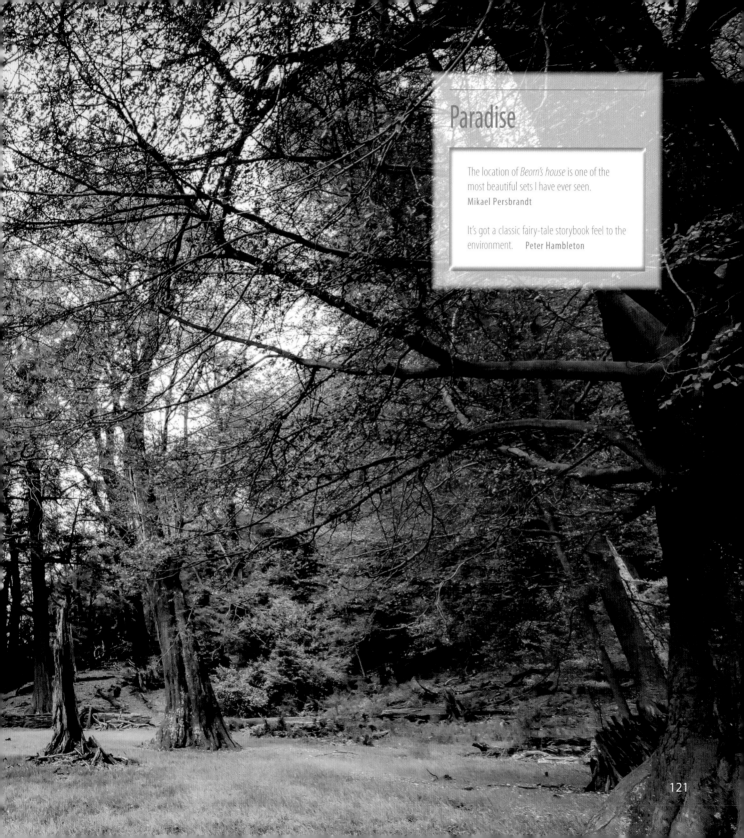

Paradise

The location of *Beorn's house* is one of the most beautiful sets I have ever seen.
Mikael Persbrandt

It's got a classic fairy-tale storybook feel to the environment. Peter Hambleton

Helicopter locations

Glacier Southern Lakes Helicopters
35 Lucas Pl, Queenstown
www.glaciersouthernlakes.co.nz

A screenshot still from the SpaceCam shows the party traversing the top of Treble Cone. Warner Bros. Pictures

The Hobbit featured many dramatic, sweeping views of New Zealand's breathtaking Southern Alps. Many of these places are inaccessible unless you happen to be an experienced mountain climber or tramper, but this doesn't mean you can't experience the same grandeur and awe-inspiring scenes.

Queenstown-based Glacier Southern Lakes Helicopters was one of the companies used to transport cast and crew as well as massive amounts of equipment.

Many mountain scenes were filmed from helicopter with the cast later added digitally by the

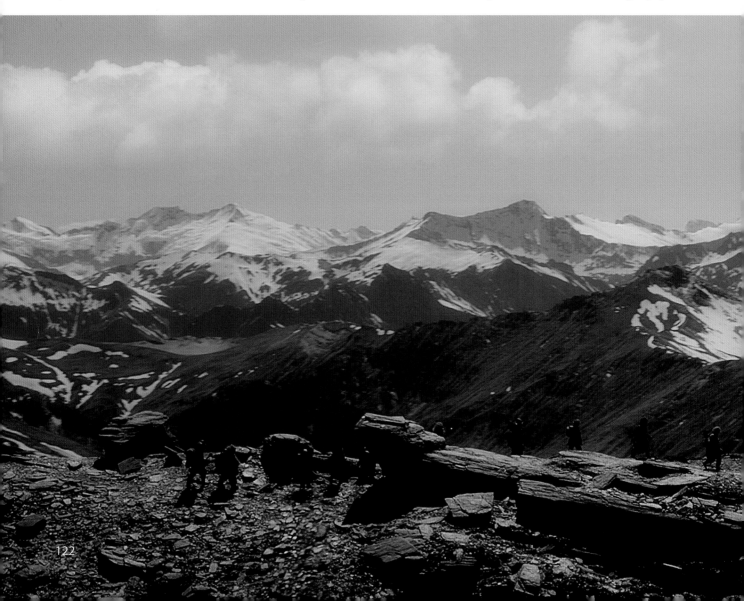

magicians of Weta Digital. For these shots, principal filming pilot Alfie Speight flew a modified helicopter specially fitted with a nose-mounted SpaceCam camera. The new SpaceCam RX system was configured for 3D shooting with two Red Epic cameras and incorporated image roll, straight-down pan and a multiplex single-mode fibre-optic line for image data transmission through a rotary joint. Superbly reliable, the system did not lose a single shot, despite a daily average of seven to eight hours in the air.

Glacier Southern Lakes Helicopters offers a number of scenic flights from Queenstown, including visits (and sometimes landings) to all the places featured here, to enable you to share some of the magic. If you're lucky, you might even have Alfie Speight as your pilot.

We used the SpaceCam a lot — a rigging mechanism for the 3D camera, which sat inside a protective dome canopy, allowing the camera to sit on a gimbal which could rotate 360 degrees. It's like having a Steadicam mounted to the front of a helicopter, and is used for creating very still, flowing shots which can be extremely wide or extremely close. **Andy Serkis**

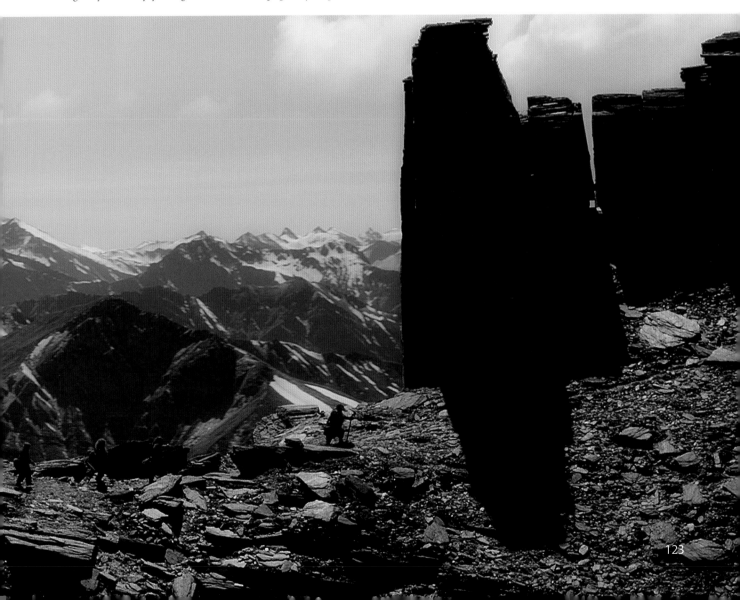

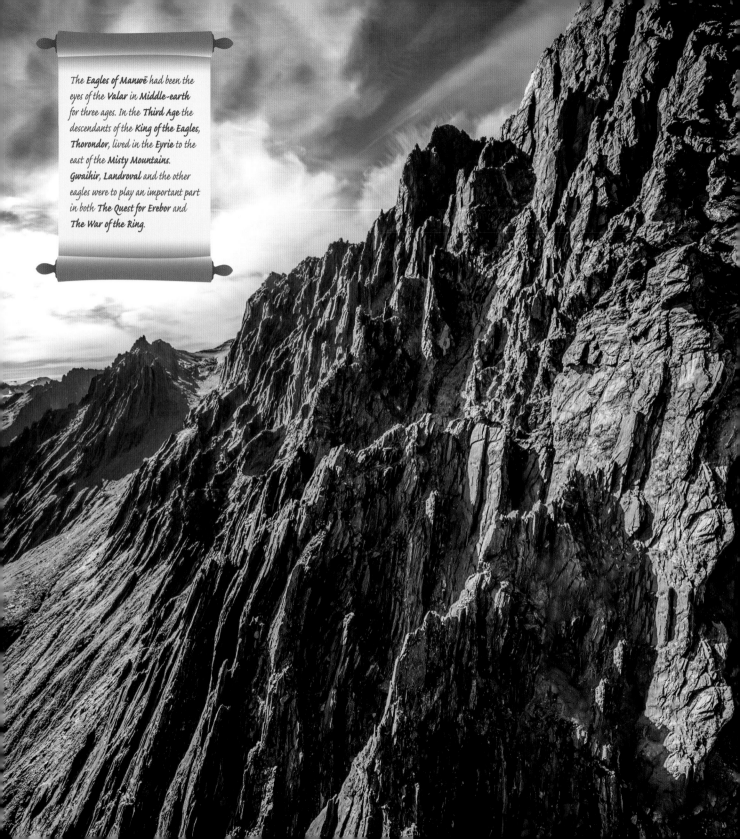

The **Eagles of Manwë** had been the eyes of the **Valar** in **Middle-earth** for three ages. In the **Third Age** the descendants of the **King of the Eagles, Thorondor,** lived in the **Eyrie** to the east of the **Misty Mountains. Gwaihir, Landroval** and the other eagles were to play an important part in both **The Quest for Erebor** and **The War of the Ring.**

Organ Pipes

As the *Great Eagles* of the *Misty Mountains* rescue the *Company* from the clutches of *Azog* and his minions, they take them towards their *Eyrie* and are shown flying against a number of different backdrops, including the aptly named Organ Pipes. These are situated to the west of Treble Cone and south of the Mt Aspiring Hut road and track. Reaching over 1900 metres, this jagged teeth-like range was filmed in spring after the winter snows had melted, leaving the schist rock exposed.

This same range was seen in *The Hobbit: The Desolation of Smaug* when *Gandalf* climbs precariously towards the *High Fells* and the resting place of *The Nine*.

Opposite The aptly named Organ Pipes tower above the helicopter as principal filming pilot Alfie Speight manoeuvres ever closer.
Ian Brodie

Below The Organ Pipes dominate the foreground against the backdrop of the Matukituki Valley and road. Despite their height they are not visible from the Mt Aspiring Road. Ian Brodie

Glacier Southern Lakes Helicopters
35 Lucas Pl, Queenstown
www.glaciersouthernlakes.co.nz

You'd see mountains and you'd think if you saw one of those in England you'd go look at that mountain, look at that, isn't that beautiful? In the South Island it's everywhere.
Martin Freeman

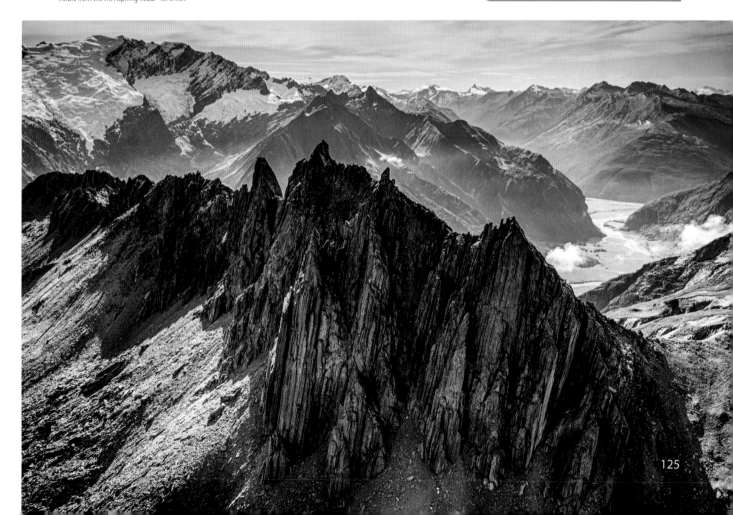

Earnslaw Burn

Earnslaw Burn and the surrounding area have long been favourites for international film-makers, featuring in films such as *The Lord of the Rings* and countless television commercials.

In *The Hobbit: An Unexpected Journey*, the *Company* are seen approaching the *High Pass* to cross from *Eriador* into *Rhovanion* and on towards *Erebor*. Led by *Gandalf*, they are seen walking under a high mountain peak surrounded by cascading waterfalls. The location itself is accessible via the Earnslaw Burn track — but is for experienced trampers only, with specialised back-country skills.

Thankfully there is an easier way, with Heliworks Queenstown Helicopters. It offers a number of options, one of which includes travelling into the location, a picnic lunch under the falls, then flying back to Glenorchy and joining Nomad Safaris for a two-and-a-half-hour film location tour. The picnic lunch under the towering twin peaks of Mt Earnslaw (the name appropriately means Eagles' Hill) is an unforgettable experience.

i Heliworks Queenstown Helicopters
Tex Smith Lane, Queenstown
www.heliworks.co.nz

i Nomad Safaris, Queenstown
www.nomadsafaris.co.nz/combos.html

A location that just rings of Middle-earth. Mt Earnslaw towering over the burn is a star in its own right, having appeared in *The Lord of the Rings* as well as numerous international television advertisements.
Ian Brodie

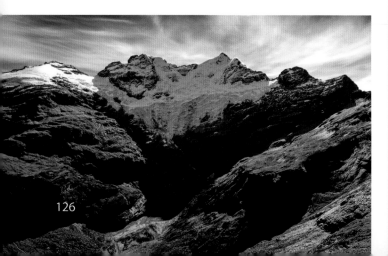

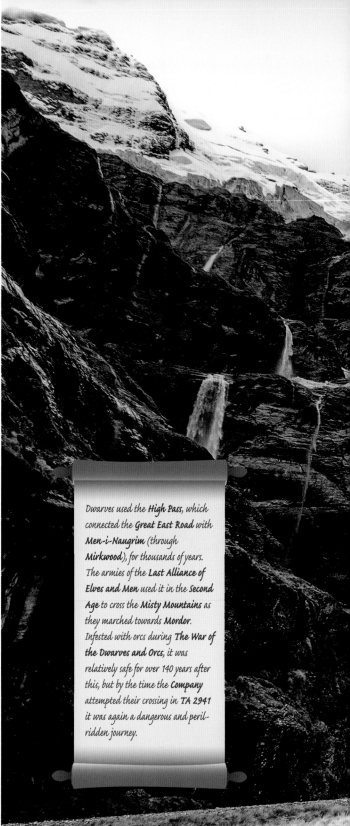

*Dwarves used the **High Pass**, which connected the **Great East Road** with **Men-i-Naugrim** (through **Mirkwood**), for thousands of years. The armies of the **Last Alliance of Elves and Men** used it in the **Second Age** to cross the **Misty Mountains** as they marched towards **Mordor**. Infested with orcs during **The War of the Dwarves and Orcs**, it was relatively safe for over 140 years after this, but by the time the **Company** attempted their crossing in **TA 2941** it was again a dangerous and peril-ridden journey.*

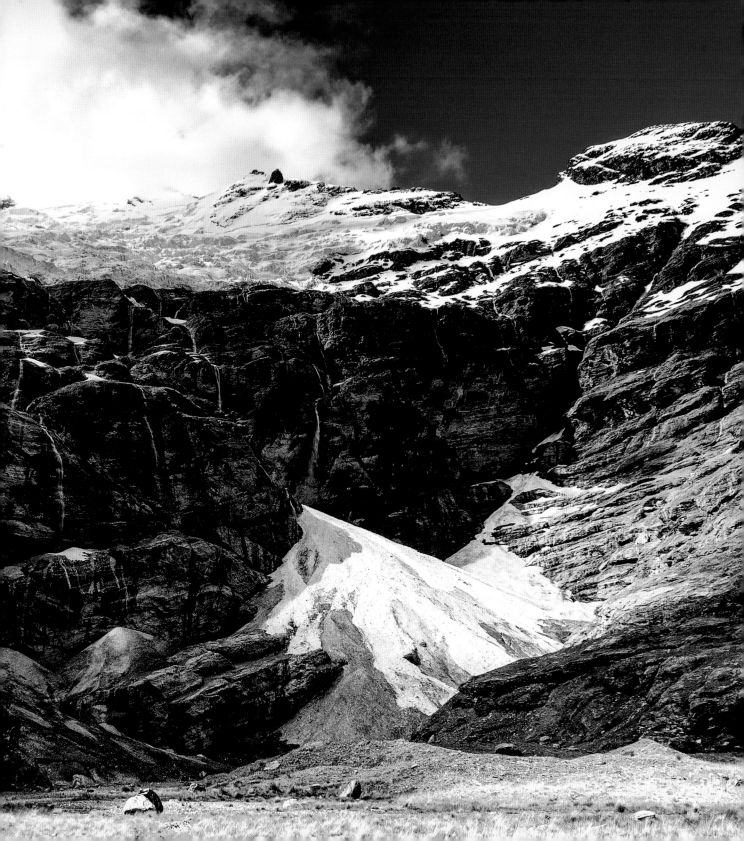

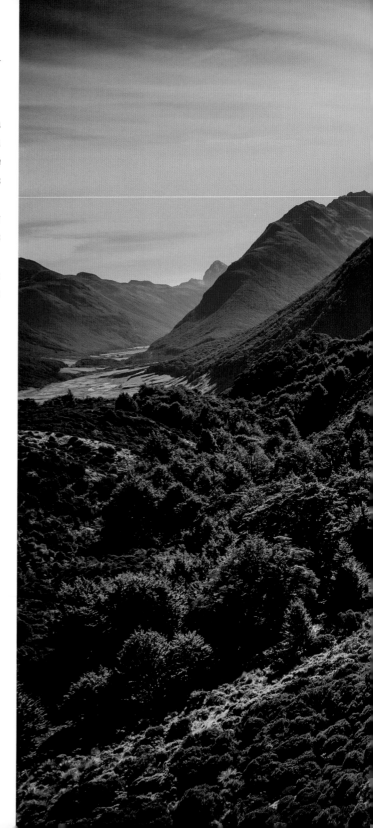

Passburn

The Passburn Valley and Saddle are situated west of the Greenstone Valley, a spectacular setting of golden tussock in a stream valley surrounded by high mountain peaks. In 2012 it was introduced in the first trailer for *The Hobbit: An Unexpected Journey* and seen in the film as the *Company* trek from *Rivendell* towards the *High Pass* over the *Misty Mountains*.

Cast and crew were taken into the area by helicopter and filmed by SpaceCam from multiple angles to showcase the dramatic mountainous scenery of both New Zealand and *Middle-earth*.

This location is part of Te Araroa, The Long Pathway (see page 132), but can also be seen when undertaking the *Hobbit* scenic flight with Glacier Southern Lakes Helicopters.

i Glacier Southern Lakes Helicopters
35 Lucas Pl, Queenstown
www.glaciersouthernlakes.co.nz

i www.teararoa.org.nz

This job was my first in a helicopter; I had never been in a helicopter before. **Martin Freeman**

Seasonal contrasts at Passburn. The scene at right is how the location appeared in the trailer for *The Hobbit: An Unexpected Journey*, whereas in winter (overleaf), snow cloaks the valley and hides much of the golden tussock. Ian Brodie

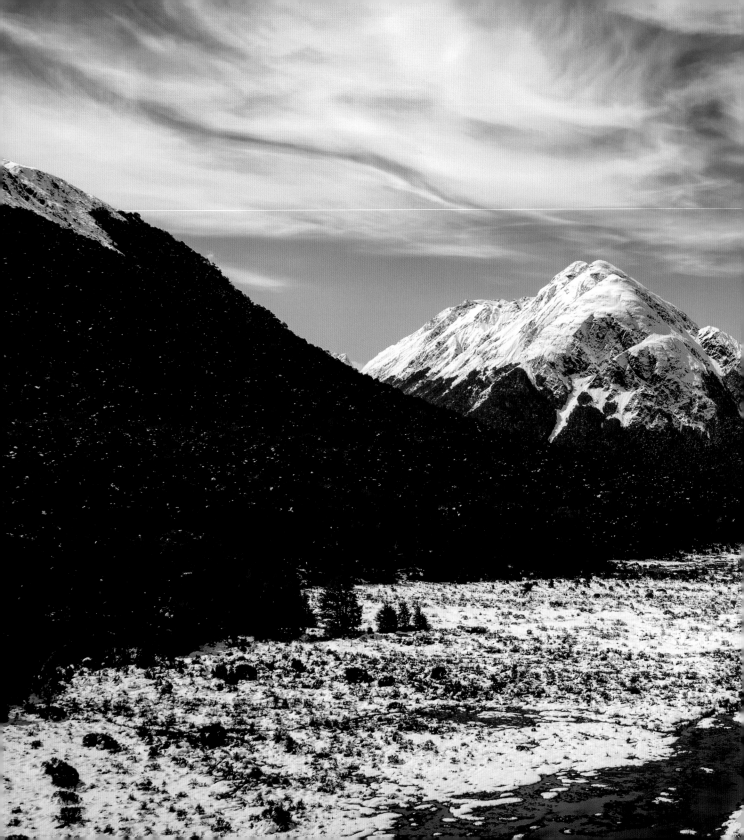

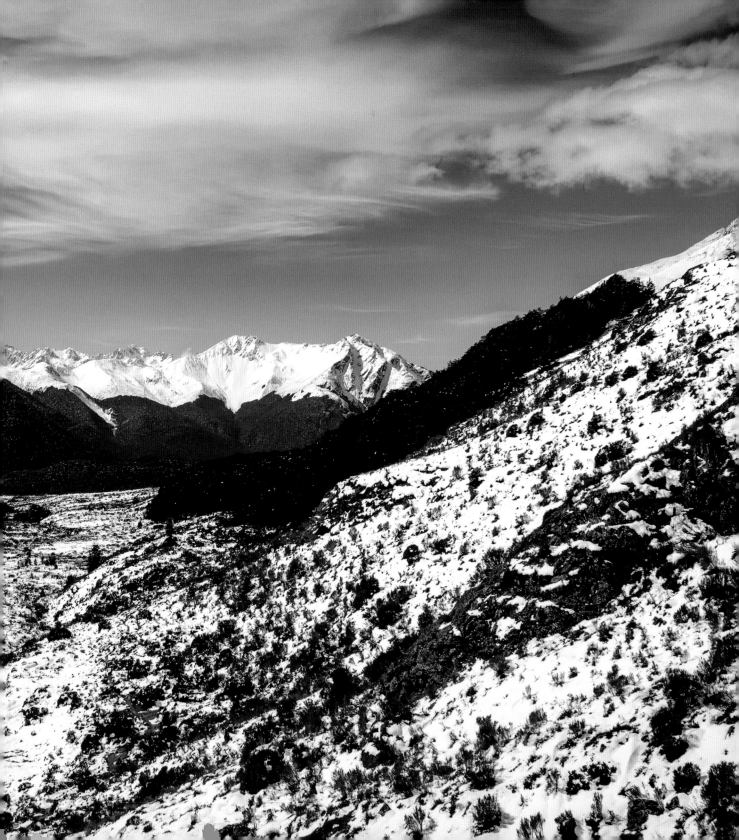

Mararoa Saddle

Glacier Southern Lakes Helicopters
35 Lucas Pl, Queenstown
www.glaciersouthernlakes.co.nz

www.teararoa.org.nz

> It's one of those moments when you're just pinching yourself all the way in the helicopter going oh my gosh, oh my gosh.
> Adam Brown

The Mararoa Saddle is seen in the prologue of *The Hobbit: An Unexpected Journey* in a sequence where *Thorin* is leading the dwarven *Erebor* refugees through the wild lands after their escape from *Smaug*.

The actual location is accessible as part of Te Araroa, The Long Pathway, a 3000 km trail stretching from Cape Reinga in the north of New Zealand to Bluff in the south. Officially opened by the Governor General in 2011, Te Araroa is the result of many years of hard work by dedicated volunteers who have worked tirelessly to create one of the world's longest walking trails. The trail encompasses all of our diverse scenery and can be undertaken in small portions or its entirety, so a proud walker can rightfully claim to have walked from Cape Reinga to Bluff.

The section crossing this area is the Mavora Walkway, a 47 km four-day moderately difficult tramp from Greenstone (on the shores of Lake Wakatipu) to the Mavora Lakes camping area.

The location is also seen when flying with Glacier Southern Lakes Helicopters on its *Hobbit* scenic flight.

Below and opposite A wild and remote landscape, accessible only on foot or by helicopter, the Mararoa Saddle was 'populated' with dwarven refugees to illustrate the wild lands the dwarves of Erebor took to after their homeland was taken by the dragon Smaug. Ian Brodie

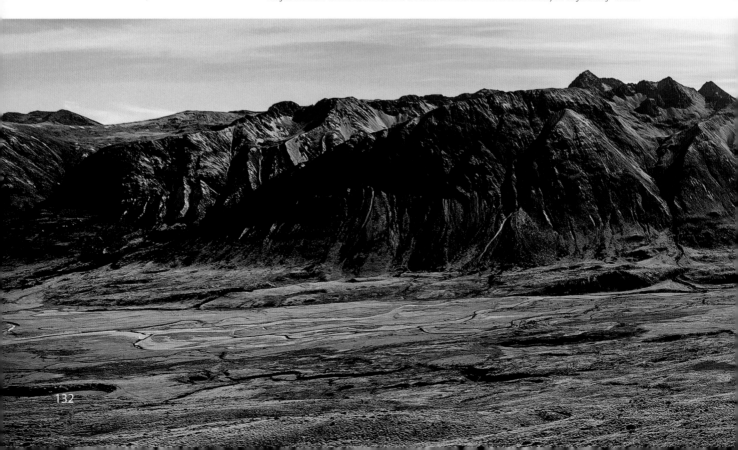

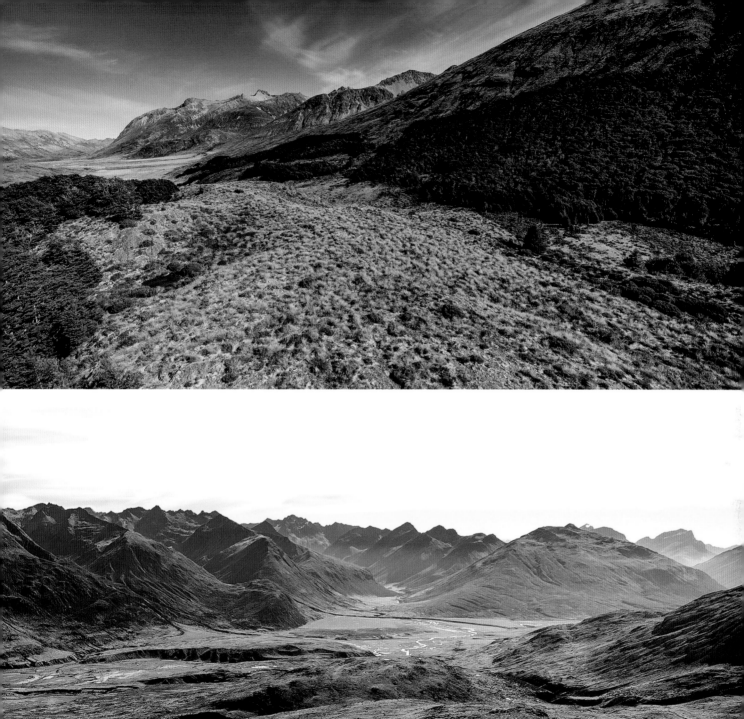

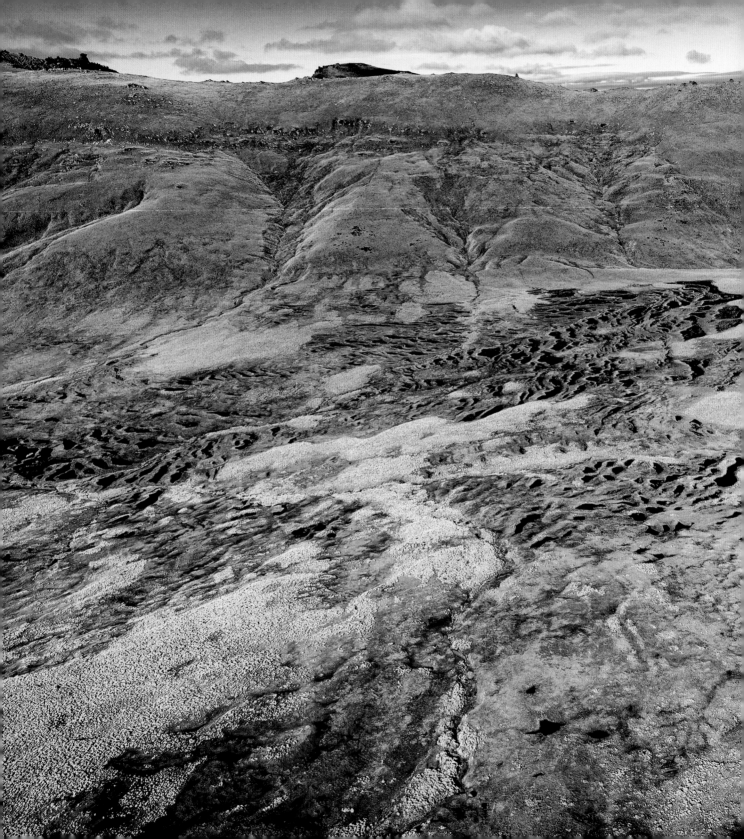

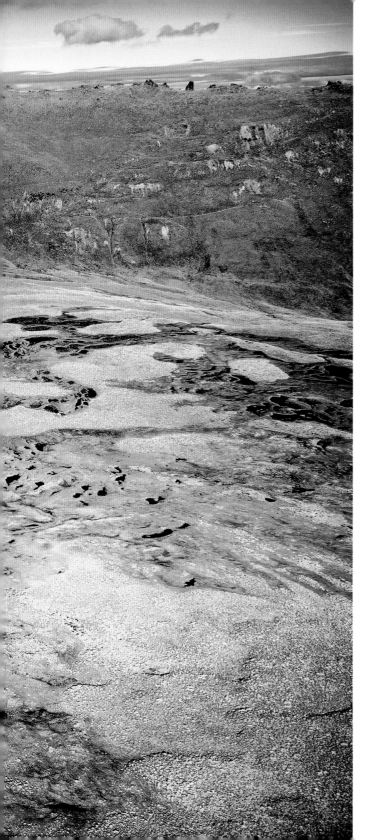

Nokomai String Bog

A dramatic scene in the prologue of *The Hobbit: An Unexpected Journey* has *Thorin* leading the dwarven refugees in narrow file across a desolate landscape interspersed with swampy streams. Called the Nokomai String Bog, it is on private land and accessible only by helicopter, but you can combine a visit to this spot with a farm stay on one of the largest farms in the country.

Nokomai Station is located one hour south of Queenstown and has a rich farming and gold-mining history. Staying in one of four comfortable cottages can be a very special time with a number of activities available. These include fly-fishing the world-famous Mataura River, mountain biking, walking and hiking or just lazing in a comfortable chair on the veranda with a good book. You can also visit the Nokomai String Bog with Nokomai Helicopters. The opportunity to stay on this farm among some of the most spectacular scenery of Southland is a wonderful way to soak in the landscape of *Middle-earth* Aotearoa.

i Nokomai Station
www.nokomai.co.nz

The vivid reality of CGI characters achieved by Weta Digital meant that a number of inaccessible but ideal locations could be used in the *Hobbit* films. The remote Nokomai String Bog was filmed from a helicopter SpaceCam and then the dwarven refugees added in post production. Ian Brodie

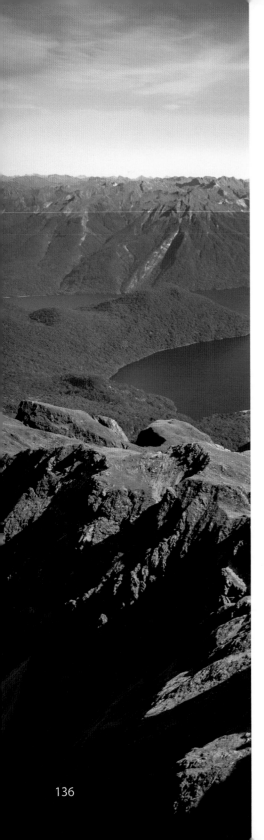

Introducing Te Anau

Gateway to Fiordland National Park, Te Anau sits beside one of our most splendid lakes. As you take in the lakefront with brooding bush-covered foothills and towering peaks, it's not hard to imagine yourself in the mountainous realms of *Middle-earth*.

The second largest lake in New Zealand, Lake Te Anau covers 43,200 ha and is over 417 metres deep. While legends describe Tu-te-Raki-Whanoa carving the fjords with his magical adze, Te Hamo, and Maori used the area for seasonal food gathering, there were few permanent residents. In 1773 Captain Cook and his crew were the first Europeans to visit, spending five weeks in Dusky Sound.

While you're spoilt for choice with so many scenic opportunities, including Milford Sound, Doubtful Sound and Te Ana-au Caves, the daily caves tour comes highly recommended. A boat cruise to the western side of the lake joins a guided tour of the caves, which are unique in the southern hemisphere and still geologically active. As you enter the caverns, you'll hear the sound of rushing water carving passages from the limestone. The combination of twisted rocks, an underground whirlpool, waterfall and a boat trip to view the glow-worms is a fantastic way to spend an enthralling two-and-a-half hours.

Situated 12 km from Te Anau amid the bush-covered Kepler Mountains, island-studded Lake Manapouri (Lake of the Sorrowing Heart) is an area of unspoilt beauty. When Koronae went deep into the forest, she fell and became stuck. Moturua found her sister but was unable to release her, and they lay together until they died, their tears creating Lake Manapouri.

Highly recommended as an ideal way of exploring the area is the full-day Doubtful Sound excursion with Real Journeys. It starts with a cruise across the lake, then a bus takes you over the Wilmot Pass (671 metres) to a three-hour boat cruise on Doubtful Sound. Three times longer than Milford Sound and with a surface area 10 times larger, Doubtful Sound was sculpted over millions of years by the collision of rock and ice, and is now cloaked in dense, cool temperate rainforest.

At the Nee Islets, New Zealand fur seals can be seen basking on the rocks, while the sound is home to a pod of about 60 bottlenose dolphins as well as the rare and very shy Fiordland crested penguin. Here, the crystal-clear silence of complete isolation is one of the area's many charms.

The tour then returns to the underground Manapouri Power Station, the largest in New Zealand and one of this country's greatest engineering achievements. The power station hall was excavated from solid granite rock 200 metres below the level of the lake.

Lake Te Anau has three fjords (arms) that reach into the encircling Alps. They are the only inland fjords in New Zealand (all the rest are on the sea coast). Ian Brodie

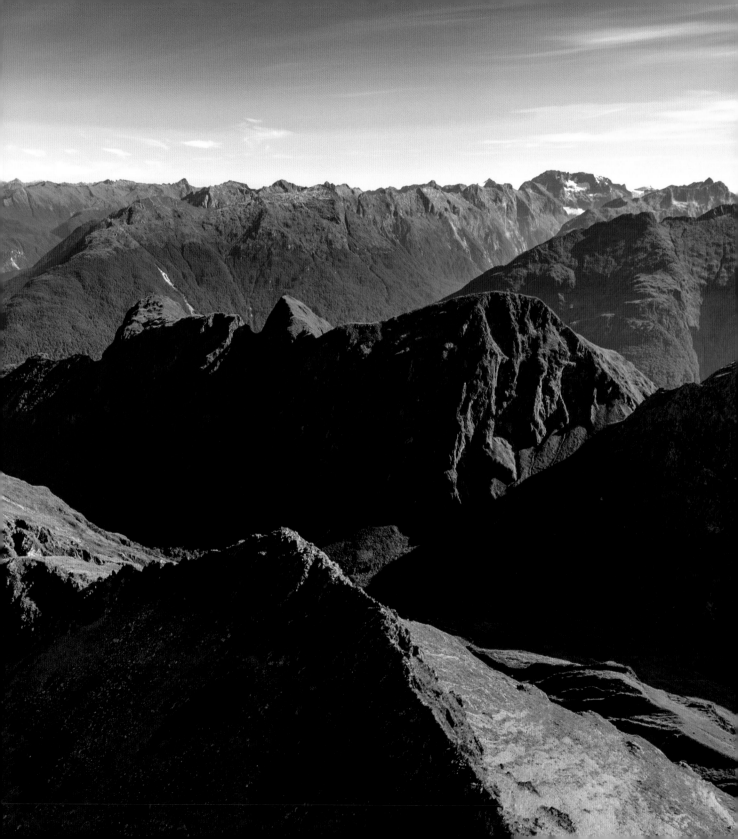

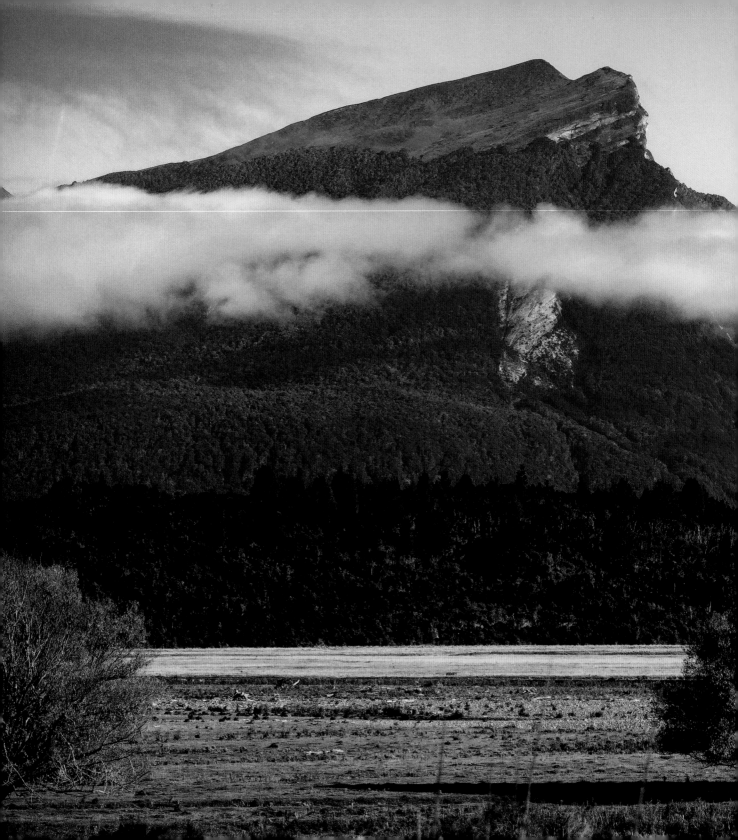

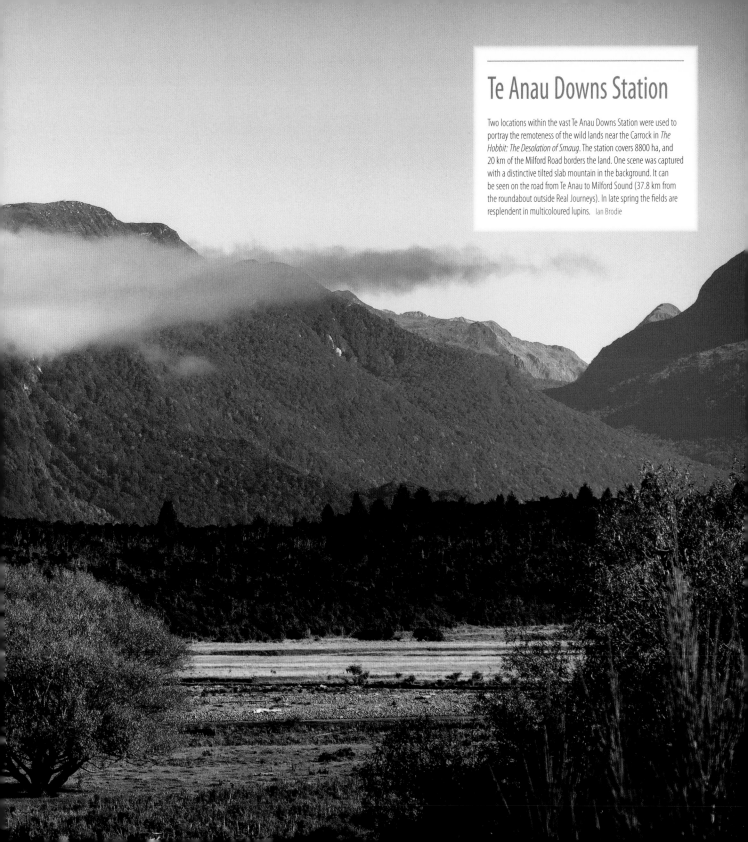

Te Anau Downs Station

Two locations within the vast Te Anau Downs Station were used to portray the remoteness of the wild lands near the Carrock in *The Hobbit: The Desolation of Smaug*. The station covers 8800 ha, and 20 km of the Milford Road borders the land. One scene was captured with a distinctive tilted slab mountain in the background. It can be seen on the road from Te Anau to Milford Sound (37.8 km from the roundabout outside Real Journeys). In late spring the fields are resplendent in multicoloured lupins. Ian Brodie

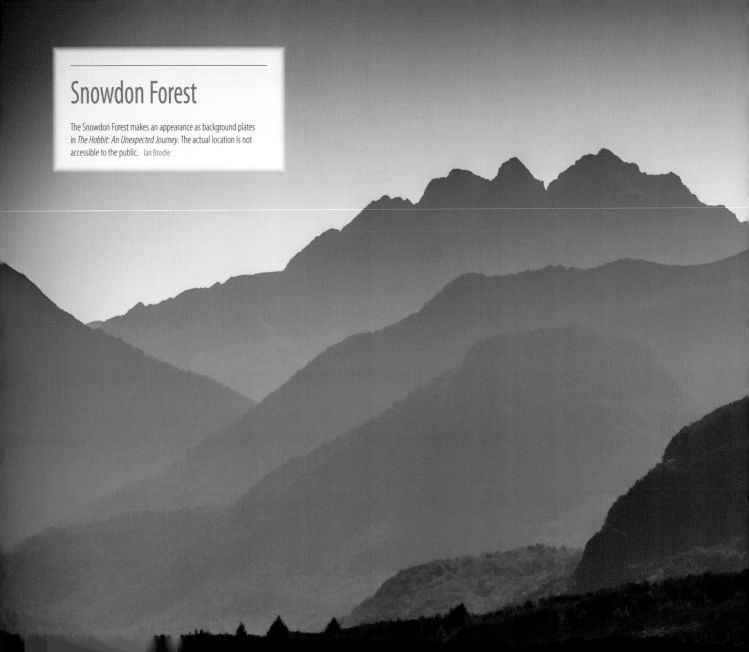

Snowdon Forest

The Snowdon Forest makes an appearance as background plates in *The Hobbit: An Unexpected Journey*. The actual location is not accessible to the public. Ian Brodie

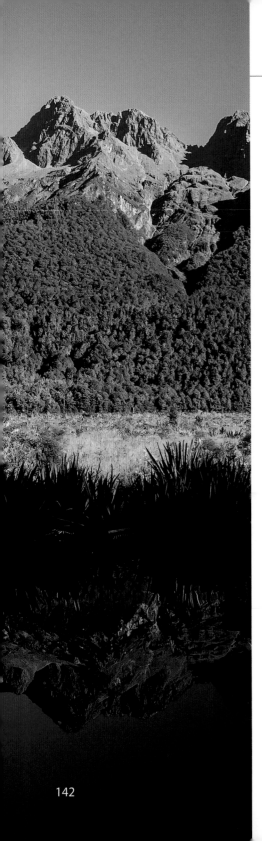

Milford Sound

Arguably the most well-known tourist destination in New Zealand, Milford Sound is named after Milford Haven in Wales and is a typical fjord, with deep water almost completely enclosed by high cliff walls rising to 1200 metres. The iconic Mitre Peak (1692 metres) is one of the most photographed peaks in the country. The area also has one of the world's highest rainfalls, but whatever the weather, this is a must-see on any tour of *Middle-earth* Aotearoa.

The road from Te Anau to Milford is a photographic journey, with breathtaking scenery. From the rolling hill country of Te Anau Downs Station, the road enters the Eglinton Valley where bush grows far up the mountains before yielding to precipitous rock faces, alpine tussock and snow. A fog often runs along the ranges, and if it all looks familiar, this region was used to portray the *Misty Mountains* in *The Fellowship of the Ring*.

Pause at the Mirror Lakes and take a short walk. On a still day the Earl Mountains are reflected perfectly in the deep-blue water.

As the road climbs higher the Homer Tunnel appears, a very small dark hole in the cliff face. Work began on the 1270-metre tunnel in 1935 but it wasn't opened until 1954. A car park at the Te Anau end is a great stopping place.

Te Anau: 118 km
Queenstown: 286 km

Redcliff Café, 12 Mokonui St, Te Anau

Aden Motel, 57 Quintin Dr, Te Anau
www.adenmotel.co.nz

Fiordland i-SITE, 85 Lakefront Dr, Te Anau
www.fiordland.org.nz

www.nzta.govt.nz/projects/milfordroad/

Left and right On a perfectly still clear morning, the Mirror Lakes live up to their name. The short 200-metre walk from the road is an ideal place to pause your journey through to Milford. Ian Brodie

Overleaf At Milford Sound, all the superlatives ring true as the high peaks drop directly into the fjord. Arguably New Zealand's most famous tourist attraction, it was described by the writer Rudyard Kipling as the eighth wonder of the world. Ian Brodie

Overleaf inset Allow time on your journey to pause and view the Hollyford River, with its glacial-coloured water and ice-smoothed rock, surrounded by dense mountain beech. Ian Brodie

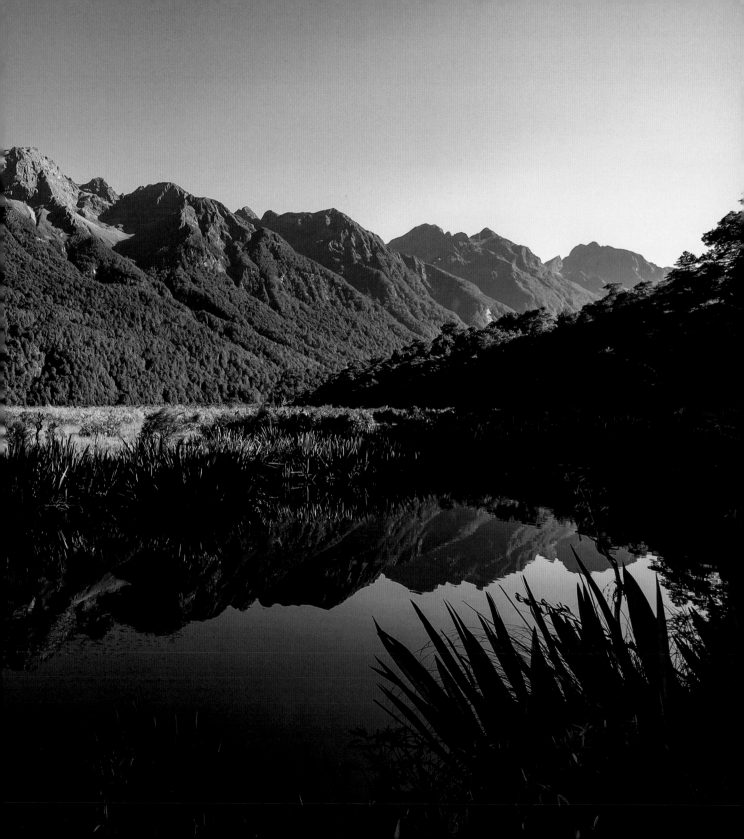

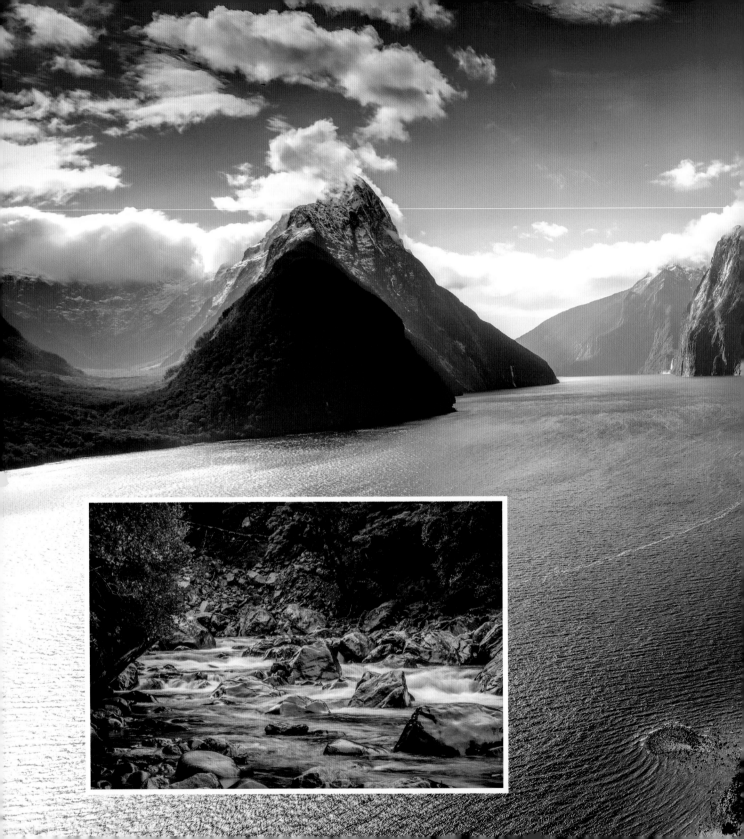

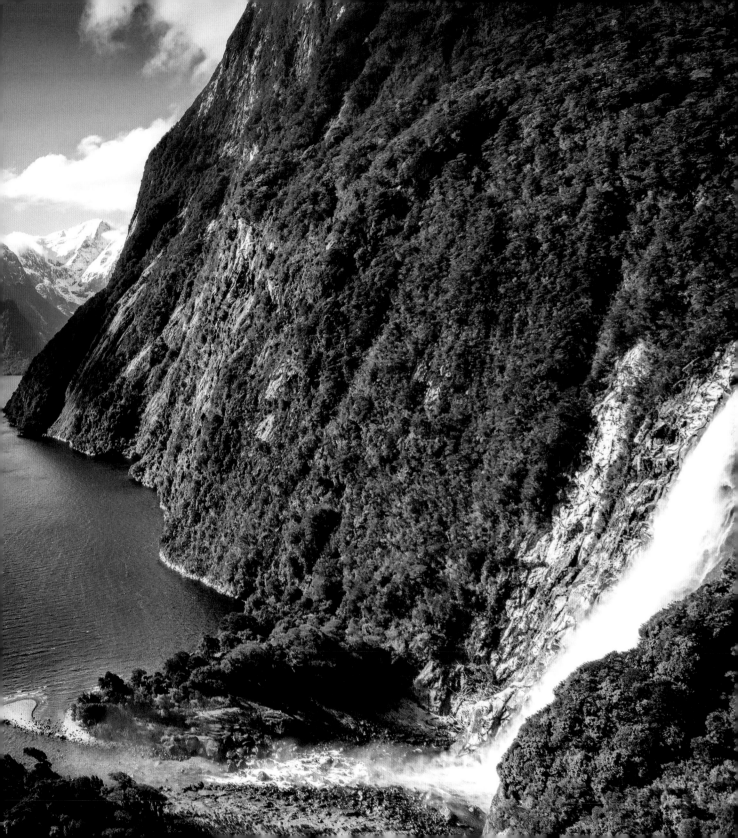

The Lower Hollyford Valley

The Homer Tunnel (1:10 gradient) runs through unlined granite to the Cleddau Valley, and then it's a twisting downhill rush to sea level and Milford Sound. Keep a watch for the signposted walk to The Chasm, an essential stop. As you start this short bush walk, the awesome sound of roaring water surrounds you. Over thousands of years the river has carved its way through granite to create a series of waterfalls, half hidden in stone, forcing the water through a narrow abyss. On a rainy day the sheer power is unbelievable.

At Milford Sound a boat trip to the sea entrance is highly recommended, giving a closer view of Mitre Peak, waterfalls and the Milford Road.

As you drive back towards Te Anau, 30 km from Milford Sound is a signpost to Gunns Camp and the Lower Hollyford Valley. The drive up this 8 km road follows the Hollyford River through native beech, encircled by the high peaks of the Southern Alps. There are some excellent photo stops, including Moraine Creek and the walk to Humboldt Falls.

For those with more time, a guided walk through the valley is the best way to see this world heritage area.

i Real Journeys, Milford Sound
www.realjourneys.co.nz

i Hollyford Track
www.hollyfordtrack.com

A small mountain stream rushes to join the Hollyford River in the Hollyford Valley. If time permits, there are guided tours in this area, from a one-day heli-hiking tour to a three-day wilderness adventure. Ian Brodie

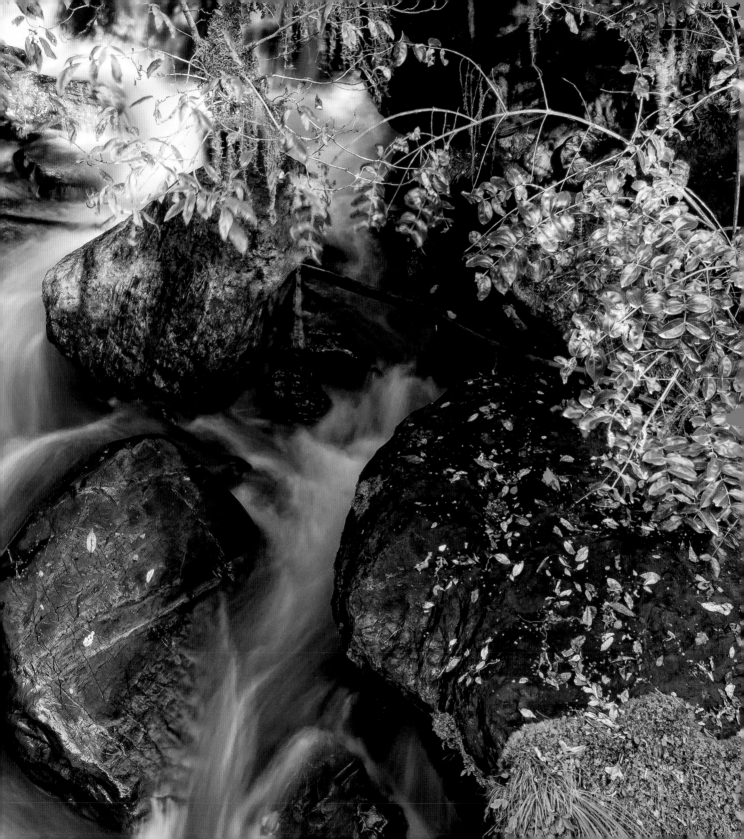

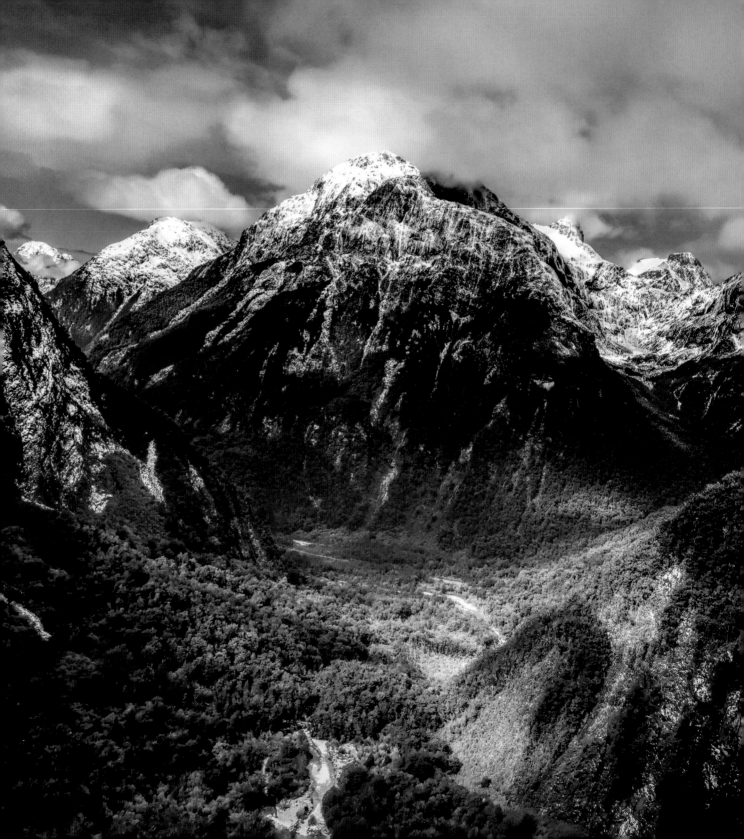

Sutherland Falls

The location of the *Eagles' Eyrie* is deep in the Southern Alps. As spectacular in real life as it appears in the film, it can only be reached by air. Situated near Sutherland Falls and the Mackinnon Pass, the base of this unnamed mountain (580 metres) is accessible two ways, both breathtaking.

The first requires a few days and a reasonable level of fitness, but means you experience the world's finest walk — the Milford Track. This 53.5 km hike, from the head of Lake Te Anau to Milford Sound, follows a Maori route for transporting greenstone. Established as a guided tour by Quintin McKinnon in the late 1800s, the Milford Track can be experienced as a freedom tramp or fully guided tour. Day three climbs to the highest point of the Mackinnon Pass, then ascends towards Quintin Hut and the bottom of the Sutherland Falls (580 metres), fed by Lake Quill. Helicopter pilot Alfie Speight flew film crew across the lake and down the falls with a 3D SpaceCam camera to record the dramatic journey to the *Eyrie*.

The location can also be experienced on the scenic flight to Milford Sound from Te Anau or Queenstown — travelling through the valley is like flying with the giant eagles.

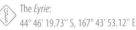
The *Eyrie*:
44° 46' 19.73" S, 167° 43' 53.12" E

Glacier Southern Lakes Helicopters
35 Lucas Pl, Queenstown
www.glaciersouthernlakes.co.nz

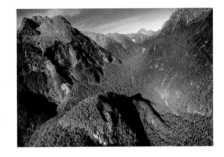

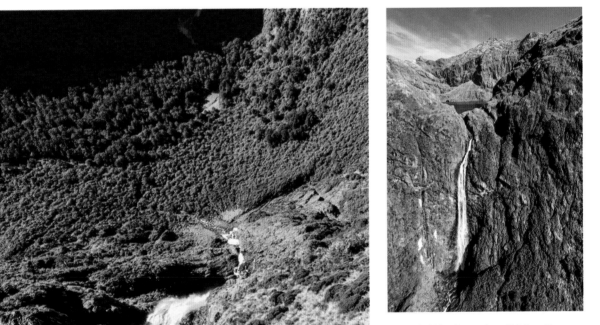

The Sutherland Falls rank among the world's highest, with a total drop of 580 metres in leaps of 229, 248 and 103 metres. Fed by water from the snow-fed Lake Quill, the falls were named for Donald Sutherland, a prospector, who in 1880 was the first European to see them. Ian Brodie

149

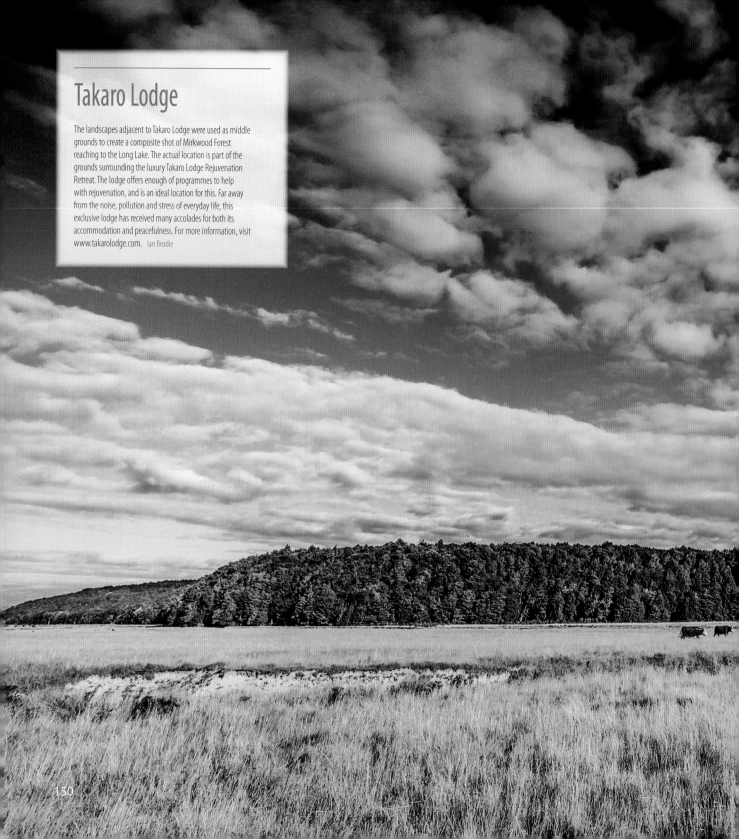

Takaro Lodge

The landscapes adjacent to Takaro Lodge were used as middle grounds to create a composite shot of Mirkwood Forest reaching to the Long Lake. The actual location is part of the grounds surrounding the luxury Takaro Lodge Rejuvenation Retreat. The lodge offers enough of programmes to help with rejuvenation, and is an ideal location for this. Far away from the noise, pollution and stress of everyday life, this exclusive lodge has received many accolades for both its accommodation and peacefulness. For more information, visit www.takarolodge.com. Ian Brodie

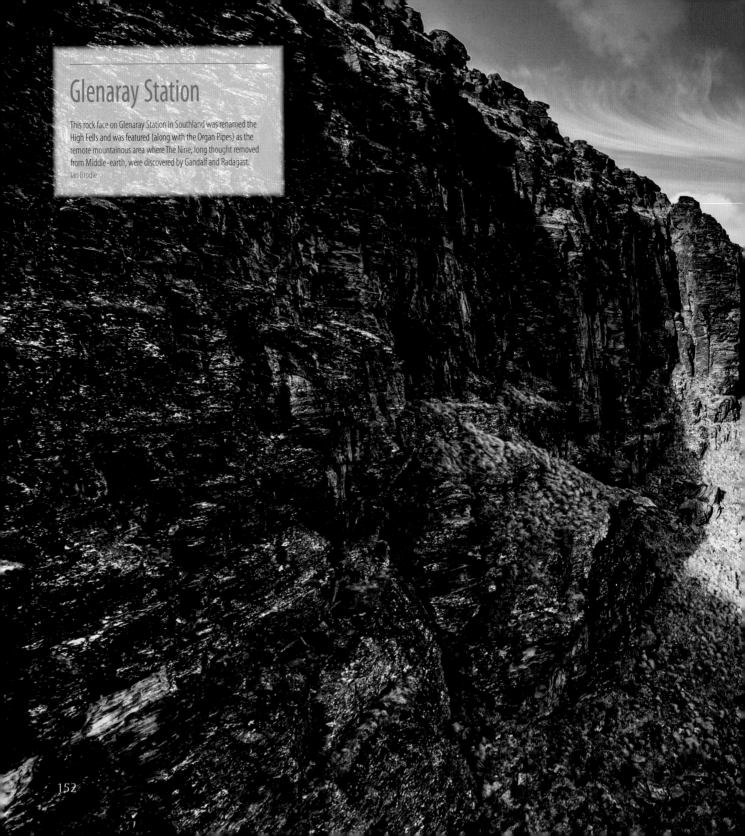

Glenaray Station

This rock face on Glenaray Station in Southland was renamed the High Fells and was featured (along with the Organ Pipes) as the remote mountainous area where The Nine, long thought removed from Middle-earth, were discovered by Gandalf and Radagast.

Ian Brodie

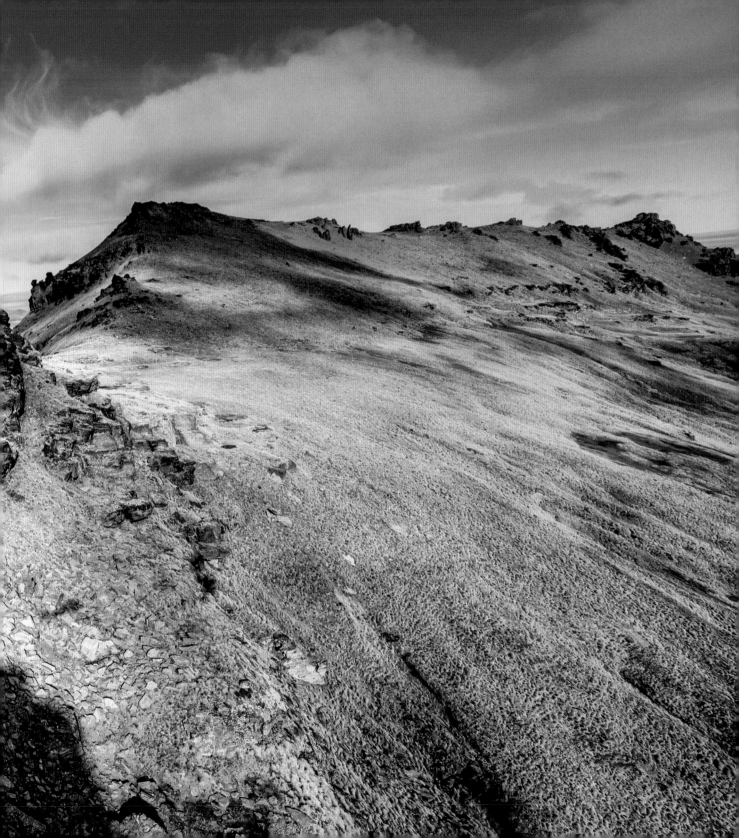

Introducing Dunedin

New Zealand's oldest city combines a rich architectural heritage with a modern-day attitude. Situated on the shores of Otago Harbour and surrounded by rolling moors, Dunedin seems to owe as much to Edinburgh as it does to the southern hemisphere.

In 1848 the Lay Association of the Free Church of Scotland decided to call its principal town Dunedin (in Scottish Gaelic, Dun Eideann means Edinburgh), and settlers created the Edinburgh of the south.

As a university city, Dunedin is a centre of innovation and eco-tourism, its vibrant culture contrasting with its Victorian and Edwardian architecture. Many activities and attractions are situated within walking distance of the Octagon, where Scottish poet Robert Burns casts his gaze over the city centre (his nephew was one of the city founders). Be sure to visit St Paul's Cathedral and the nearby First Church of Otago, before discovering the stunning Chinese Garden, with hand-made wooden buildings crafted by artisans from Shanghai. An appropriate end to a walking tour is the Speight's Brewery heritage building where you can enjoy a fine meal with a taste of the Pride of the South.

 Queenstown: 282 km
Christchurch: 361 km

 Speight's Brewery, 200 Rattray St, Dunedin
www.thealehouse.co.nz

 Scotia Bar & Bistro, 199 Upper Stuart St, Dunedin
www.scotiadunedin.co.nz/index.php

 The Bay Café, 494 Portobello Rd, Macandrew Bay
www.thebaycafe.co.nz

 Scenic Hotel Dunedin City
Corner Princes and Dowling Sts, Dunedin
www.scenichotels.co.nz/hotels/scenic-hotel-dunedin-city

 858 George St Motel, 858 George St, Dunedin
www.858georgestreetmotel.co.nz

 Dunedin i-SITE, 26 Princes St, Dunedin
www.dunedinnz.com

 Chinese Garden, Rattray St, Dunedin
www.dunedinchinesegarden.com

 Glenfalloch Woodland Gardens
430 Portobello Rd, Macandrew Bay
www.glenfalloch.co.nz

 Royal Albatross Centre and Fort Taiaroa,
1260 Harington Point Rd, Harington
www.albatross.org.nz

 Larnach Castle, 145 Camp Rd, Otago Peninsula
www.larnachcastle.co.nz

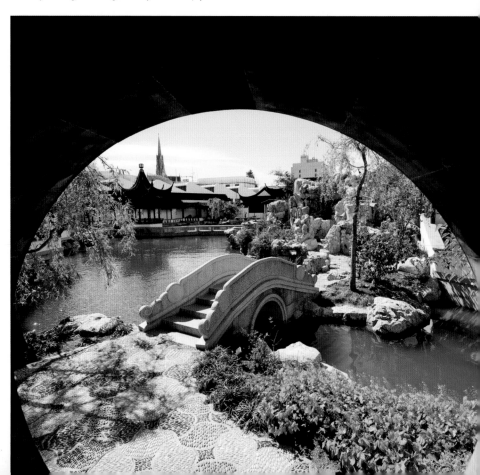

A day tour along the Otago Peninsula is one of contrasts as you stroll gardens, climb castle steps, sit on old stone walls, marvel at wildlife, walk on a beach and taste fresh seafood.

Start at Glenfalloch Woodland Gardens; nestled in a valley, these are particularly attractive in spring when azaleas, rhododendrons and magnolias brighten the valley.

Pause at Macandrew Bay or Portobello for refreshment, before continuing to the Royal Albatross Centre at Taiaroa Head and a guided tour to see magnificent northern royal albatrosses float above on their three-metre wingspans.

Be sure to visit the former coastal defences as well as the beautifully restored disappearing gun, built in 1886 in case of Russian invasion. Continue to enigmatic Larnach Castle, built in 1870, and our only castle. There is a restaurant within, and the gardens provide a dramatic foreground to Otago Peninsula, with its sweeping bays and coves.

At Sandfly Bay, deep-blue ocean contrasts with bleached, white sand dunes. There are wooden hides here and if you're patient you might see a rare yellow-eyed penguin or Hooker's sea lion. At nearby Lovers Leap, just along from the bay, the trees provide a very *Middle-earth* feel.

All of this can be achieved in a day trip but as a special treat, stay overnight at Larnach Castle to make the most of this amazing peninsula.

Opposite The Dunedin Chinese Garden was designated a Garden of National Significance in February 2011 by the New Zealand Gardens Trust, an arm of the Royal New Zealand Institute of Horticulture Inc. Ian Brodie

Below Robbie Burns dominates this view of Dunedin's Octagon and could just as easily be imagined as part of Edinburgh. Ian Brodie

Overleaf The intense blue of the Pacific Ocean at Sandfly Bay, just one of the dramatic beaches on Otago Peninsula. Ian Brodie

Overleaf inset Seagulls squawk incessantly along the walk to historic Taiaroa Head. Ian Brodie

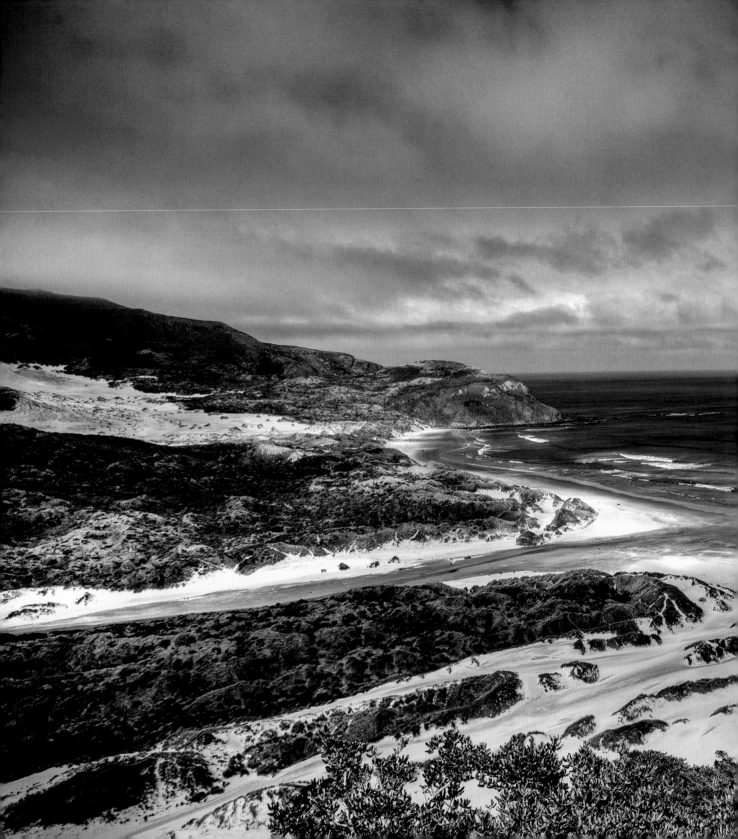

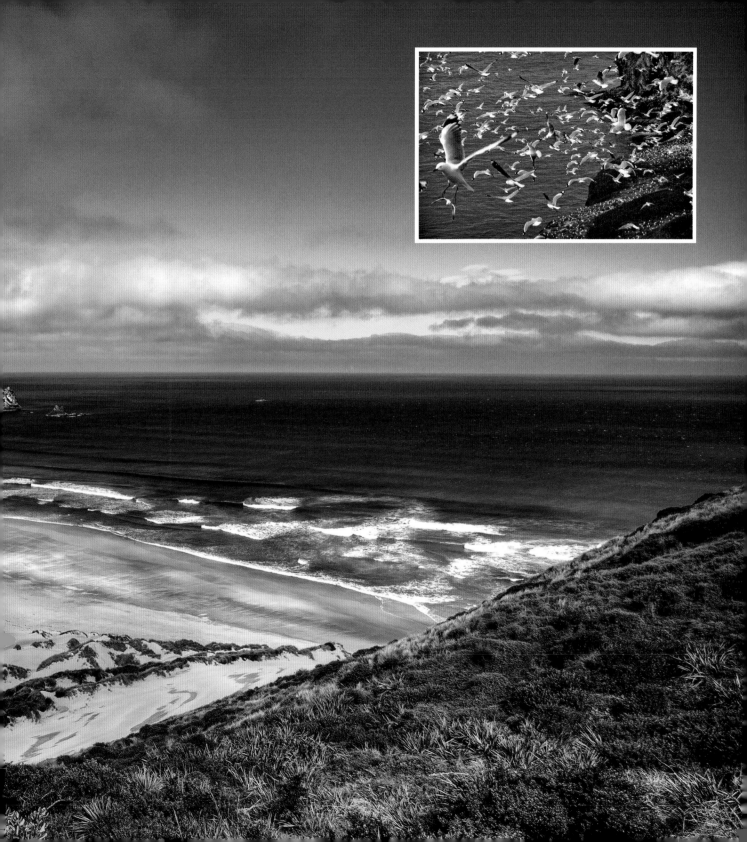

Introducing Middlemarch

Middlemarch is reached by road or train and both routes are worthy of separate adventures, so my suggestion is the return trip on the Taieri Gorge Railway from Dunedin. The 60 km rail journey through the rugged Taieri Gorge is a fantastic introduction to Middlemarch and the Strath Taieri.

The drive to Middlemarch is equally inspiring. A great place to stop for morning coffee is the charming village of Outram, on the edge of the Taieri Plains. As the road leaves the plains it climbs over a number of rolling green hills and continues climbing until you enter the Strath Taieri — a landscape like no other in New Zealand.

Middlemarch lies nestled in an ancient glacial valley overlooked by the aptly named Rock and Pillar Range. It is a land of sparse population, rocky tors, seasonal magnificence and light which casts a glow in all directions. The town is also a terminus for the Central Otago Rail Trail, which crosses to Alexandra. The trail follows the railway line built over 160 years ago, linking Dunedin with the Central Otago goldfields. Opened in 1907 and closed in 1990, the railway was a lifeline. Since then, the trail has been voted one of the top five experiences in New Zealand, a fantastic way to explore this vibrant area.

The location where the *Company* are attacked by orcs en route to *Rivendell* is on private land and inaccessible, however a number of public places will evoke this scene.

Schist rock outcrops which seem to grow out of the tussock hills dominate, and the perfect way to immerse yourself into the scene is to walk to Sutton Salt Lake. Nestled among eroded tors, this is the only saline lake in New Zealand, entirely filled by rainwater. The lake may be dry in summer months, with a salty brine edge. The walk will take an hour but I recommend spending half a day. Every tor requires investigation and, if you're in a group, the opportunity to re-create the scene is irresistible, though prepare for intense heat in summer and biting frost in winter.

Cafés in Middlemarch provide lunch, while the chance to have a picnic in the shade of the tors shouldn't be missed.

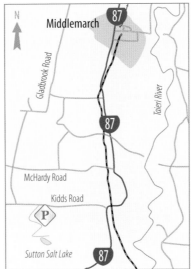
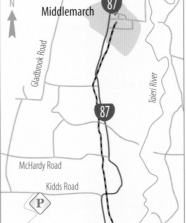

Left The landscapes of Middlemarch are some of the most beautiful in New Zealand. Golden tussock, dramatic schist tors and seasonal variations all combine to make this part of the country a must visit. Ian Brodie

 Queenstown: 233 km
Dunedin: 80 km

 Car park, Sutton Salt Lake, Kidds Rd, Middlemarch:
45° 33' 50.61" S, 170° 05' 17.43" E

 Hyde Memorial, SH87:
45° 21' 20.72" S, 170° 14' 03.44" E

 Wobbly Goat Café, 17 Holyhead St, Outram

 Kissing Gate Café, SH87, Middlemarch

 Quench Café, 29 Snow Ave, Middlemarch

 The Strath Taieri Hotel, Snow Ave, Middlemarch
www.strathtaierihotel.com

 Pukerangi Homestead, 38 Reefs Rd, Pukerangi
www.pukerangihomestead.co.nz

 Dunedin i-SITE, 26 Princes St, Dunedin
www.dunedinnz.com

 www.middlemarch.co.nz

 Taieri Gorge Railway, 22 Anzac Ave, Dunedin
www.taieri.co.nz

Central Otago Rail Trail
www.otagocentralrailtrail.co.nz

> The Rock and Pillar, it just sounds monumental, and it is. Richard Armitage

159

Hartfield

Erosion of the softer soils has resulted in these rocky tors covering the landscape and provided a dramatic location at Hartfield as the party rush to escape the orcs and find the sanctuary of Rivendell. Ian Brodie/Warner Bros. Pictures (inset)

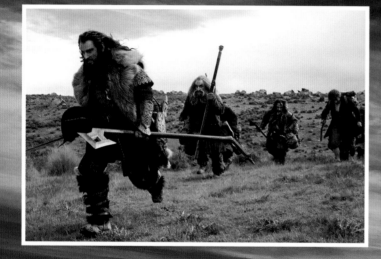

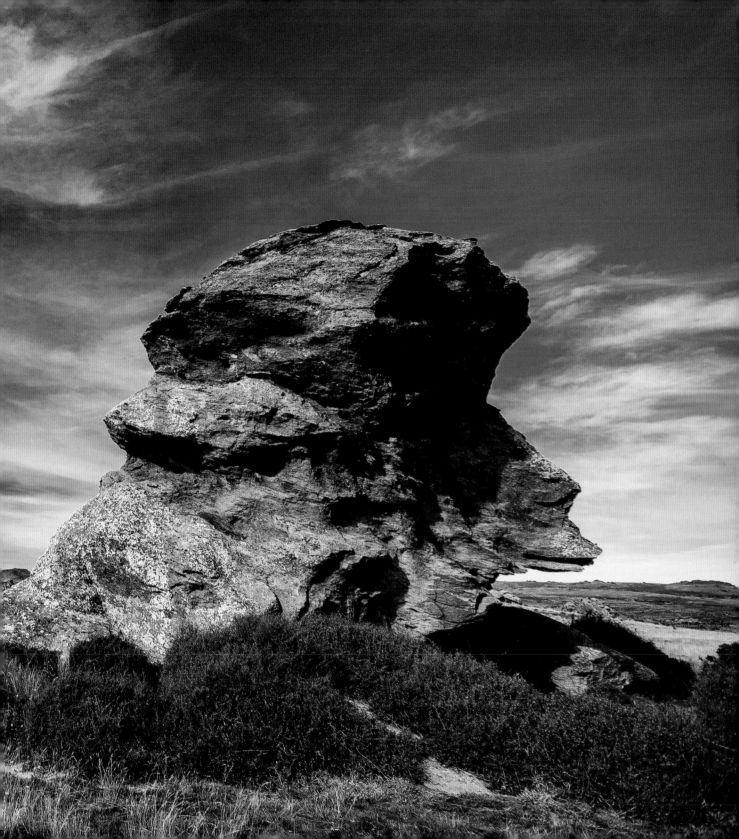

St Bathans

 Middlemarch: 101 km
Alexandra: 62 km

 Vulcan Hotel, Loop Rd, St Bathans

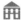 Vulcan Hotel, Loop Rd, St Bathans

 www.visit-centralotago.co.nz

 Vulcan Hotel, Loop Rd, St Bathans

If you continue past Hyde towards Alexandra, detour to St Bathans, which arose in the 1860s as a service centre for surrounding goldmines. As gold was excavated, the town boomed and at one time there were more than 2000 miners and 13 hotels.

The gold and the miners have long gone, and nowadays the population of 10 enjoys a quiet life, here among the Hawkdun Range, the Blue Lake ... and the ghost in the Vulcan Hotel.

Dating back to 1882, the sun-dried mud-brick hotel makes a pleasant stop for a coffee on a sunny day, with tables on the footpath. The adjacent Blue Lake began as a small hill. As miners searched for the mother lode, the hill became a pit, then a deep depression, with tunnels forming the deepest mining hole in the southern hemisphere. After they left, water slowly filled the shafts and created a stunning blue lake, its colour produced by minerals in the surrounding cliffs.

Autumn is a magical time — while the gold in the hills may have long gone, it remains in every poplar and birch tree.

Enjoy a welcome coffee or other liquid refreshment in the historic Vulcan Hotel (below) before crossing the road and marvelling at the man-made Blue Lake (right). Ian Brodie

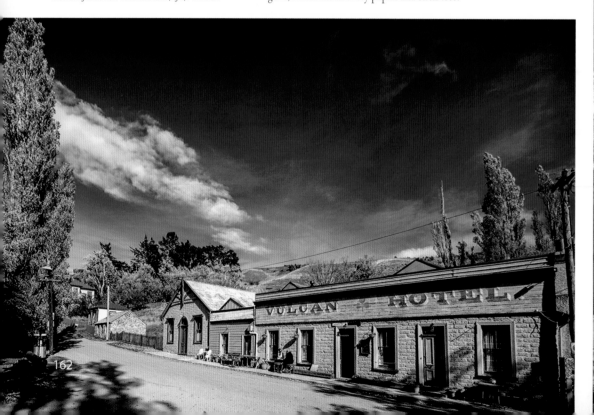

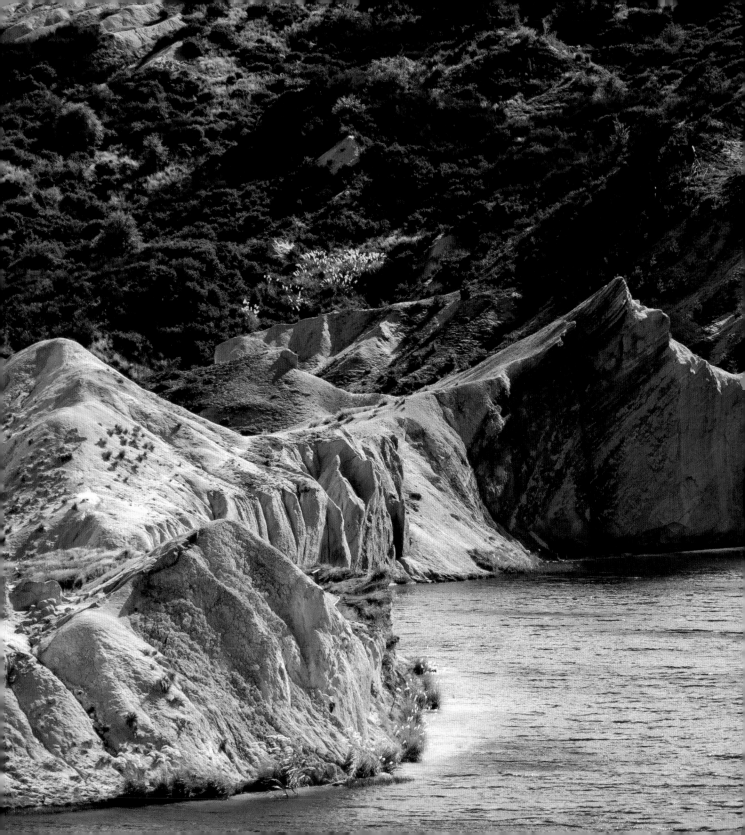

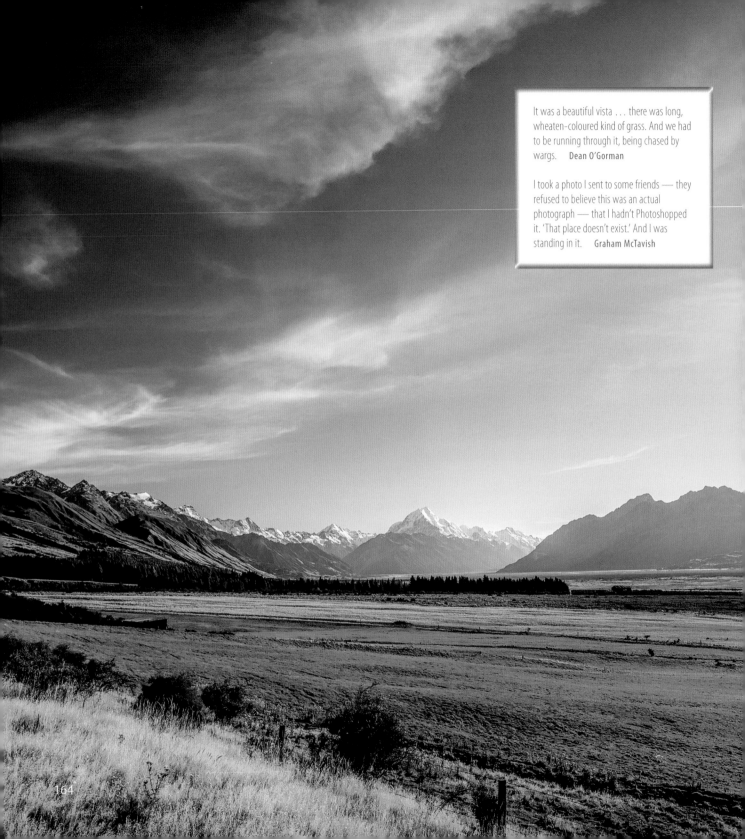

It was a beautiful vista . . . there was long, wheaten-coloured kind of grass. And we had to be running through it, being chased by wargs. **Dean O'Gorman**

I took a photo I sent to some friends — they refused to believe this was an actual photograph — that I hadn't Photoshopped it. 'That place doesn't exist.' And I was standing in it. **Graham McTavish**

Introducing Aoraki/Mt Cook

When travelling through the Mackenzie Basin, drive up to the alpine village of The Hermitage, nestled under the Southern Alps in Aoraki/Mount Cook National Park. First climbed on Christmas Day 1894, Aoraki/Mt Cook was a training ground for famous New Zealand mountaineer Sir Edmund Hillary, conqueror of Mt Everest.

From The Hermitage, alpine walks have wonderful views of the mountains and glaciers, and it's also the departure point for scenic flights to nearby movie locations.

If time is limited, one of the best walks is through the Hooker Flats (four hours return) on a well-formed track to Sefton Stream with a view of the terminal moraine of the Hooker Glacier.

Staying at The Hermitage is a treat — magnificent lodgings surrounded by the *Misty Mountains*. Nearby Glentanner Park also has accommodation or you can return to Twizel.

Named after Twizel Bridge in Northumberland, the town was built in the 1970s for people working on the Upper Waitaki Power Scheme. Most have since left but the town, with Lake Ohau and its associated ski field, is a popular holiday destination. Close by is man-made Lake Ruataniwha, with rainbow and brown trout.

Snuggled under the foothills of the Southern Alps, the area experiences extreme weather — cloaked in snow in winter, while hot summer nor'westers bring temperatures of 30-plus.

Accommodation and restaurants are available in town; there is also a well-equipped camping ground and numerous farm home-stays.

 Christchurch: 285 km
Middlemarch: 277 km
Wanaka: 143 km

 The Old Mountaineers Café, Mount Cook

 The Hermitage, Mount Cook
www.hermitage.co.nz

 Mackenzie Country Hotel, Twizel
www.mackenzie.co.nz

 Aoraki/Mt Cook Visitor Centre
www.mtcooknz.com

 Twizel Visitor Centre, Market Pl, Twizel

Opposite The view of Aoraki/Mt Cook from the main highway between Lake Pukaki and The Hermitage. Ian Brodie

Below High cirrus cloud masks the blue sky over the entrance to the Tasman Valley at Mount Cook. Ian Brodie

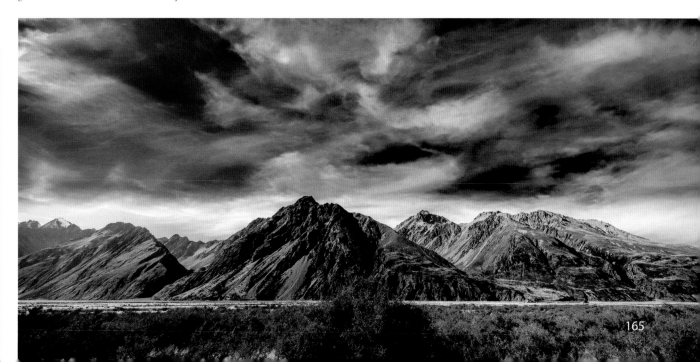

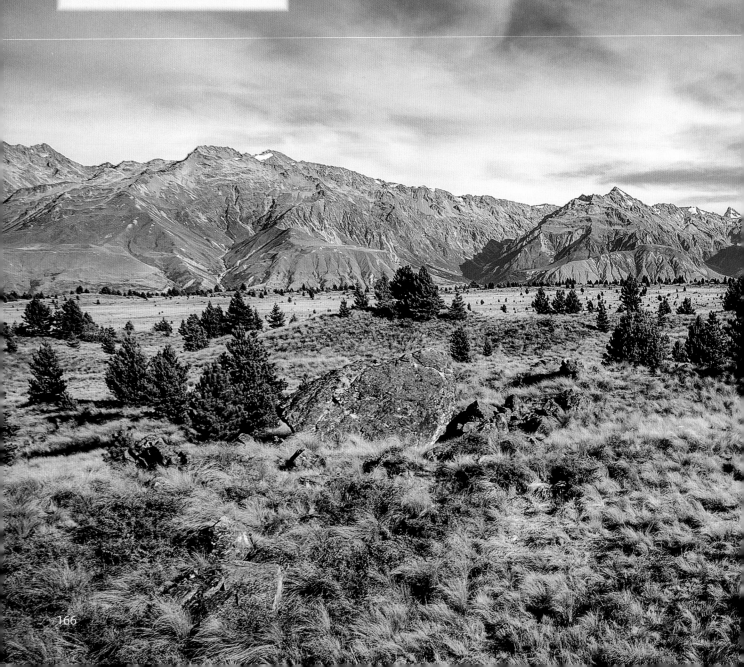

Braemar Station

Staying at Braemar Station is a treat, and it allows you to explore the landscape that was used to show the escape from warg-ridden orcs to the secret entrance to Rivendell. Ian Brodie/Warner Bros. Pictures (insets)

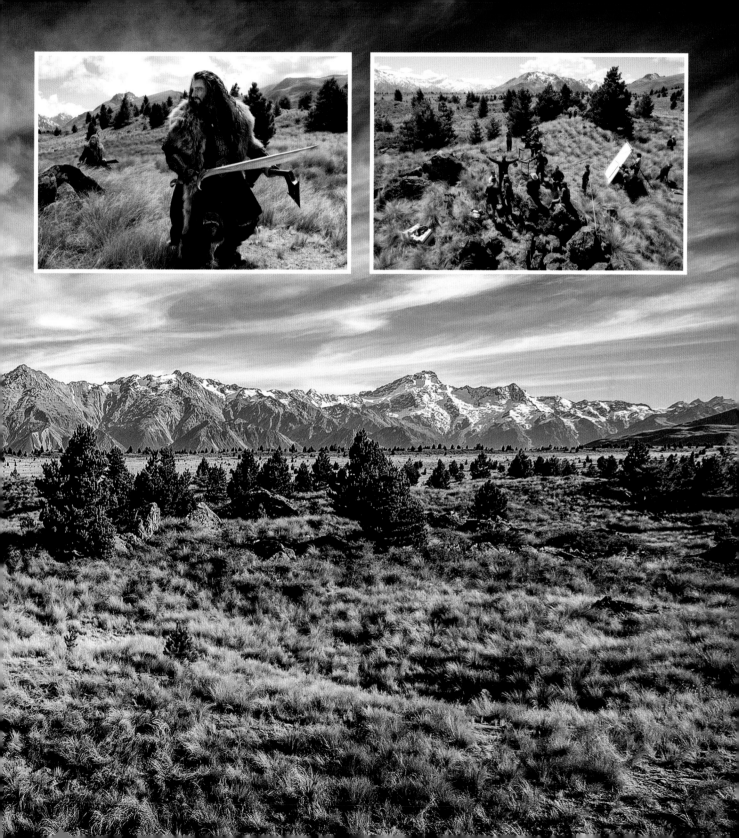

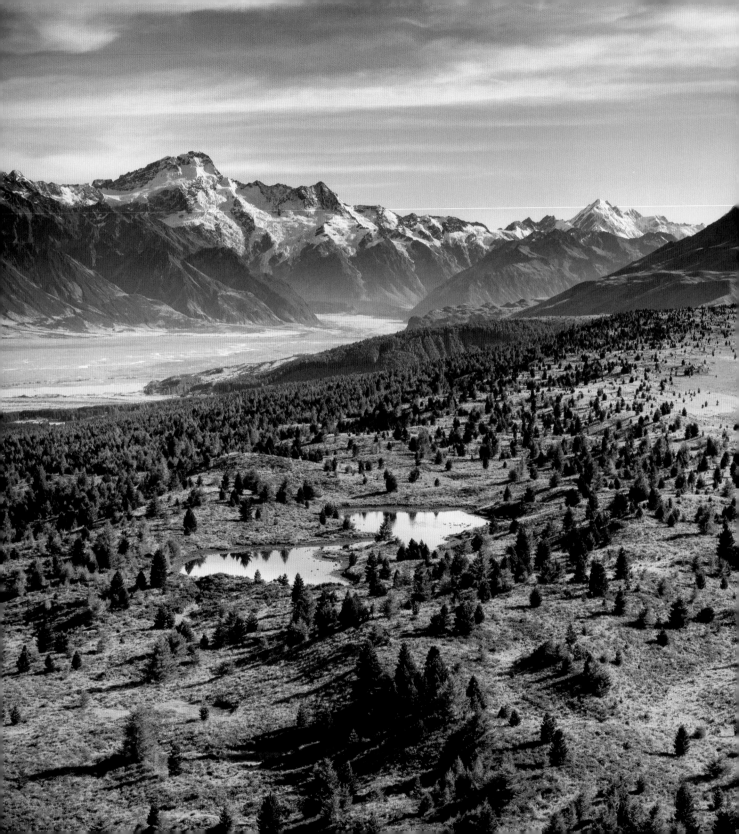

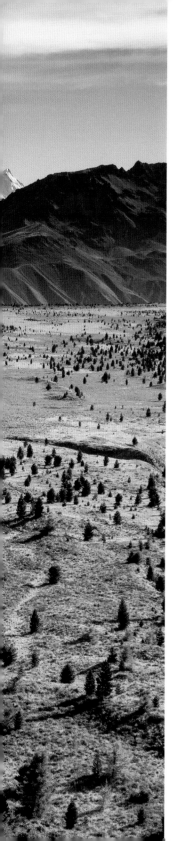
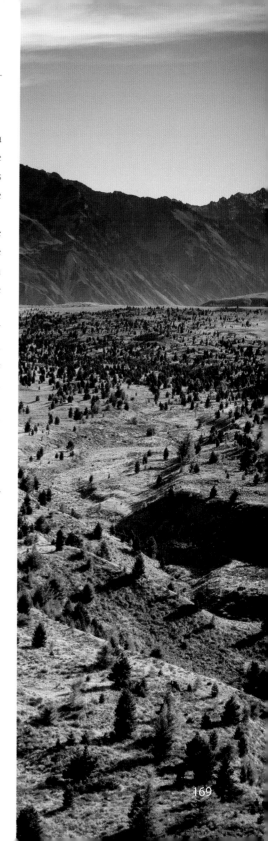

Lake Pukaki

When you first come across Lake Pukaki it's as if somebody dropped a colour bomb — the distinctive blue appears as a jewel among gold. The lake was formed when receding glaciers blocked the valley, and its colour is created by glacial flour — finely ground rock ejected by the Tasman Glacier.

The rolling tussock hills on the lake's eastern side were used for the epic chase by orcs and wargs as the *Company* searched desperately for the secret entrance to *Rivendell*. The area's similarity with Middlemarch means the scene moves seamlessly to Pukaki with a view towards the Southern Alps and Aoraki/Mt Cook standing in for the *Misty Mountains*.

The best way to see this location is by Heliworks' scenic helicopter flight. Based at Mount Cook Airport, Heliworks was involved with filming and provides a stunning flight across Lake Pukaki to the location. After lift-off and views of Aoraki/Mt Cook and the Tasman Glacier, you head across the head of the lake towards the location. Skimming over the tussock your pilot will also reveal the location for the impressive aerial scene as the *Company* escape the *Misty Mountains* after defeating the *Goblin King*.

To really enjoy this location there is the opportunity to stay at Braemar Station, the farm that was used in filming. Various types of farm-stay accommodation are available especially suited to families. During your stay you can mountain-bike to the locations, go trout fishing, or just relax with a good book and watch the sun set over the *Misty Mountains*.

i Heliworks Helicopters, Mount Cook Airport
www.heliworks.co.nz

i Braemar Station Accommodation, Lake Pukaki
www.holidayhouses.co.nz/properties/23432.asp

A general view of the location as seen on a Heliworks helicopter tour from Mount Cook Airport.
Ian Brodie

Suggested itinerary

Red Carpet Tours operates fully escorted specialised tours of New Zealand, featuring locations from *The Hobbit* and *The Lord of the Rings* film trilogies. Their people are total enthusiasts of all things *Middle-earth* Aotearoa and you are guaranteed an amazing experience.

If you require a personalised tour, Mike the Guide offers bespoke tours of all the *Middle-earth* locations in New Zealand.

For those wishing to travel individually, this itinerary will take you to most of the locations featuring in *The Hobbit*. It is an extensive tour, which will introduce you to the beauty of New Zealand, with some great off-the-beaten-track visits. To really appreciate them, you should allow extra time for two-night stays in many places to allow full exploration.

i Tourism New Zealand — www.newzealand.com

i Air New Zealand — www.airnewzealand.co.nz

i Department of Conservation — www.doc.govt.nz

i Red Carpet Tours — www.redcarpet-tours.com

i Mike the Guide — www.miketheguide.com

> Because you come from New Zealand you almost have to say New Zealand is beautiful sometimes, but New Zealand is unbelievably beautiful. **Dean O'Gorman**

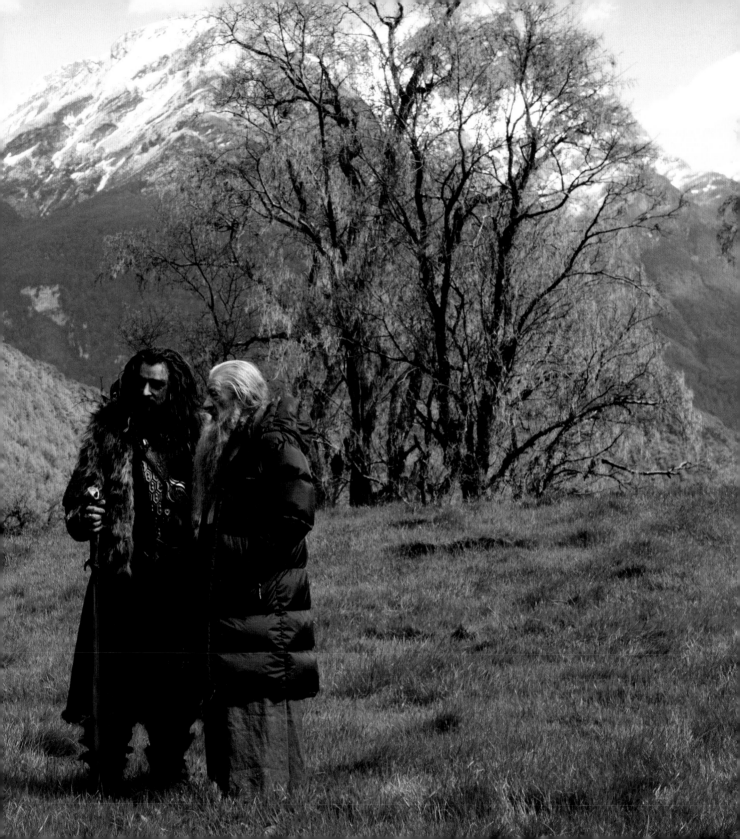

Day 1 : Auckland — Matamata — Waitomo
◇ Hobbiton

Day 2 : Waitomo — Piopio — Ohakune
◇ Trollshaws

Day 3 : Ohakune — Wellington
◇ The Lonely Mountain

Day 4 : Wellington
◇ Weta Cave

Day 5 : Wellington — Picton — Nelson
◇ The River Running
◇ The Ringmaker

Day 6 : Nelson — Collingwood
◇ Edge of the Shire
◇ The River Running
◇ Rough Country near Rivendell

Day 7 : Collingwood — Punakaiki
◇ Edge of Mirkwood

Index

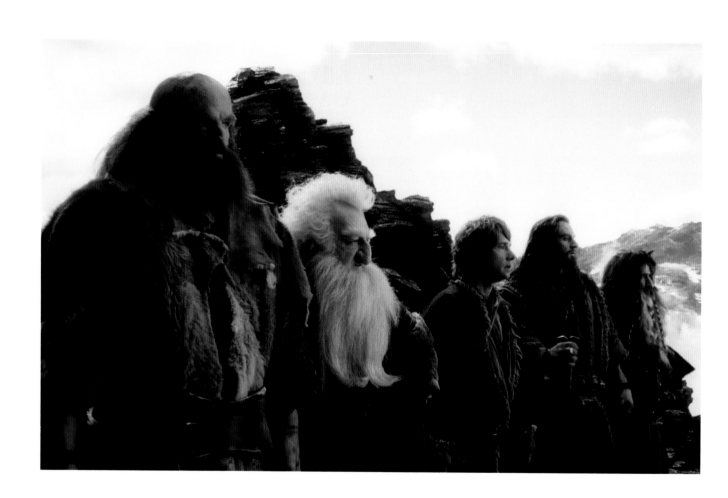